The Digital Filmmaking Handbook

MARK BRINDLE

Inspire. Learn. Film. Think.

Be unique.

Be yourself.

Be Kareem...

V.

Dubai, 28. december 2015.

Quercus

Contents

Advanced filmmaking

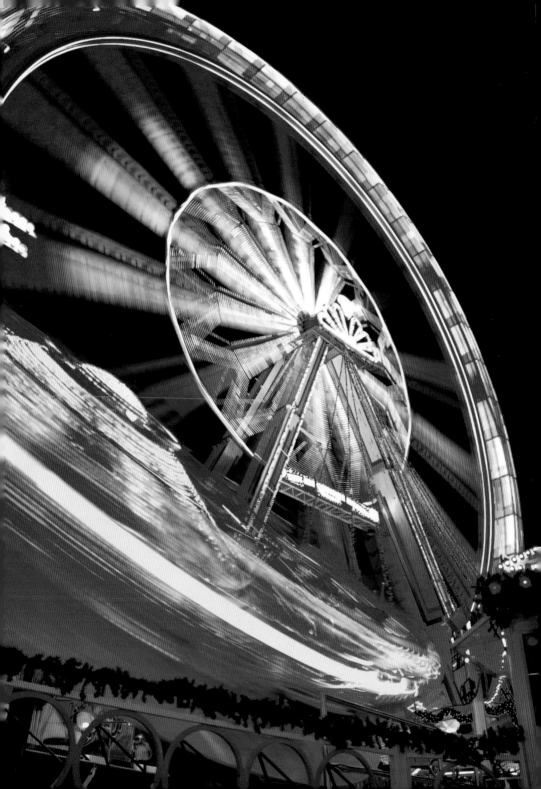

Foreword

Movies are a kind of magic. It follows that filmmakers are kind of magicians too. We create grand illusions that entertain, that make us laugh, and make us cry. And if you are reading this book, I suspect you are already an illusionist in the making.

Since the invention of movies, expensive cameras and filmstock have blocked so many filmmakers from producing their stories for the big screen. That's all changed now. The only limitation you face is 'how big is your imagination'? And what was previously the big screen, is now any screen, from the one down at your local multiplex, to the small screen on your phone.

We no longer need massive, big budgets and famous actors, nor posters the size of houses. Through social media we can connect with other filmmakers and actors, we can share knowledge and resources, as well as connect directly with audiences.

We are genuinely living through a cultural and industrial revolution the likes of which the film business has never experienced.

And believe it or not, you are about to ride the crest of this exciting wave.

Over the years, I have made feature films, TV shows and even been Oscars-shortlisted for a short film. Through the *Guerilla Film Makers Handbooks* I wrote, I have interviewed literally hundreds of filmmakers and if there is one thing that truly unites all of us, them, you and me, it is the love of movies and the making of them.

The act of thinking up an idea, writing it, seeing it brought to life with actors, light, design, music, editing…and finally presenting our flickering, magical illusion to an audience is an amazing experience.

And if you are lucky and talented enough to create something that really connects with people with thrills, laughter, tears, scares, reflection, even world-changing ideas…then you are in for an amazing ride, and hopefully a prosperous career too.

There are many hurdles ahead of you, but if you are resourceful I'm sure you will find your way over, around, under, or through them. Know that at each one you encounter, you'll probably feel like there is no way forward. Some will give up at this point. But you won't. Keep going. Never stop. Never give up.

If you dream big and never take no for an answer, then who knows, and I might be seeing you at the Oscars one day soon.

Let the magic begin…

Left: Creativity meets technical excellence in this long exposure, low frame rate video image. Be inspired to create stunning digital videos that can turn more mundane scenes into fantastic reality.

Chris Jones,
London

Introduction

Filmmaking has changed beyond recognition in the last few years, with ever cheaper and more accessible technology and the emergence of large-sensor DSLRs. There has never been a better time to shoot your own expert HD footage and, in a few simple steps, shape it into a coherent story. It is now possible to shoot a beautiful-looking film completely on DSLR, with minimal or no crew, and achieve something that can happily be screened in cinemas or on TV. In this book we will show you how easy it is to progress from a little smartphone video to a well-shot short or even feature film.

This book will teach you in easy steps how you can graduate from a fully automatic point-and-shoot to more advanced formats and kit, until you are confident enough to shoot, record and edit your own footage and sound and create professional videos and films. If you have ever wanted to pick up a camera and shout 'action', then this book is for you. Whether you want to make your name with the next independent breakthrough movie or just improve your own family videos, you will find lots of useful practical information on all aspects of filmmaking here.

The book follows a natural progression from basic to advanced level, to allow you to build up your knowledge and skills in all aspects of filmmaking – from video and sound recording to editing and finishing. We mix in the theory you need with practical tips

and techniques to help you gain confidence in using your camera and sound-recording gear, before diving into drama production and advanced post-production. Each section can also be read individually if you want to jump straight in.

THE BASICS

In this preliminary section we will be teaching you how to make and finish your first film. We will cover all the basic techniques for video and sound recording and suggest ideas for filming specific types of films, before completing the section with a look at editing and exporting your film to the internet.

Your equipment

Here, we'll look at the equipment you'll be using for filmmaking – what the gear is for and why you might need it. There's a mix of basic and advanced equipment – from video cameras and microphones to lighting, computers, video monitors and steadicams – to help you decide what is right for you now and what might be useful in the future.

Using your kit

Once we know what we need, we'll start to look at how to use it. In this section we cover camera-handling techniques and how to set up lighting and sound-recording gear, and go through the technical areas of shot composition, shutter speed, ND filters, using depth of field, setting colour balance, using picture styles and choosing between natural and artificial lighting for the best effects.

Below: *If you are the proud owner of a new video camera, try getting to grips with it in a peaceful, natural environment, so that you can take your time exploring all the settings without being hassled.*

Your first film project

Now it's time to put your new knowledge into action by filming specific projects such as a friend's wedding, live music, a sports or wildlife film, interviews or family videos. Learn about basic make-up and what not to wear, as well as how and when to use different camera shots to make your editing easier.

Basic editing

This section explains how to physically get your video from your camera into your computer and how to edit it into your first video using entry-level software. We show you how to add a soundtrack and video effects and then upload your video to the internet to share with friends and family.

ADVANCED FILMMAKING

Armed with the skills to create a simple project, we'll now delve a lot deeper into the art of filmmaking, especially into techniques used for shorts and feature drama as well as documentary production. We will cover all aspects of the digital filmmaking process, from planning, scriptwriting and casting to shooting the film and eventually taking it into the edit. We'll explain how to add special effects, sound effects and Foley until you have a finished film on Blu-ray or the internet.

Pre-production

Before we go into the actual shoot, we take you through the process of pre-production, where you will learn how a script is written, what makes an exciting story, and what genre your story might fall into. Then we will consider all the tasks that need to be organized before you start shooting your film, like planning and scheduling the production, finding funding sources, how to go about casting your film, how to choose locations and get filming licences for them, and tips on make-up and wardrobe.

The shoot

Before we take you through the various aspects of a film shoot, we'll discuss the key jobs on set – from focus puller to script supervisor, from key grip to director. We'll explain the process of blocking a scene for actors and camera, rehearsing it, setting it up, and why it is useful to understand headroom, eyelines and the all-important concept of the stage line. We'll go deeper into all other aspects of practical filmmaking on set, including advanced composition techniques, 3D filmmaking, chroma keying, and using car camera rigs. Finally, we'll discuss documentary and its different approach to planning, scripting and production.

Advanced editing

This section brings together all the stuff that needs to happen to complete your film. We look at importing footage, synchronizing and cleaning up picture and sound, and fixing shaky or noisy footage, and then go on to cover editing techniques, types of cuts and transitions and how to edit the film with music. Finally, we explain how to create a credit sequence and do a colour grade.

Going live

Now that the film is completed, you are ready to release it to your friends, family or the wider world at large. We'll now look at delivery formats such as DVD and Blu-ray and how to output your film for film festivals as well as self-distribution via the internet and video-sharing sites such as YouTube and Vimeo.

Right: Adventure documentaries have gone mainstream, with films such as Within Reach *or the mountaineering docu-drama* Touching The Void *making a considerable impact at the international box office.*

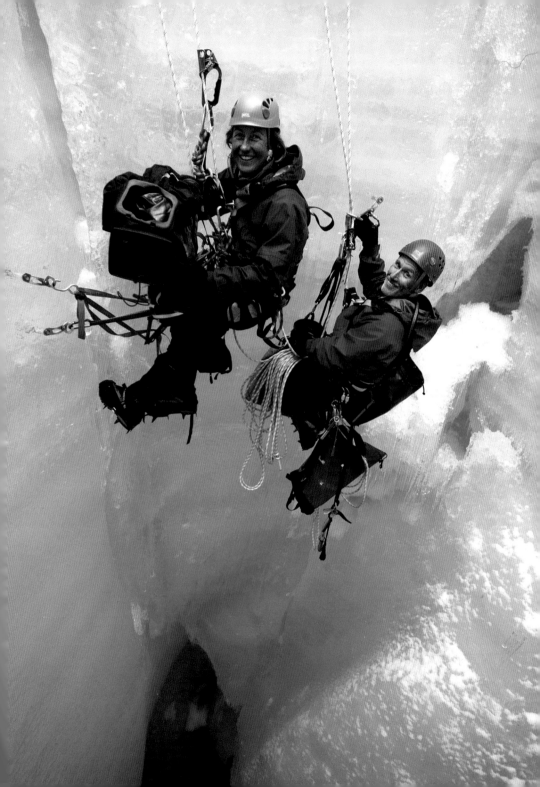

From **35mm** to **DSLR**

35mm film has been the mainstay of cinema and TV production for years, but digital video has eaten away at the differences in the last two decades and many advocates now believe digital is finally better than film.

Standard film sizes were developed to make it easier to produce and distribute movies worldwide. 35mm refers to the width of the photographic film, and it became the international standard in 1909. The larger formats of 65mm and 70mm were developed almost at the same time, but due to higher costs these sizes are rarely used today, except for IMAX cinema films.

Above: *The Arriflex LT 35mm movie camera was and still is Arri's flagship film camera across all budgets.*

Lowering costs

Processing and duplicating film incurs costs, as does making reels for distribution to cinemas and maintaining archive copies. With the advance of much cheaper digital technologies, the use of film in TV production and feature film production has been steadily eroded as digital quality has improved. Some memorable low-budget independent films were shot from the mid- to late 1990s on standard-definition camcorders such as the Sony VX100 and the Panasonic DVX100, which shot at 24 frames per second 'progressive mode' to mimic the look of film. Danny Boyle's apocalyptic zombie horror film *28 Days Later* used multiple Canon XL1 camcorders to keep the costs down. Digital video didn't have the light sensitivity that film can offer, nor the shallow depth of field, but it showed that features could be made digitally yet still look good when projected at the cinema.

ⓘ What is HD?

HD (high definition) is a format of digital video that was originally designed as a replacement for standard-definition TV broadcast. HD TV has a frame size of 1280 x 720 pixels (720p) or 1920 x 1080 (1080i/p), also known as 'full HD'. HD also refers to any digital video for cinema or non-broadcast and ranges in pixel width from 1280 and 1920 to 2K, 3K, 4K, 5K and right up to 8K ultrahigh-definition video.

Changing times

With the advent of high-definition TV channels, cheaper HD camcorders and increased demand for HD TVs in the home, more and more content began to be shot in HD. Feature films were shot in 100% digital to reduce costs, especially on effects-heavy films such as *Star Wars II*, filmed in 2002 on a Sony CineAlta F900. Panavision modified this so that it could use cinema lenses, thus achieving cinema-like shallow depth of field.

Getting the all-important shallow depth of field requires a large image sensor. A cheap way of achieving this was to use a 35mm lens adapter bolted onto the front of the camcorder with cinema lenses or stills camera lenses on the front of the adapter. This led to some pretty cumbersome camera systems, until the unexpected arrival of the DSLR (digital SLR) camera that could shoot video.

The rise of the Canon 5D

One of the first DSLR cameras to shoot full HD video with a frame size equivalent to 35mm film was the Canon 5D Mk II. This full-frame DSLR gave filmmakers the opportunity to capture beautiful digital video that looks like film, works well in low light and on a minute budget. Since its release at the end of 2008, the video DSLR and large-sensor camcorder market has literally exploded.

At the top end, a whole host of advanced digital cinema camera systems have been created by Arri, Sony, Canon,

Above: *Changing filmmaking for ever, the Canon 5D Mark II became the darling of the indie filmmaker.*

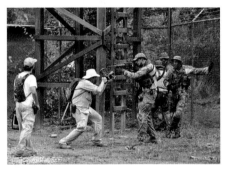

Above: *The action feature film* Act Of Valor *was shot almost entirely on the Canon 5D due to its incredible versatility and light weight.*

Panasonic and RED. Digital projectors have been rolled out in cinemas, internet speeds have increased and today HD digital cinema and HD digital TV have become the norm.

The recent sad demise of Kodak is another sign that the days of film appear to be numbered.

Left: *Building on their success in the DSLR market, Canon have developed the top-of-the-range EOS C500, designed for cinema or TV use.*

Your equipment

In this section, you'll find all you need to make an informed decision about what equipment to buy, including:

- **What type of camera** is best suited to the kinds of projects you are planning to undertake

- **How to enhance the capabilities of your camera** by considering viewfinders, additional lenses, monitors, steadicam devices, dollies and tracks

- **Which type of microphone or external recording device** to consider for the job

- **Adding simple lights and reflectors** to your list of equipment

- **Understanding what resolution, aspect ratios and frame rates** do to your footage

Lights, camera, action!

Creating video has never been so easy, thanks to the low cost of equipment today. Choosing what to buy really depends on what type of video you want to shoot. You should start with a small camcorder and work your way up with increasing experience and skill.

With the price of memory cards dropping all the time and some cameras coming with built-in memory for recording many hours of HD video, media costs are nearly 'free'. TV studios are off-loading good-quality SD (standard-definition) tape-based cameras onto the second-hand market in favour of new HD formats, so there are good opportunities to grab some bargain machines on which to learn your skills. With the price of large-sensor HD cameras still dropping you may wonder if it's worth buying older kit, but consider if you really do need the latest version. Equipment changes very rapidly and manufacturers announce and discount cameras sooner than ever, meaning that last year's 'great video camera' is even cheaper, but still a great camera.

Above: If you're the owner of a DSLR, invest in a few prime lenses as the quality is much better than zooms.

Good glass

Lenses are always worth keeping hold of as long as you can get a lens adapter to make them fit onto your camera. Older Nikon F-series lenses fit onto Canon (and Nikon) DSLRs, like the Canon 5D MkII, using cheap metal adapters. They also fit onto M43-mount cameras like the Panasonic AF101 or GH2. You can get adapters for many brands of film camera lenses like Minolta and Leica and, as long as you're willing to shoot with manual aperture and manual focus, these lenses will be sharp and fast enough for video. They are still cheap on websites such as eBay, as many people prefer modern auto-focus lenses.

Sounds right

Good audio is essential for great video, so listen critically to the sound quality coming from your camera microphone. If it's not good enough, consider buying a very good mic and a relatively cheap external sound recorder before replacing the camera. Sound recorders have become more affordable since the transition from tape-based DAT (digital audio tape) machines to solid-state memory cards. It's worth looking at small two-channel recorders such as the Zoom H4n to give you professional balanced XLR connections for microphones if your current video camera doesn't support external mics, or upgrading your mic instead. A good-quality microphone is a wise investment that will last for years.

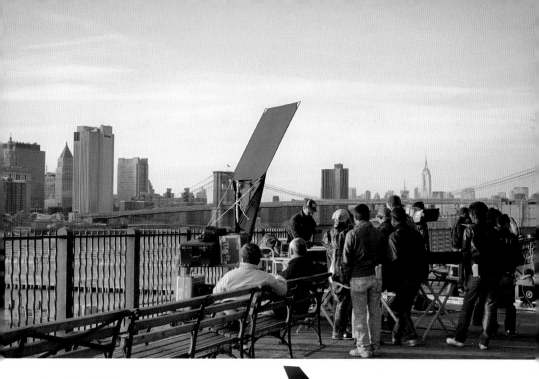

See the light

Lighting costs haven't really dropped for professional equipment. You need to be careful when comparing the cost of continuous lighting fixtures designed for the rigours of video production against something made for home or garden use. LED lighting seems to be the future for studio lighting due to its lower energy cost, smaller size and cooler operating temperatures, but prices are still extremely high for good LED lights such as the Kino Flo Celeb or the Gekko Kelvin panel. Do your research and test out different lights to find ones that meet your needs and match your budget.

Below: Invest in a good microphone, preferably with a fluffy windshield to reduce noise.

Above: Ensuring that the crew is small and the equipment portable and minimal is crucial in keeping down the cost of your first projects; often, the stunning backdrops come free.

Left: A Fresnel Redhead is small, very portable and the mainstay of micro-budget filming.

Types of camera

Cameras and camcorders come in all shapes and sizes and are designed with every imaginable user in mind. The possibilities are endless, and some of them very tempting. Imagine the types of films you'd like to make, and the way you'd like to work — gun and run, or slow and deliberate.

Digital cinema cameras

If your budget is positively unlimited, digital cinema cameras will be the thing for you. Used at the top end for feature-film production, 35mm-sensor, film-style digital cinema cameras such as the RED One and RED Epic boast huge 4K or 5K sensors, 13+ stops of dynamic range and RAW image capture. Forty-eight RED Epic cameras were used to film Peter Jackson's *The Hobbit 3D*. Direct competition comes from the Arri Alexa Studio 3.5K camera and the Sony F65 CineAlta 4K camera, with similar low-light capability and film-like image quality.

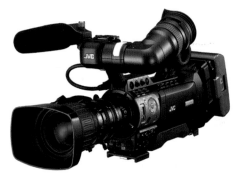

Above: JVC's flagship prosumer ENG camcorder, the GY-HM790, widely used in documentary shoots.

ENG and broadcast cameras

Moving across the budget range, we have ENG (electronic news gathering) cameras, designed for sports, adverts and high-end corporate video. Shoulder-mounted cameras such as the Panasonic HPX-3700 and Sony HDW-F900R have a ⅔-inch CCD sensor and a high-quality B4-mount zoom lens with servo-control for fast zooms and a large EVF (electronic viewfinder) for critical focus. These robust HD broadcast cameras have great ergonomics and a long recording time.

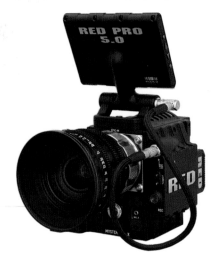

Above: The RED Epic was used to shoot The Hobbit 3D, as well as The Amazing Spiderman and The Girl with the Dragon Tattoo.

Large sensor cameras and DSLRs

Video-capable DSLRs have been a game-changer for the independent filmmaker market and have spawned a whole host of large sensor 'filmic' video cameras from traditional manufacturers such as Sony (F3, FS700) and Panasonic (AF101), who are trying to

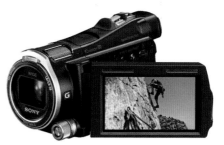

Right: The Nikon D800 boasts a 36.3MP sensor and great video recording. It has been used as a 2nd unit camera for films and commercials, like this one (far right) for the mobile phone network 3.

catch up with market demand. Most 35mm CMOS-sensor DSLRs such as the Canon 5D MkII and III or the Nikon D800 offer superb low-light filming, with interchangeable lenses in a lightweight package. Once you add on accessories, lenses, EVFs, HD monitors and camera rigs, things do get pricier, but the basic camera lets you shoot beautiful film-like video with shallow depth of field.

Broadcast video camcorder

This category is partway between professional ENG cameras and consumer camcorders – referred to as 'prosumer' video cameras. These are cameras good enough for TV broadcast, corporate work, promos and internet use, with professional controls and XLR audio for external microphones. Expect flip-out screens and viewfinders, but no shoulder mounts and smaller ½- or ⅓-inch CCD or CMOS sensors.

Consumer goods

With smaller ⅓- or ¼-inch CCD or CMOS sensors, we have the all-in-one video cameras that have been the mainstay of the consumer video market. With flip-out LCD touch screens, image stabilization and face recognition to help auto-focus, these cameras have become adept at producing great HD home movies with minimal user know-how.

Above: The Sony HDR-CX700V is a small, top-quality camcorder, with 1920x1080 HD, 24fps CinemaTone preset, and 96GB Flash Memory.

i Sensor sizes

Some video cameras use electronic image sensors the same size or larger than a standard 35mm film frame – the standard for the cinema world for many years. Smaller image sensors are called 'crop' sensors, based on how much smaller they are. The Sony F3 has a full-frame sensor, and the smaller APS-C-sized sensor on the Canon 7D is referred to as a 1.6x crop sensor. The sensor sizes go all the way down to a tiny 5.76 x 4.29mm in some compacts.

Medium format
50.7 x 39mm

35mm
full frame
36 x 24mm

APS-H (Canon)
28.7 x 19mm

APS-C (Nikon,
Pentax, Sony)
23.6 x 15.7mm

APS-C (Canon)
22.2 x 14.8mm

Four-thirds
system
17.3 x 13mm

Bullet cams and POV cams

Originally designed for CCTV or industrial use, bullet cameras are robust, 'go-anywhere' devices that are generally cabled up to a recorder. The GoPro Hero camera changed this market somewhat as a very small and affordable HD camera that features a super-wide-angle lens in a simple-to-use, watertight package. This type of camera is called a POV (point of view) camera, a wearable camera used for action sports filming or just getting shots from the point of view of the person wearing the camera. POV-type cameras offer very little in the way of controls, and use auto-exposure, auto-white balance and fixed focus to ensure a decent image.

Below: The GoPro Hero HD camera comes with a vast amount of accessories – even a surfboard mount.

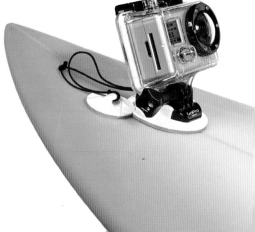

Above: POV cameras are great for hands-free activities, as they are mostly hardwearing and sometimes even partially waterproof.

3D glasses

3D filmmaking was very much a specialist category and reserved for large-scale feature films until the advent of 3D televisions and cheap full-HD 3D camcorders from JVC, Sony and Panasonic. Similar to the compact all-in-one category, these cameras usually feature two CMOS sensors and lenses side by side and are designed primarily for playback on home 3D TV or uploading to the internet.

Smartphone steadicams

Most smartphones and tablets have built-in HD video-recording capability, and video apps provide controls for variable frame rates, white balance and touch-screen spot focus and exposure controls, plus built-in LED lighting for night-time close-up filming. Holding the camera steady is still a problem, but many new accessories exist for this market, including dollies and handheld rigs. Smartphone video is definitely here to stay and seems to be heading down the 3D route as well.

Left: The Sony compact 3D camcorder HDR-TD10 offers great 3D recording at consumer level – but don't forget those glasses.

4:1:1, 4:2:2 and 4:4:4

Video is compressed in many ways to reduce the amount of data needed. The human eye does not notice loss of colour information as much as loss of brightness level, so a good way to reduce the data rate is to throw away some of the colour information. Colour sub-sampling is represented by a three-way ratio like 4:1:1, meaning that within a 4 x 2 pixels area 1 sample is taken of the chrominance value for the first row of 4 pixels and 1 sample for the second row, thus averaging out and throwing away colour information for each row. More colour-accurate 4:2:2 sampling means that 2 samples are taken per 4-pixel row. 4:4:4 means 4 samples are taken for each row – 1 sample per pixel – so 4:4:4 is uncompressed video.

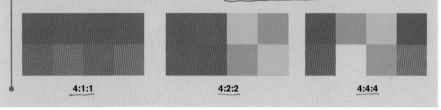

| 4:1:1 | 4:2:2 | 4:4:4 |

Viewfinders and monitors

Checking and maintaining the correct exposure when lighting changes is crucial for achieving good-looking video. In HD focusing is even more critical: a good viewfinder and monitor are essential, especially if you have graduated to manual focusing.

All video cameras have some kind of viewfinder or live-view LCD screen so that you can see what you're filming. Top-end cameras for ENG (electronic news gathering) or EFT (electronic film and TV) are geared around a shoulder mount with a large and bright viewfinder that's in just the right place for your eye. Video DSLRs have small LCD screens that pack in a lot of pixels to give a sharp image. Camcorders have flip-out LCD screens as well as viewfinders to give you nearly the best of both worlds, but the quality can often fall short. Whatever viewing option you have on your camera, there are some standard tools to help you compose and, more importantly, focus your shot.

Composition tools

Most cameras give you the ability to show a grid overlay in a variety of formats, varying from a centre marker to a 'rule-of-thirds' (see page 42) overlay to help you compose the elements of a static scene, with the horizontal and vertical grid also helping to keep your handheld shots on a straight track. You can also get framing overlays for title safe and action safe areas (see page 163), to give you safe space around your picture for TV broadcast.

Get your levels right

Many cameras support an adjustable zebra pattern – a special striped overlay on parts

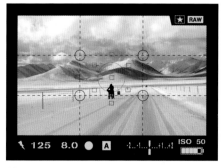

Above: *Most cameras and camcorders feature some kind of rule-of-thirds overlay grid, often integrated with the focus. This is helpful not only in determining your overall safe area – where you want the main action to occur – but also in reminding yourself of the basics of good composition.*

Top to bottom: *Camera feed without filter.* **Top to bottom:** *Feed with false colour overlays.*

of the video where light levels exceed your preset levels. False colour overlays work in a similar way, but with a range of colours to show the different light levels within your scene. Skin tone is normally pink, with dark colours representing areas below 10 or 20% and bright yellows and reds showing you close-to or overexposed areas. Waveform overlays, available on some cameras and external monitors, are great for showing the overall light levels reading for the whole scene.

Maintain your focus

Peaking tools vary between cameras, but they all share the principle of using a high sharpness algorithm to display the in-focus areas with well-defined sharp edges. As you move the focus away from an object, it is very easy to see the sharp lines change. Some peaking and focus detail tools switch the viewfinder to black and white and then use a different colour, such as red, to highlight the area in focus. Pixel-to-pixel zoom allows you to zoom in to the highest detail to check the focus. Some cameras, especially DSLRs, only support this feature when you're *not* recording – great to set up your shot, but not so great once you're actually filming.

External monitors

If your camera does not have the right tools, you may need an external monitor. This can also allow the director, the focus puller or your client to watch the action. Check your camera outputs and choose a suitable monitor with HDMI, HD-SDI or component HD inputs. Expensive broadcast-quality monitors will have multiple inputs with signal pass-through (to daisy-chain more than one monitor) and focus-assist features, but a cheap, big HDMI TV may suffice if you have the space for it.

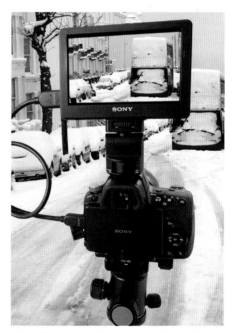

Above: *External monitors can be used on anything from a DSLR to most camcorders and are very helpful in a controlled environment.*

Lenses

Understanding camera lenses will give you more control and a wide array of creative options, but choosing the right lens for your purpose can become a trade-off between cost, size, lens speed and image quality. With all lenses, though, the optical principles remain the same.

All lenses perform the same function of focusing light onto the camera sensor and controlling the amount of light passing through with a physical aperture. Lenses come with AF (auto-focus) with servo-assisted zoom controls, IS (image stabilization) and electronic apertures, fully manual controls, or something in-between. Lenses are built from a series of lens elements that work together to produce sharp images with low distortion. Lenses are denoted by focal length and maximum aperture size (see box below). Technically, a 50mm lens should be 50mm long and a 300mm lens 300mm long – but due to the advanced design of the lens elements this is thankfully not the case.

Need more then one lens?

Zoom lenses have an adjustable focal length and are useful for filming live events, news, sports, or situations where you need to reframe your shot quickly. A zoom lens covers a range of focal lengths from wide angle to close-up and many zooms have a 2x extender built in to allow you to increase the range even more. Fixed focal lenses are called prime lenses, and you will need more than one prime lens to cover all your shots. Primes generally produce better quality images since they are less complex, minimize distortion, and perform better in low light. Special lenses such as macro lenses for extreme close-ups and fish-eye lenses for very extreme wide-angled shots are also options, but try to limit their use.

i F-stops

The f-stop is a ratio of the focal length of the lens to its diameter. As you close down the aperture, the diameter gets smaller and less light gets through. Manual aperture lenses are marked in f-stops, from the most open aperture at say f/1.4 (also written as f:1.4 or f.1.4), through f/2, f/2.8, f/4, f/5.6, f/8, f/11, f/16 and f/22. As the aperture is stopped

down, the amount of light is halved for each 'stop' as the area of the hole gets smaller. So f/4 lets in twice as much light as f/5.6. Some zoom lenses cannot go to their maximum aperture at every zoom setting, so you may have a lens rated as f/3.5–f/5.6. This lens type is not ideal for video, as the aperture changes as you zoom in or out and will change the exposure of your footage.

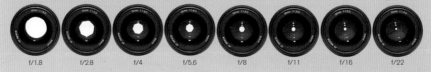

| f/1.8 | f/2.8 | f/4 | f/5.6 | f/8 | f/11 | f/16 | f/22 |

Above: *Most consumer camcorders don't come with interchangeable lenses, but the slightly pricier ones that do – such as the Sony NEX-VG20 – give you endless options to improve on lenses supplied as standard.*

What you see

The angle of view or FOV (field of view) is directly related to the focal length and camera sensor size: the larger the sensor, the wider the FOV for the same lens. So a 50mm lens on a full-frame sensor camera such as the Sony F3 would have a much wider FOV than the same 50mm lens on a smaller-sensor camera such as the Panasonic AF101 with its M43 2x crop sensor or the Canon 7D with its APS-C 1.6x crop sensor.

Most all-in-one video cameras with zoom lenses show a magnification factor (for example, 14x) instead of focal length, as it can be easier to visualize. For example, a Canon XF300 camera has a focal length of 4.1–73.8mm, which is equivalent to

29.3–527.4mm on 35mm (or 18x zoom), due to its small sensor. Showing the equivalent focal length makes it easier to compare the camera against a standard 35mm-sensor camera. Lenses are grouped by their equivalent focal length into super telephoto (300mm+), telephoto (300–135mm), medium telephoto (135–85mm), so-called 'normal' (50mm), wide-angle (28mm), very wide-angle (24–20mm) or ultrawide-angle (smaller than 16mm). Most so-called action or helmet cams have wide-angle lenses between 16mm and 24mm for ultimate focus.

Below: *A series of images taken of the same motif with different lenses shows the effect each focal length has, with 50mm being the most neutral.*

24mm

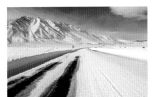
35mm

50mm

70mm

100mm

170mm

Tripods and monopods

Camera supports are essential for a steady shot. Any unsteadiness in your video can distract the audience – and if you are projecting video onto a big screen, any shakiness will be magnified many times over. Tools do exist in post-production to 'de-shake' footage, but should be used as a last resort.

Basic camera support starts with using what is around you: support yourself and the camera on a tree or on a wall, a chair or a bean bag, or pull your elbows into your body and move at the waist to try to keep handheld shots steadier. You may want to use a camera rig consisting of a shoulder mount and some front handles – typically rigs are used with rods to allow you to attach a follow-focus device to the camera lens. The camera weight is supported across your shoulders and can be balanced front/back with counterweights. The advantage is that you can move around freely and get different angles, but your shots will still not be that steady and you will tire quickly with the extra weight of the rig and camera.

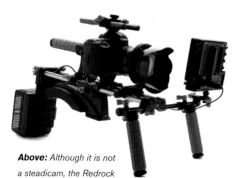

Above: Although it is not a steadicam, the Redrock shoulder support for video and DSLR cameras will give good results. The season finale of the US television show House *was shot entirely on a Canon EOS 5D Mk II such as this one.*

Tripods

For steadier shots using small DSLRs or small digital video cameras, you can use lightweight photographic tripods or lightweight video tripods. Tripods have three adjustable legs to keep them upright and a moving, lockable head to enable pan and tilt shots. They have a removable base plate on the tripod head that attaches to the underside of the camera. To use smartphones or any cameras without a base mounting screw on a tripod, you will need some kind of adapter. The best types of tripod have a fluid head that enables variable friction damping of the pan-and-tilt action – so you can perform steady camera moves at speeds to suit your shot.

Monopods

Monopods tend to be lighter than tripods and can be carried and set up more quickly as they only have a single leg to drop down. However, some monopods do not have a rotating head, so make sure you try out a few to get the features you want.

Tripods and monopods are made

Right: A monopod, like this one made by Manfrotto, is a great lightweight alternative if you don't want to lug around a tripod.

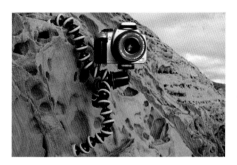

Above: *The Joby GorillaPod tripod has bendable legs that can stand up straight or bend around anything in the vicinity.*

of aluminium or carbon fibre and you generally get what you pay for. Carbon is lighter, but doesn't like exposure to water or marine environments and is more prone to cracking if it is not maintained well. Larger tripods come with floor or mid-level spreaders to help support the weight of the camera and avoid the tripod buckling.

Weight and levels

Fluid-head video tripods usually come equipped with a spirit level and a ball joint head that allows you to level the head quickly without having to keep adjusting the legs. Some tripod heads have built-in lights on the level – ideal for setting up in low light.

Never overload your tripod. Both tripods and heads have weight limits and, if overloaded, the legs could slide down or the head might not hold the camera in a locked-off position. Professional video tripods come in a variety of leg lengths, from small baby tripods to extra-long lengths, and will support different weights with bowl head sizes from 75mm, 100mm to 150mm for very heavy-duty tripods. Be safe and always use the right tripod for the camera and rig.

Above: *A sturdy, solidly built tripod still gives the best support for your camcorder, especially if you can afford the extra weight on your day out filming.*

Useful tips

• If shooting handheld, try using the viewfinder framing lines or grid lines to match up horizontal or vertical edges in your scene to help keep your shot steady.

• Build a monopod using a bit of string. Attach a length of string to your camera base via a screw and let it dangle down, stand on the end of the string and pull the camera up so the string is taut. Keep the string tight and you have a makeshift monopod.

• For extra security, use sandbags on your spreaders and on tripod feet.

Steady your camera

Almost every movie uses camera movement – from subtle tripod moves to long tracking and sweeping crane shots – to lead the audience into a scene, emphasize a detail or make the viewer feel that they are virtually part of the action.

On big blockbuster, CGI-heavy films such as *Avatar* or *Transformers*, some of the camera moves are done using software and virtual cameras. Motion-control systems can program camera moves so that they can be repeated again and again to get the perfect performance.

Tracking shots

On a low budget you needn't be restricted to handheld or tripod shots; there are lots of ways to create interesting moves. Sliders are cheap and add subtle camera tracking to your videos. They come in sizes from about 0.5m to several metres long and can be floor mounted or supported on one or two tripods or heavy-duty light stands. Sliders are lightweight and very versatile, allowing you to move the camera horizontally or at an angle when coupled with a tripod head. Some sliders come with motors to give you speed control over the moves.

The next step up in terms of set-up time and crew needed is the track dolly. You can get a simple dolly that attaches to the tripod feet – useful for moving the tripod between positions in a studio. A track dolly runs on track, and the set-up time is not insignificant, especially on surfaces that are not already flat and need wedges and packing to keep the track running smoothly. Dolly tracks come in straight or curved sections to give you the length of tracking shot you need. Some track dollies are 'ride-on' to allow the camera operator to be pushed or pulled – ideal if you're trying to adjust focus and re-frame your shot at the same time as moving the camera.

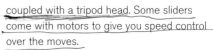

Angled when coupled with tripod head

Left: *Big-budget film shoots often use cranes and dolly tracks to cover complicated scenes from all angles.*

Right: *You don't have to have a large budget to achieve great track shots with this simple camcorder track from Konova.*

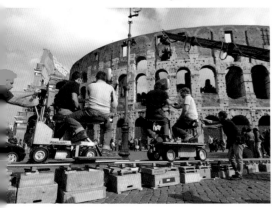

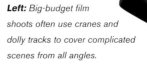

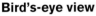

Bird's-eye view

Raising or lowering the camera is a great device when moving between two shots – revealing a character as the camera is lowered or revealing a landscape as it's raised high. A jib arm allows you to raise and lower the camera in a controlled manner by using a counterbalance system of weights. A jib is usually controlled from the front, using a tripod head to add pan-and-tilt capability. Fluid moves come from the fine balance between camera and head weights and counterweights on the back to allow fingertip control.

A camera crane is longer than a jib, since it is operated from the back rather than the front. A crane doesn't have a normal tripod head, although it may have a motorized PTZ (pan–tilt–zoom) system to add on extra capability. Cranes are counterbalanced, too, for smooth operation and have the ability to point at the same object as they are raised and lowered, or to be set to point at the horizon. It's much harder to produce the same effect with a jib.

Right: The Steadicam Pilot from Tiffen is the professional yet lightweight option for smooth camcorder shots.

Above: A small tripod crane with monitor support from ABC – great for shooting highly effective camera sweeps.

Top left: Motorized heads give you the ultimate flexibility with a camera crane.

Smooth running

Getting smooth handheld shots when you're following action is almost impossible – the body's motion is transferred to the camera, resulting in an up/down movement as you walk. The invention of the Steadicam system in the 1970s, using a sprung arm and vest, fixed that problem and allowed long, complex sequences to be shot in a continuous take. Camera stabilizers, such as the Tiffen Steadicam, are now smaller to accommodate lighter cameras and DSLRs, but a vest and arm are still desirable to produce the smoothest shots.

Useful tips

- Simulate a tracking shot using a long telephoto lens while panning your tripod. Foreground clutter gives depth.

- Remove wobbles from your tracking shots in post-production with de-shake software built into Adobe After Effects, Apple Motion or similar programs.

Microphones

Your camera or camcorder probably has a built-in microphone. This will suffice for some situations but should not be relied on for the majority of your sound, as it can suffer from handling noise. Instead, consider a better quality external mic.

Microphones come in a variety of shapes and sizes, but are generally classified by their technical make-up – either dynamic or condenser – and by their pick-up pattern – either omni- (all directions) or uni- (single) direction mics. Dynamic mics like the classic Shure SM58 are the most durable and are used regularly as handheld vocal mics at gigs as they can cope with really high sound levels close up and take a lot of knocks.

Above: The Shure SM58 is still considered the must-have workhorse of the recording industry.

Below: It's a good idea to invest in a windshield and make using it a habit. You will drastically cut down on unwanted noise. This 'Deadcat' from Rode is the perfect accessory to the Rode VideoMic Pro.

Condenser microphones

Due to their increased sensitivity, condenser microphones are ideal for video, but usually cost a lot more and are less robust to both sound levels and to being knocked about. Treat your condenser mic well or you may have to replace it sooner than you would want. Condenser mics need to be powered either by a built-in battery or externally over a cable from your camera or external recorder. This is called phantom powering, which is normally labelled on the camera as -48V. Small electret condenser mics used as clip-on lapel mics are known as lavalier mics and are usually powered from a small radio transmitter pack.

Pick-up patterns

Every microphone has its own sound pick-up pattern – a three-dimensional area of sound sensitivity around it. Omnidirectional mics will theoretically pick up sound equally well in all directions and are used for lavalier mics. Directional mics (favouring sound coming from a single direction) are used as onboard camera mics and boom mics, as they can be pointed directly at the sound source without picking up as much unwanted off-axis noise. Unidirectional mics have a range of pick-up patterns, from the cardioid pattern (named after the heart-shaped pick-up pattern) of the SM58 – which is ideal for a mic

Shotgun microphone

XLR connection for additional microphones

on a PA system, as it does not pick up sound behind the mic or induce nasty feedback or handling noise – through the more tapered and further-reaching pick-ups of the supercardioid, to the longer reach of shotgun mics. These highly directional mics are ideal when you can't get your mic as close to the action as you would like.

Radio mics usually consist of a transmitter (Tx) and receiver (Rx) pair that are set to the same frequency, with a mic input on the Tx and an output on the Rx to plug into your camera or recorder. Frequencies used are in a licensed band and are country specific, so you will normally need a licence to operate them. The actual microphone may be a lavalier mic,

Above: JVC prosumer camcorder GY-HM100U with shotgun microphone.

but you can also get vocal stage mics with built-in radio transmitters and separate mic transmitters to turn your shotgun mic into a radio mic on a boom pole or on a mic stand.

Specialist mics exist for recording surround sound over five or more channels at once, and parabolic mics are designed for picking up birdsong in nature filming.

Microphone pick-up patterns

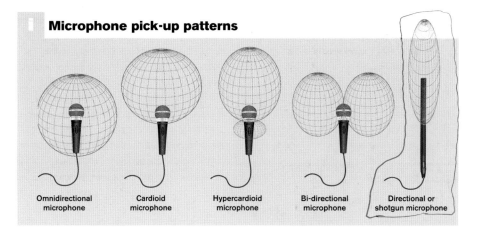

| Omnidirectional microphone | Cardioid microphone | Hypercardioid microphone | Bi-directional microphone | Directional or shotgun microphone |

External **recording devices**

Does your camera support high-quality recording or have inputs for external microphones? If not, then external recorders are a great solution. They are also invaluable if you want to record a 'wildtrack' — background sound such as traffic noise or birdsong that you might want for the edit.

External audio recorders have been used since the beginning of the 'talkies', when early cameras did not record picture and sound onto the same device. Modern TV and feature films are still recorded with independent sound on a separate audio recorder to ensure the best quality. The sound person records and monitors via a sound mixer with quality pre-amplifiers into an external audio recorder, which allows them to be un-tethered to the camera. Recorders are mostly solid state now, although DAT (digital audio tape) and Minidisc recorders are still useful.

***Above:** The BeachTek DXA-5DA audio mixer and adapter can be routed between an external microphone and your DSLR, vastly improving your external audio options.*

Sound mixers

Good external audio mixers and recorders will have a highly readable and highly responsive levels meter marked in decibels (dB) from zero down to -60 dB or lower, with 'headroom' markers at the high end to show you how close your signal is getting to peaking. Controls will include a physical knob for each channel, so that you can 'ride the levels' and adjust the gain of the incoming audio signal. There will be per-channel monitoring via the headphone jack socket and per-channel monitoring of the levels so that you can isolate each channel's sounds. Other features include built-in limiters to avoid peaking and low-cut filters to remove low frequency and wind noise.

If you're a self-shooter or have a small crew and work on a low budget, you can skip the mixer and just use an audio recorder with its own mixer controls. These devices have XLR inputs and provide phantom power (-48V) for microphones — useful if you need to use a shotgun mic and your DSLR only has a mini-jack input. They have switchable sample rates from 44.1KHz (default for CD audio), 48KHz (default for video) and higher quality 96KHz 24-bit recording. The higher the sample frequency, the more storage space is used — but a 4GB card will take many hours of high-quality audio, so it's best to record at as high a sample rate as your editing system will allow.

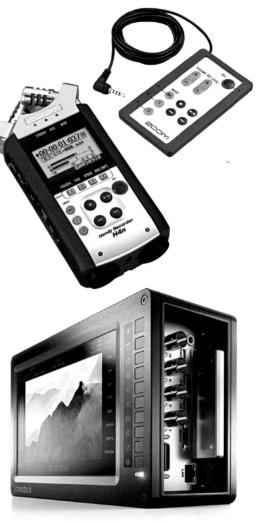

Right: The H4n sound recorder is Zoom's most sophisticated handheld recorder to date. Devices like these can be camera- or tripod-mounted, as well as remote-controlled (far right), and offer broadcast-quality sound at a budget.

External video recorders

Many video cameras use highly compressed codecs like AVCCAM, AVCHD or H.264 at 17–40Mbps and do not record all the sensor data. These data rates are great for a lot of scenarios, but when you want to get the best quality possible for colour grading and visual effects work, you need to record more of the original uncompressed data. Solid-state video recorders that use memory cards or SSDs are widely available from the likes of Atomos, AJA, Cinedeck and convergent devices. They can record video at very high data rates for 1080, 2K and 4K frame sizes, with inputs for HDMI and HD-SDI. They also record embedded audio in the data signal but don't usually offer direct audio inputs or sound-mixing controls, as the manufacturers expect you to use external audio recorders.

Above: The Cinedeck EX is a portable and rugged direct-to-disk, cinema-grade HD/2K video recorder, monitoring and playback system.

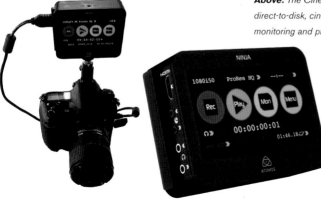

Left: The Ninja 2 recorder from Atomos is a top-class budget video-recording device that records high-quality video straight to removable hard disks and fits almost any camera.

Lights and reflectors

Lighting is fundamental to producing good-looking video. Continuous, electric lights have evolved a language of their own, so let's look at some of the terminology.

Basic lights can be categorized by the colour of their light (tungsten or daylight), whether they produce hard or soft shadows, and the amount of light output (in watts). A standard three-light kit with light stands is the tungsten Fresnel 'Redhead' in a range from 650W to 1000W. The lamp-head design incorporates a parabolic reflector that focuses the light forwards and the built-in lens gives you control over a flood (wide) or spot effect. The name Redhead comes from the colour the lamp heads originally came in – only red.

Smaller sets of 'reporter' lights of 250–350W are available with similar focus ability, as well as larger tungsten Fresnels in the

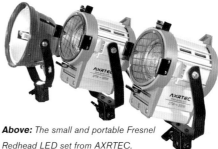

Above: The small and portable Fresnel Redhead LED set from AXRTEC.

2–20KW range. HMI (hydrargyrum medium-arc iodide) lights are more efficient and are closer to daylight colour temperature, but cost more to buy or rent.

Hot and cold lights

Electric lights have been around more than a hundred years, but it's only relatively recently that designs have changed radically to improve efficiency. To cut down on excess heat generated from Redheads and similar 'hot lights', new 'cold lights' exist in the form of fluorescent tube lights from the likes of Kino Flo and LED light panels, made using multiple point sources. Fluorescent tubes are available in both daylight and tungsten colour temperatures to allow you to match them to the colour of your other scene lighting. LED lighting technology is still under development, so the cost is high, but these types of light fixtures look set to replace many indoor studio lights as they will save money, especially on air conditioning and space: you can put a cold light a lot closer to your actor and thus have a smaller studio.

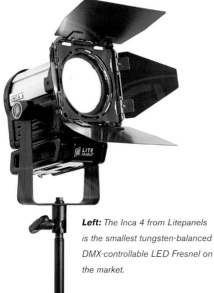

Left: The Inca 4 from Litepanels is the smallest tungsten-balanced DMX-controllable LED Fresnel on the market.

Left: Multi-coloured gel filters clip straight onto the lights.

Light shaping

Good lighting is about adding and subtracting light. Hard lights come with 'barn doors' to help shape the direction of the light coming out, literally acting as dark reflectors to stop light from going in all directions. Additional 'flags' are used on light stands or on grip arms to block light, as well as net scrims, to reduce light hitting parts of your scene.

Diffusion

Hard light sources like the sun or a Redhead lamp produce hard shadows. However, the light can be diffused by bouncing it from a hard surface or reflector, which will make it softer and more flattering – better for people shots. Soft boxes can be used to diffuse hard lights and these fit over the front of Redheads. A basic soft diffusion is a diffusion gel, which attaches to the front of the light to soften it.

Changing colour

If you are shooting with a mix of tungsten and daylight lamps, you can choose gel filters to change the colour of the light output from one set to match the other (CTB [blue] filters change tungsten to daylight; CTO [orange] the opposite). Heat-resistant gels can be attached to the front of lights with metal clips or straight onto the barn doors. Some handheld or camera-top lights will have special built-in dichroic filters to do this job. Using gels and filters, however, will cut down on the amount of actual light available.

Below: A street scene at night is never simple:
① 25W Christmas lights.
② Yellow Kino Flo lights out of the store windows.
③ Blue floodlight on church.
④ Concealed green 1000W Fresnel Redhead.
⑤ Concealed blue 500W Fresnel Redhead.

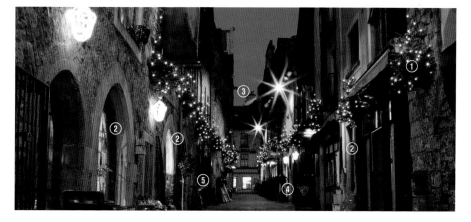

Which **computer?**

You've shot your video, but which computer and software should you use to edit it all together and play it on? And what about screens, graphics cards, memory cards and storage for your files?

Mac or PC is not the only choice you need to make, you might also consider using a tablet instead of a mouse, which is what a lot of editors prefer.

For multimedia the Apple Mac has been the standout choice for years, but Windows machines have been making up ground. Apple Macs run on Intel processors, as do PCs. They both have 64-bit operating systems for multi-tasking (Windows 7 and Mac OS X) and a wide range of software support. The processor and graphics card specifications change constantly, but direct comparisons

Above: A powerful iMac running the Apple-native FCP X.

Right: Even small laptops like this Dell XPS are capable of running software like Pinnacle happily.

between one machine and another can be straightforward if you do your research.

PCs have more hardware options available, with more manufacturers' graphics cards, memory chips and peripherals supported. However, the wide range of hardware for a PC does not always lead to machine stability – a fact Apple has exploited to build its large following in the professional video market.

Applications

For PCs, there are video-editing programs such as Avid and Sony Vegas and simpler apps from Roxio, Corel and Pinnacle. Adobe provides full-featured apps such as Premiere, After Effects and Photoshop for both PC and Mac platforms. The mainstay professional video production suite on the Mac has been FCP (Final Cut Pro), with a range of great apps for editing, motion graphics and audio work. However, with the poor uptake of its latest version, FCP X, and the excellent DaVinci colour grading system now coming to Windows, you might be tempted to buy a new PC and use Adobe's production suite instead.

Screens – size matters

For HD video you will need a full HD screen of at least 1920 x 1080 (widescreen), with a fast refresh rate and a decent contrast ratio. Avoid a glossy screen: although they make your videos look good, they also reflect light and make it harder to get your work done. Larger screens are best for avoiding eye-

Above: *FCP X is Apple's latest version of Final Cut Pro.*

Above: *DaVinci Resolve gets to grips with colour grading.*

Above: *Adobe Premiere hopes for a comeback with its Premiere CS6.*

strain, so go with 23 inches or larger. Avoid VGA- (video graphics array) only screens as these do not make the most of your graphics cards; go for DVI (digital video interface) or HDMI (high-definition multimedia interface).

The faster the better

You'll need a fast processor and a powerful graphics card to work with modern video formats such as H.264 and AVCHD, even just for playback. You will be converting between file formats, rendering out effects – all number-crunching tasks that need the best multi-core hardware you can afford.

Big disks

You'll also need large and fast HDDs (hard disk drives) to store your video files. Use only 7200-RPM+ drives, since 5400-RPM drives are too slow for video. SSDs (solid state drives) are becoming large and cheap enough to use instead – these have higher read and write speeds than normal HDDs and are quiet and energy efficient.

RAID disk arrays

For faster video speed, consider RAID disk arrays. RAID stands for Redundant Array of Inexpensive Disks – sets of HDDs that can be read from and written to simultaneously to increase throughput. RAID arrays are set up as either 'mirrored', where data is copied exactly the same (a mirror image) across multiple drives, or 'striped', where data is

written in small chunks to one of several disks at the same time. Mirrored arrays are safer than just having one drive, since the data is copied to multiple drives in your system and will be safe from a single drive crash.

You can buy external all-in-one RAID devices, but avoid any designed just for back-up as these are generally too slow. Drive enclosures should be connected to your computer by SATA or Intel's new Thunderbolt interfaces to benefit from the speed increase.

Data capture and transfer

You need interfaces or memory card slots to capture or copy the data from your camera. Modern cameras use removable memory cards or USB interfaces directly. Future cameras may support USB3 or Thunderbolt technology for speed.

For broadcast work, you may need an SDI (serial digital interface) capture and playback card for your computer in order to connect to external tape decks or direct to camera.

DVD and Blu-ray

You would expect to have a DVD re-writer on any computer you bought today. For PCs you may want a Blu-ray drive, too, to watch your HD movie as it was intended. You can author Blu-ray titles on both Mac and PC using Adobe Encore, or Roxio Toast for simpler menus, but you will only be able to playback Blu-ray disks on a PC as Apple does not yet fully support Blu-ray.

Resolution and aspect ratios

Modern digital video technology is not just one thing – it is in fact a confusing maze of formats, resolutions, frame rates, sensor sizes and yes, even pixel sizes. You don't need to understand all of it, but a basic grasp of the technology will help you in every aspect.

Digital video comes in a range of standard frame sizes depending on the TV system it was designed for. SD (standard definition) in the UK and most of Europe is PAL at 720 pixels wide by 576 pixels high at 25 fps (frames per second) or 50 interlaced fields (see page 188). In the USA, parts of Asia and Japan, it's NTSC at 720 by 480 at approx 30 fps or 60 interlaced fields. SD video has different shapes or aspect ratios for the width and height: either normal (4:3) or wide screen (16:9). Wide-screen format is known as anamorphic because you're still only using the same 720 by 576 pixels in the case of PAL – but your image is squashed into the frame and then stretched out for playback on a wide-screen TV by using non-square pixels. Switching information in the TV signal or DVD player will tell your TV set the correct way to display the image and add letterboxing as necessary to 'unsquash' it.

High definition

Thankfully, the newer standards of HD (high definition) video are always in a 16:9 aspect ratio to match wide-screen HD TVs and come in frame sizes of either 1280 by 720 or 1920 by 1080, with square pixels for both PAL and NTSC. Differences in frame rate exist between PAL HD and NTSC HD, with standards for both interlaced (1080i) and progressive video (720p, 1080p). Many

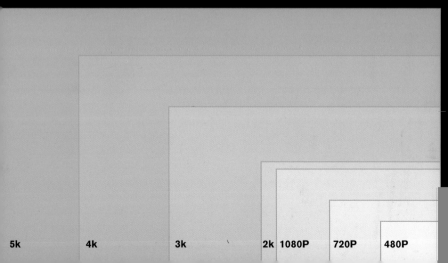

| 5k | 4k | 3k | | 2k | 1080P | 720P | 480P |

1920 x 1080

1440 x 1080

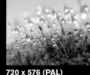

720 x 576 (PAL)

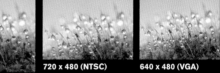

720 x 480 (NTSC) **640 x 480 (VGA)**

1280 x 720

cameras can be switched between these two formats to give you a range of frame rates to work with, including 23.976 (23.98), 24, 25, 29.97, 30, 50, 59.94 and 60 fps. Rates are referred to as 720p25, meaning 25 progressive fps at 1280 by 720 frame size, or as 1080i50, meaning 50 interlaced fields at 1920 by 1080.

Huge data rates

Larger frame sizes exist for digital cinema cameras shooting at 2K (2048 x 1536 pixels), 3K, 4K (4096 x 3072 pixels) and 5K right up to ultrahigh-definition video (UHDV) at a whopping 8K resolution. Large frame sizes need lots of space for the data generated, especially at high frame rates. Imagine the frame size in pixels multiplied by the amount of data bits per pixel representing colour information (usually 8 bits for each pixel in red, green and blue), then multiply this by the frames per second (fps) and you will end up with huge data rates for just one second of video. This data rate is referred to as uncompressed data, but in reality most

cameras use heavy compression algorithms to greatly reduce the data rate down to more manageable values.

Codecs

SD video cameras record in the DV codec (at about 8:1 compression) or in proprietary formats such as DVCAM from Sony. DV needs 12GB per hour of video (or 25Mbps), the same as the HDV codec. HDV is a common HD camera algorithm, but it is difficult for computers to edit, so the video tends to get converted into another format before editing. Other HD camera/recorder compression algorithms include AVCCAM, AVCHD, XDCAM, RAW, DNxHD, Apple Pro Res and even H.264 (normally for web video delivery), which is used on many Canon DSLRs at low data rates (<30Mbps) but gives surprisingly good picture quality. HD camera codecs are increasingly compared against the BBC minimum HD delivery standard of 50Mbps for 1080, so if you're planning to shoot for TV it's best to check the broadcaster's requirements before choosing your camera.

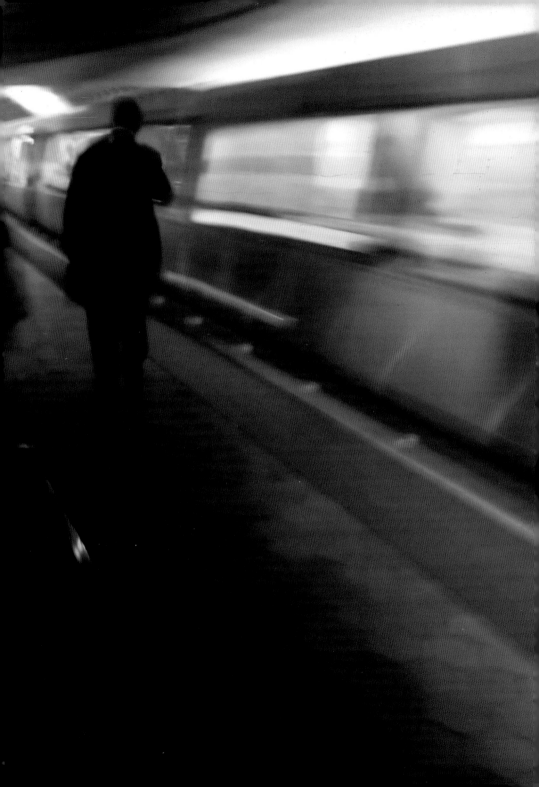

Using your
video camera

In this section, you'll get to grips with your camera and simple sound recording equipment, including:

- **How to use composition, framing and depth of field** to focus audience attention and create suspense

- **Mastering handheld and tripod techniques** so that you are ready to shoot on the go, in low light and other challenging situations

- **Learning creative techniques –** shutter speed, variable frame rates, colour balance, exposure and neutral density

- **Working with lights, filters and matte boxes** to achieve a professional look

- **How to create more impressive work** by mastering the film look and basic sound-recording techniques

Composition

The way you frame your shots is an artistic choice but also a storytelling device, and the position, angle and lens of the camera all have a bearing on this. Learn the basic rules of composition and framing first so that in future you can feel confident breaking them.

When telling a story, you can choose to present the viewer with only a part of the available information in the viewport of the camera, or you can select a camera position that might hide information that only becomes apparent when the camera is moved. The camera can be a passive third-party observer or give the impression of someone's point of view within the scene.

Rule of thirds

If you split your frame into thirds, both horizontally and vertically, the main intersections of the inner lines give four points that are generally used to line up the main subjects in the scene. Splitting the frame into thirds helps the viewer understand the perspective of the scene. Normally,

landscapes have the horizon aligned to the upper or lower thirds horizontal line to show more foreground or more background – trying to give a more three-dimensional quality to a two-dimensional medium.

Unlike stills photography, where framing can only give a *sense* of movement, when filming you must leave room for *actual* movement to happen. The vertical thirds are used to provide room for your subject to move across the scene. When a moving subject is framed from the left vertical as they walk to the right, with the camera tracking them, this implies that the action will happen in the right-hand section of the frame – in the 'walking room' or 'looking room'. If the subject is framed walking the same way but composed against the right-hand vertical, it implies something is going to come at them from behind.

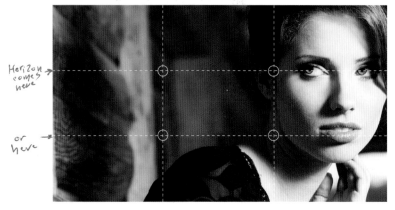

Horizon comes here

or here

Left: You can use the rule of thirds to give your subject some room to look or move into. This creates an interesting visual tension, as well as somewhere to lead into in the edit.

Right: Most of the helmet cameras on the market use wide-angle lenses in order to capture more of the action and keep the focus.

Lens perspective

Your choice of lens will affect the look of your scene. A 'normal' lens (the 35mm equivalent is a 50mm lens) will give a similar perspective to that of your own eyes. A wider lens, used from the same distance, will give the same perspective but show more of the scene and usually with a deeper DOF (depth of field). An extreme wide-angle lens can be used to distort the look of any subjects brought close to the lens, making them appear larger, or it can create a separation of characters at either side of a wide shot. A telephoto lens will bring the foreground and background closer by compressing the space between them and can cause movement to/from the camera to appear to take longer to achieve. A telephoto lens will also create a shallower DOF and isolate a subject from the background to help focus attention on the subject only.

Camera angles

Most shots of people are filmed at the subject's eye-level and with the eyeline aligned with the upper horizontal line from the rule of thirds. Mounting the camera higher than the eyeline and pointing downwards is called a high-angle shot and can give the impression of a dominant relationship by looking down on the subject. A high-angle shot is equally useful as an establishing shot, whether revealing a location or space or as a bird's-eye view. If the camera is mounted low and looking up it's called a low-angle shot, which can imply a more submissive relationship between two subjects and make the subject being viewed seem more menacing or powerful. A low-angle shot can also be used as a POV (point-of-view) shot for someone on the ground.

Above: A high angle suggests dominance and takes the audience out of the position of a neutral observer; an eye-level shot is normal, expected and therefore not noticed as such; a low-angle shot elevates the subject into a dominant or sometimes threatening position.

Handheld techniques

Large or small, cameras can be difficult to hold steady. You will need to adopt a solid stance for the larger ones and the help of a shoulder mount; smaller cameras may require a rig. Try to become 'as one' with your camera and stable, shake-free handheld footage will be easier to achieve.

ENG-style cameras have a shoulder mount and a large adjustable viewfinder to help connect your head and shoulders to the camera. Your right hand is normally securely attached to the zoom lens servo control and your left hand will be on the manual-focus control ring. The weight of the larger lens and professional battery system on the back will help to balance the camera front to back across your shoulder. If you plant your feet a shoulder's width apart, one foot slightly in front of the other, and take the camera weight through your body, you can create a solid platform for a stable handheld shot.

Below: At the top end of camera supports, the Manfrotto SYMPLA shoulder rig – initially designed for professional cameras – is now easily adaptable for DSLR and home use.

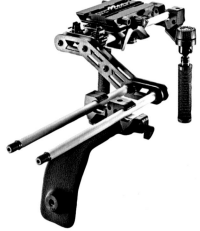

Bend and twist

Handheld panning shots require you to rotate at the waist, with muscle control from your thighs and buttocks. Practise your pan shot in advance, with knees slightly bent and feet facing the mid-point of the pan. If you pan more than about 180 degrees, you may lose your balance unless you swivel a bit at your knees and feet. Tilting the camera up or down is straightforward – use your right hand to pull down the lens or push it up. If the camera is balanced properly on your shoulder, it will pivot happily. You can add after-market cine-style accessories, like a left front handle to allow you to hold a horizontal shot for longer when you do not need to re-focus.

Smaller cameras

Handheld filming can be tricky with small cameras like DSLRs, especially with the impact of skew and wobble caused by rolling shutter CMOS sensors (see page 50). One method is to use a loupe attached to the LCD panel on the back and then jam this into your eye socket, creating a solid connection with your head. Your right hand will hold the camera and your left hand will control focus. This lightweight approach can lead to less fatigue and, with your elbows locked against the sides of your body, you can create a stable platform for filming static shots, pans and tilts. If you need more accessories on your camera – an HD monitor, a follow-focus or matte

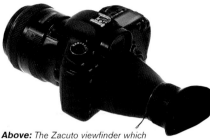

Above: The Zacuto viewfinder which helps stabilization through firm body contact.

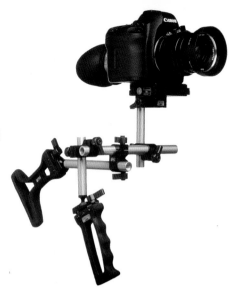

box, for example – you will need to use some kind of rig that can be properly balanced for handheld work in a similar way to the ENG-style shoulder mount. This involves adding counterweights and/or a professional battery system to the back of the rig, so that it is balanced from front to back. For any low shots you may need a top carry handle, but try not to overload yourself. Many rigs are modular and can be quickly rebuilt in different configurations to suit your requirements.

Above: The Zacuto chest support again helps stabilization by maintaining firm contact with the body, as well as helping support the camera weight.

Image stabilization

Many cameras or lenses have built-in IS or OIS (optical image stabilization) that will compensate for small amounts of horizontal or vertical movement. These systems should be switched off when using a tripod as they can interfere with what should

Above: The Olympus OM-D with its widely hailed 5-axis stabilization system.

be a steady pan shot by trying to compensate for the 'unwanted' movement. Always test out OIS on any new lens or camera to see how it performs for both tripod and handheld panning shots before it's too late. In post-production, optical flow technology can be used to smooth out any shaky footage.

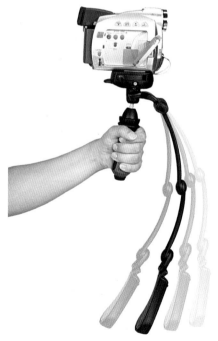

Above: The Manfrotto ModoSteady is a lightweight and low-cost steadicam for smaller camcorders, DSLRs and compacts.

Tripod techniques

As a contrast to the handheld techniques described on pages 44–5, cameras mounted on tripods produce smooth, steady shots. A tripod-mounted camera can move in many directions, but beware of moving too fast or you will encounter problems.

Even though all filmmakers use it, camera movement can quickly become a strain on the eye, and what seemed like a good idea at the time often feels flashy and overdone in the edit. Try and use movement only where necessary; you will be grateful later on.

Panning

A pan shot (from 'panoramic') is where the camera moves in a horizontal plane from left to right or vice versa. Adjust the drag on the tripod head to help you control the speed. If you're shooting progressive-mode video and try to pan too fast at 24p or 25p, you will get strobing effects caused by too rapid a movement between frames or may encounter worse problems due to rolling shutter (see box). The problems can be diminished somewhat if you shoot at a higher frame rate (slow motion) or shoot interlaced video instead, as this uses two fields to represent one frame and supports more fluid motion. A whip pan is a super-fast pan that requires the fluid head drag control to be switched off and is more like a jump cut, where you don't care that you can't see what happens between the two positions.

Tilt

Tilting shots involve moving the tripod head up and down (tilt up, tilt down) in the vertical plane with the pan control locked off. Make sure the camera is fully balanced front to back on the head by adjusting its position on the sliding plate. If your tripod head has a counterbalance system, make sure this is set to the correct weight for your camera and rig. If it's set too high, you will be 'fighting' the counterweight for your tilt move and have problems holding the position at the end of a move. If it's set too light, you will need lots of fluid drag to stop the head from dropping too quickly.

Above: Tripod heads have a 3-way tilting mechanism; some more specialized video heads, such as the 501HDV from Manfrotto, have fixed counterbalance springs for even smoother tilting movements.

Tracking and crabbing

If you use a good tripod dolly or pedestal on a very flat studio floor, you can perform extra camera moves to emulate those available with a track dolly or crab dolly. Tracking in and out from a subject usually requires a focus pull to keep the subject in focus and may involve a tilt up or down. Crabbing from side to side usually requires a pan to keep the camera pointing at the subject.

Above: The Camera Table Dolly from Photojojo turns your compact, DSLR or smartphone into a smooth tracker, providing you run it on a smooth surface.

Go Dutch

Normally tripod heads are levelled to the horizon using the built-in bubble spirit level; this ensures that panning shots remain horizontal. Any small deviation is, in fact, quite noticeable and so the deliberate use of an off-angle, referred to as a 'Dutch angle', can make the viewer uncomfortable – an effect that is regularly exploited by filmmakers in horror and suspense films.

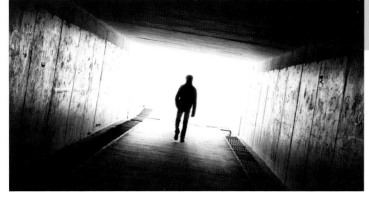

Rolling shutter

CMOS image sensors can exhibit strange wobble or skew phenomena when filming motion, due to the way data is read from the sensor. Instead of reading the instantaneous value of the light level and colour from each part of the sensor at once (a global shutter), the sensors use a rolling shutter that clocks in data in a top-to-bottom fashion. Static or slow-moving subjects appear correctly but fast motion can produce a jelly-like wobble (more so if handheld), as if filmed underwater, or a movement skew where straight vertical lines appear slanted.

Rolling shutter Global shutter

This is caused by the position of objects in the frame moving during the time it takes for the rolling shutter to finish clocking in a single frame. Try to keep camera movement slow, pan with a moving subject to maintain its position in frame, or use a higher frame rate, a camera with a global shutter such as the Phantom Flex, or a CCD sensor.

Left: The so-called Dutch angle is a great way to create a brooding atmosphere of danger and threat.

Depth of **field**

Selective focus is a great tool to create suspense and control your audience's focus. This technique is much easier to master than you might think, and once you are familiar with it it will soon become second nature.

When you set up a shot, you normally want the main subjects to be in sharp focus – but what about the rest of the scene? Perhaps you want to blur a distracting background to give more emphasis to the main subject, or maybe you want your audience to see all the beautiful scenery as well as the foreground action. By using selective focus, you can choose how to direct the viewer's attention.

When you focus your lens, the focal plane (the bit that's in focus) has a variable thickness, which extends in front of and behind the point of maximum sharpness. The width of this 'in-focus area' is referred to as the DOF (depth of field). By understanding how your camera controls the width of this area, you can choose how much of your scene is in focus and how much is blurred.

Size is everything

DOF is related to the sensor size, the focal length, diameter and aperture setting of your lens and the distance between you and the subject you are focusing on. The larger the sensor, as on a 35mm cinema camera or DSLR, the shallower the DOF and the more selective you can be. The longer the focal length of your lens, the shallower your DOF can be, too. You can still create a shallow depth with an ultra-wide lens, but the subject must be very close – possibly too close for some lenses to actually focus on. Small-sensor video cameras will produce a very wide DOF, unless you increase the focal length by zooming all the way in and then bringing your subject closer to you.

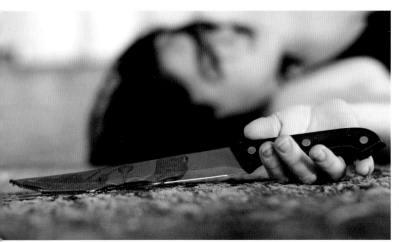

Left: Using a shallow depth of field to pull the viewer's attention towards an object – in this case, the bloody knife – is an often-employed technique in TV shows such as CSI or Law & Order.

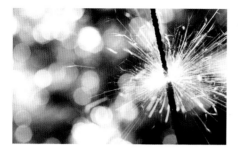

In control

With all things being equal (lens focal length, sensor size, subject distance), the main control for DOF is the aperture control on the lens. As the aperture is closed down (larger f-stop value), the effective diameter of the lens gets smaller and this leads to more of the image appearing to be in focus – a wider DOF. So to shoot with a wide/deep DOF you need more light (so that you can work at smaller apertures such as f/8, f/11, f/16), a smaller sensor camera, a wide-angle lens, or to be further away from the subject. To create a shallow DOF you need a large-sensor camera with a large aperture lens (f/1.4, f/2 or f/2.8, for example) and less light, a longer lens, or to be closer to your subject.

Some lenses have DOF markings on them, but if you want to know how wide your depth will be for a given lens, aperture or subject distance, download a DOF app onto your smartphone.

Bokeh

With shallow DOF, you get blurred and out-of-focus areas in your scene. Any highlights in the blurred area create near-circle shapes that resemble the aperture blades of your lens. These shapes are called 'bokeh', from the Japanese for 'blur', and are more or less round depending on how many blades are in the aperture. When fast lenses are fully open to the widest aperture, it's the actual round barrel of the lens creating the bokeh that produces softer and more natural out-of-focus areas.

Shutter speed

Shutter speed is used extensively in stills photography to freeze action or increase available light. However, don't be tempted to use shutter speed for aperture control when shooting video. It needs to be at a constant value based on the camera speed (frames per second) to avoid unwanted results.

Historically, cameras had a mechanical rotating shutter that allowed light to expose onto the film and then covered the aperture while the film advanced to the next frame. This shutter was a rotating disc with half of the disc cut out so that it represented a shutter angle of 180 degrees (180° being half of the full circle of 360°). In a cine camera the shutter rotates constantly while filming. At 24 fps each frame takes 1/24sec to pass, so the amount of time the shutter is open for each frame is equivalent to 1/48sec (half of 1/24sec), since half the time the shutter is open allowing light to pass, and half the time the shutter is closed to allow the film to advance by one frame. For PAL systems running at 25 fps, the default 180° shutter speed is 1/50sec. Some cine cameras have variable shutter angles so that shutter speed can be changed independently of the camera speed – more like digital video cameras.

Setting shutter speeds
Modern digital video cameras and DSLRs have a shutter speed setting (and some also have

the historical shutter angle setting). Although the digital sensors on these cameras do not use a rotating mechanical shutter any more, the principle is the same and shutter speed is used to control the amount of time light is allowed to shine onto the sensor. At 1/50sec for PAL at 25 fps, video looks 'normal' but as you change the shutter speed up or down, you give less or more time for action to occur *between* frames of video. So shutter speed is responsible for how smooth or jerky your video looks. If you have a really slow shutter speed such as 1/12sec or 1/6sec, images will tend to blend across frames and give you a dreamy look with visible trails.

Conversely, at high shutter speeds such as 1/250sec or more, motion can start to look more strobe-like, actors become more robot-like as each frame is only exposed for a short amount of time and more movement happens between frames. This is a great tool for

Below: A small aperture (f/16) lets in less light and therefore needs a longer shutter speed than a large aperture (f/2.8) to expose correctly.

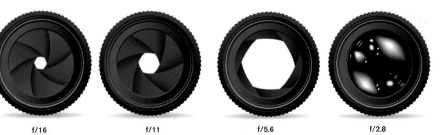

| f/16 | f/11 | f/5.6 | f/2.8 |

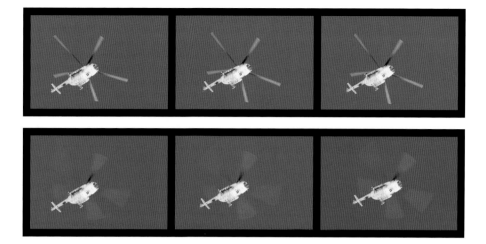

Above: The helicopter shot at 1/50sec is almost crisp, even at the speed the rotors are going at (top). Shot with a shutter speed of 1/12sec, the rotors blur (above).

freeze-framing action sports, as you will get crisper stills images, although normal playback of your video may appear jerky as your eye perceives the movement between frames and the lack of any motion blur. High shutter speed can give great dramatic effect to fight scenes and heighten a sense of unreality.

Depth of field

Shutter speed will influence depth of field (see page 48), as you will need to change the aperture to compensate for the different amount of light falling onto the sensor when you change the shutter speed. Video cameras can auto-link shutter speed to exposure. On DSLRs, try using P mode with a manual aperture lens and see how the camera adjusts the shutter speed; it's best to use a manual mode to ensure you're in full control of the shutter speed. Experiment and compare motion shot at different shutter speeds. Combine shutter speed with variable frame rates (see page 52) for full artistic control.

Useful tips

• For PAL systems, the default shutter speed for normal video is 1/50sec for 25p or 50i. For NTSC systems, the default is 1/48sec for 24p or 1/60sec for 29.97 fps.

• If you need to video content that includes computer screens, TV screens, fluorescent bulbs, sodium lamps (street lights) or projected images, you may get flicker if your shutter speed does not match the frequency of the power system. Adjust your shutter speed to remove flicker, as trying to remove it in post-production is very hard.

Right: A small aperture (f/16) results in a wide depth of field.

Left: A large aperture (f/4) gives you a shallow depth of field.

Variable **frame rates**

In **HD video frame rates, 1 second of footage equals 24 or 25 recorded frames (fps). The visual processor in our brains interprets this rapid succession of images as movement, and thus creates a successful illusion. Variable frame rates give you more control in situations where a faster frame rate — slowed down to 24 or 25 fps afterwards — could more fully capture very fast movement smoothly.**

Most HD video cameras provide a VFR (variable frame rate) setting of some kind, with the most basic settings coupled with a PAL and NTSC switch to provide a range from 24 fps, 25 fps to 30 fps at both 1080 and 720 frame sizes. Modern DSLRs also provide a slow-motion range of 50 fps in PAL mode and 60 fps in NTSC mode for 720 frame sizes, with some video cameras giving you these double rates for 1080 sizes as well. Very top-end digital cinema cameras support frame rates of hundreds of fps at larger-than-HD frame sizes and some specialist high-speed cameras run at tens of thousands of fps — changing everyday scenes into spectacular events.

Below: *A high frame rate is used to produce ultra slow-motion footage of this exploding water balloon, to clearly reveal the explosion in its phases.*

Slow motion

Slow-motion filming, also known as 'overcranking', is a great artistic device for filming fast action sports or fight scenes: imagine a film like *Rocky* without the use of high-speed filming to slow down the action and emphasize the reality of the punches. It can also be a tool to help solve problems in tricky situations — try using a high frame rate when shooting handheld, or filming on a boat or any other unstable platform, and you will be able to smooth out some of the jerkiness of your footage by capturing more frames. The extra frames ensure that there is a lower rate of change of scene detail between frames, which helps your audience track the action properly. One downside of high-speed filming is that you need more light to expose all the frames properly, since each frame is exposed for a shorter time.

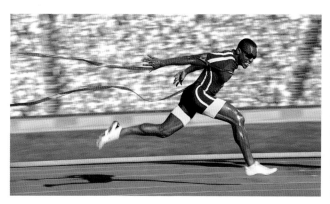

Left: Shot at a high shutter speed and frame rate, this runner is captured in ultra-crisp slow motion as he crosses the finish line.

Below: Time-lapse is great to tell highly condensed stories. Most HD cameras are capable of 'interval timer shooting', like this footage of evening traffic shot on a Nikon D90.

Lower frame rates

Shooting video at a lower frame rate ('undercranking') allows more action to happen between frames – useful for slow-moving scenes and very similar to time-lapse techniques. Where it differs from time lapse is the frame blending that occurs with low frame rate filming.

Instead of a single frame being taken once every 2 seconds, as in time-lapse filming, light is spread across frames and leaves light trails, giving a dreamy look to your video. At frame rates like 1–3 fps, you can shoot those classic late-night traffic shots with speeded-up cars and light trails on headlights and brake lights.

Exposure also changes as you now need less light for each frame, making it an easier low-light technique (although with ND filters you can use the technique in daytime).

'Speed ramping' is a technique to make use of changing frame rates while filming – ramping from high fps (slow mo) to normal speed or normal to fast speed or any combination. High-end digital cinema cameras provide programmable frame rate ramping over a defined period of time.

Useful tips

• Not all video cameras will playback your footage at the same frame rate as it was captured, so you may need to download it to your computer first to see it play properly.

• Some video cameras do not support variable frame rate but may support very slow shutter speed, which gives the same dream-like footage but without the speeded-up reality of a really slow frame rate.

• Make sure you have fast-enough media cards to support high frame rates on your video camera. Check the manufacturer's specs for supported cards.

Colour **balance**

Setting the white balance on your camera correctly has a huge impact on your footage. It's always advisable to do this before shooting, rather than trying to balance it in post-production.

I f you remember your physics lessons from school, you will know that colour temperature refers to the actual colour a black object will glow when subjected to a specific heating temperature. It's measured in degrees Kelvin (K) and describes the colour characteristics of light, usually either warm (lower temperature and yellowish) or cool (higher temperature and more bluish). It's important when setting up your shot that you match the colour temperature setting on your camera to the type of lighting you are using, otherwise you will have a large amount of work to do in post-production trying to make your video look right. The process is called WB (white balancing), meaning that you're trying to set the 'proper' colour of white.

Below (left to right): White balance presets compensate for the colour temperature at different times of day.

Presets

Video cameras typically have presets for shooting under tungsten lighting (3200K) or daylight conditions (5600K), as well as having auto WB and manual WB controls for getting the colour temperature setting just right. If you're shooting under mixed lighting you should adjust your lighting first using gels, setting your lamps to daylight or tungsten depending on the majority of lights you have. Once this is done, you can set your camera to the corresponding colour temperature or WB preset (tungsten or daylight) and off you go.

Setting white balance

If you can't use WB presets, set up your camera's white balance by using a white card that is lit in your scene. Point the camera at the white card and then use the auto WB button to set the white point. Move your camera or zoom in to make sure that the majority of the card is shown in the view-finder first.

Auto

Daylight

Colour temperature

Infrared end

800K	Fire embers
1700–1800K	Match flame
1850–1930K	Candlelight
2000–3000K	Sunrise or sunset
2700–3000K	Standard household light bulb
3000–3400K	**Tungsten lamp**
3200K	Kino Flo True Match tungsten lamps
3200K & 3400K	Dedolight dimmer presets
3200K–7000K	General fluorescent tubes
4100K–4500K	Moonlight
5500K	Kino Flo True Match daylight lamps
5200K–5600K	**Preset for daylight on many cameras**
5500K–6000K	Daylight with clear sky
6000K–8000K	Daylight hazy and overcast
6500K	Computer monitor
8000K–10,000K	Cloudy sky
10,000K–18,000K	Sun-less blue sky

Ultraviolet end

You can change the look of your video by making it 'warmer' or 'cooler'. Get yourself a set of colour-balancing cards to allow you to offset the white point a little. You can also manually adjust the colour temperature setting on your camera to give you a warmer or a cooler look. For manual white balancing on DSLRs, take a still image of a white card or surface and then assign the photo as the white source to match from the WB menu.

Black balance

If you have a BB (black balance) switch on your camera, this is for resetting the black point. Cover the lens fully and press the black balance control to tell the camera how black is black. Some cameras drift and give noisy results or odd coloration in dark areas if you don't reset the BB often enough. If your footage turns out strangely tinted, this could be the reason why.

Shade (cloudy)

Tungsten

Exposure and ND

Getting the light levels correct on your video is very much a juggling act. Once you've mastered your camera's controls sufficiently, you'll be able to achieve better balance and become more creative with it.

Exposure is the amount of light that hits your camera sensor. It's controlled by the size of the lens aperture, the shutter speed, and the amount of lighting you use. Too little light and your video may be murky, underexposed and need boosting in post-production, resulting in more noise being added. Too much light and the highlights may be 'blown out' and overexposed. Digital video cannot handle a high light level, so any overexposed signals will be clipped, giving you pure white instead.

The most obvious way to control exposure is to change the lighting – add more lights to your scene, make the lights brighter or dim them down as required. However, this is not always possible when shooting outdoors or on a low budget. As we saw on page 50, shutter speed is not changed very often when

Above: Modern DSLRs allow a wide range of ISO settings for shooting in low light.

shooting video, so you need to use other means to control the exposure.

Sensitivity

The light sensitivity of a camera sensor is represented by an EI (exposure index), using an ISO rating in a similar way to the ISO rating of film stock. The lower the ISO number, the more light is needed for a given image brightness level. ISO 100 would be a slow daylight film that needs lots of light, whereas

Below: Filmed with a small aperture of f/16 for great depth of field, the scene draws attention to both subjects (left); the same scene filmed with a larger aperture of f/2.8 firmly shifts focus to the girl (right).

ISO 200

ISO 1600

ISO 800 would be a fast film for indoor use. ISO numbers are logarithmic, so ISO 200 needs half as much light as ISO 100. Digital sensors do not have a single ISO setting like film, but have a 'native' ISO rating such as 250 or 320 (given by the manufacturer) and then use an adjustable electronic gain to simulate different ISO values. The native ISO rating may also be shown as gain in decibels (dB), too.

Large-sensor cameras such as the Sony F3 or Canon 5D MkIII have high native ISO ratings of 640 or 800 and very high gain controls up to ISO 204800 – far surpassing values for any film stock. But as the ISO value is increased, so too is the electronic gain, which will result in your video becoming much noisier. How much noise you (or your audience) can stand is for you to decide. Many cameras give remarkably good low-noise results even at ISO 1600, but it's best to experiment and test your equipment under different lighting conditions. Trying to reduce noise in post-production can be time consuming and is not always possible.

Open or closed

Lenses have a physical diaphragm or iris to stop light from passing through. The iris creates a circular aperture; as the aperture is closed or 'stopped down', the hole gets smaller and less light comes in. Lens aperture is shown in f-stops (or T-stops on cinema lenses) and is marked on manual aperture lenses. The aperture you choose has a big impact on the depth of field, as

Left: This scene was shot first in good daylight with ISO 200, resulting in a crisp, bright image. As the light turned low, the ISO was increased to 1600. Note how the image is now softer and grainier.

discussed on page 48, so controlling exposure is not quite as simple as only adjusting the aperture.

ND to the rescue

ND (neutral density) filters cut out light without changing the colour temperature (colour neutral) and come built in to many video cameras to give you a wider operating range under bright lighting conditions. If you don't have built-in ND, you can use a matte box with filters or try screw-on ND filters. Filters have ratings for light transmission and are usually graded in optical density of 0.3 (ND2 or 1 f-stop), 0.6 (ND4 or 2 f-stops), 0.9 (ND8 or 3 f-stops) or more.

Useful tips

• Use the same ISO settings when filming scenes that must be intercut in order to match the noise level in post-production.

• Use your camera's waveform or histogram feature to examine the exposure curve for your scene and to see whether you are clipping any highlights.

Picture **styles**

To get the most out of your camera, spend some time familiarizing yourself with all the presets and picture styles, so that you build up a library of favourites to access whenever the situation calls for it.

Most all-in-one cameras have built-in picture presets for controlling multiple settings at once. These presets help you quickly get close to the right set-up for a given scene, and may include Sport, Beach, Portrait or Sunset modes. The presets automatically set the shutter speed, colour temperature and focus limits on auto-focus, but they are really only useful if you're shooting fully auto.

Camera settings

AUTO	Automatic settings selection
✨	Sports
🙎	Portrait
🌙	Night
▲▲	Landscape/Outdoor
🌷	Macro
P	Programmed Mode (semi-automatic)
A	Aperture Control Priority
S	Shutter Speed Control Priority
M	Manual Control

Change the look

Advanced picture presets or 'scene files' allow you to change a whole host of settings associated with the look of your video, such as sharpness and detail, gamma curves, skin tone detail, black point, black stretch and colour curves. Some of these changes can be done (or un-done) in post-production, but not all, so it's wise to do a full end-to-end picture test before committing to using them on a critical project. Since most digital video cameras do not record a very wide range of tones from dark to light, many filmmakers prefer to shoot with a very flat or neutral profile to try to retain as much image information as possible, and then do all the colour correction in post-production.

Stretch the dark

Features such as black-compression settings are available on professional cameras to give

Below: Using the Technicolor CineStyle preset on the Canon 5D MkII allowed this footage to be given a very vibrant and cinematic feel in the grade.

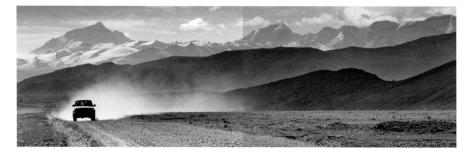

Above: If you shoot in semi-darkness and want to keep it natural, play around with low light settings together with detail and contrast – the improvements are great.

more range and detail in the highlights. 'Black stretch' (or 'master pedestal' on some cameras) can help to retain contrast and shadow detail in the darker parts of your scene. Detail settings can be used to increase or reduce sharpening of your video. DSLRs are notorious for being overly sharp, as they down-sample the data from a huge image sensor, which can lead to odd-looking aliasing (false detail) and moiré patterns. When HD first started to replace film, many actors complained that it showed too much detail and too many wrinkles due to the extra sharpness. After-market products have been created to help reduce aliasing and moiré on DSLRs; it's hoped that future cameras will address this issue fully.

Remove the wrinkles

Skin-tone detail settings are available on some cameras to control the way they record human skin, based on typical skin tone or colour (for Caucasian skin tones only). The settings can give a more flattering look and help hide wrinkles and blemishes by reducing detail. If set too high, though, they can give a strange, soft look and cannot differentiate between faces and

anything else of a similar colour in the scene. Use these settings with care.

The presets that are featured on DSLRs tend to affect only the sharpness, contrast, colour saturation and colour tone of the image. You can usually add some custom styles to give you features similar to black stretch, such as the Technicolor preset that can be installed on the Canon 5D MkII DSLR (and others) to try to boost dynamic range. Cinema cameras such as the RED Epic or Blackmagic Design can shoot RAW video for a wider dynamic range, but it must be graded in post-production to produce a viewable video.

Above: A lot of cameras nowadays feature very effective wrinkle-reduction modes.

Natural **light**

The sun bathes us with direct light. The immense variety in the colour and quantity of this light can present problems for the filmmaker, depending on the time of day and the amount of cloud cover.

Making the most of available light poses real challenges, especially when choosing the correct exposure in constantly changing conditions. Some types of filming, such as outdoor sports, news events, wildlife filming and many family videos, will always take place regardless of lighting conditions, but for drama production at least, you can have a little more control.

High noon

When the sun is at its brightest, the harsh shadows can be less than complimentary to people. Your video camera sensor will struggle too, not having enough dynamic range to properly expose the highlights and the dark areas. Contrast will be very high and the resulting video may look quite 'flat'. With so much light, it's best to keep your ISO/gain at its lowest and use ND filters to give you back control of the DOF (depth of field), using the aperture control of the lens. Try to retain detail in the background by underexposing if necessary – or better still, head into the shadows to avoid the harsh light. Daytime interiors, though, can be shot more easily, with the extra sunlight penetrating further indoors through the windows.

Above: The DigiCineMate from Sekonic is an entry-level light meter that offers HD cine, cine and photo metering modes.

Diffusion

If you have the space or budget, you can rig up diffusion panels above your scene to block direct sunlight and make it softer and more like diffused light coming through clouds. This idea works for close-up shots and mid-shots only, depending on how large an area you can cover. Another method to help overcome the harsh shadows at noon is to use fill-in lighting, especially on faces. The fill lights need to be daylight colour temperature to match the sunlight. This will reduce the high contrast, since the range of dark to light values in your scene will be reduced. You can also use large polyboard reflectors to bounce sunlight back to your subject instead of using extra lighting. Using both reflectors and diffusion can extend your shooting time and make the most of the midday sunshine.

i | Don't forget backlight!

Some consumer camcorders have a backlight button that can be used if you're shooting with auto-exposure on a bright, sunny day. Normally your subject would be silhouetted if the background was much brighter than them. The backlight mode will adjust the exposure of the dark areas and push the light areas higher, so that your subject is exposed properly rather than being seen in silhouette. It's always best to set your exposure manually to avoid this problem, though.

First and last rays

Closer to sunrise and sunset, when the sun is not very high in the sky, lighting comes more from indirect sky light than direct sunlight. Shadows are longer but not as dark as at midday, and the lower contrast makes it easier for the camera sensor to capture the scene without overexposure. The sun's light appears warmer, with the colour temperature closer to red and gold. This so-called 'golden hour' may last for more or less than an hour, depending on how close to the equator you are and the time of year, but it creates beautiful lighting conditions that are exploited in many feature films.

Above: The reflector range from Sunbounce has conquered the market for on-the-fly indoor and outdoor shoots due to its ease of use.

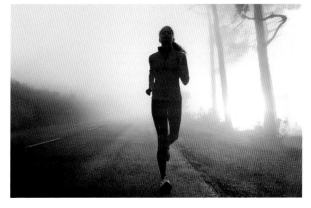

Right: The softer morning or evening light makes for great cinematic moments, as evident in this early morning jog shot from a moving car.

Filters and **matte boxes**

Filtering the light that reaches your lens will create effects you can't do in-camera or very easily in post-production. Filters and matte boxes work to reduce any haze, glare or reflection and will enhance your images.

Filters can be attached directly to the front of your camera lens (the screw-on type) or put into a matte box that's attached usually by a set of rods as part of a camera rig. Typical screw-type filters are UV (ultraviolet) or skylight filters, which are designed to reduce atmospheric haze and give you some protection for the front of your expensive lens. Good filters are very thin and only really protect against finger marks and dust. Clear filters are available, too, and can be useful to stop any blood splatters from hitting your lens while filming your indie horror epic. Filters may cause reflections, flare and ghosting, so be careful to ensure that they are not degrading your image under certain lighting conditions.

Below: Without a polarizing filter, the scene appears flatter and light reflects off the surface.

Below right: With a polarizing filter, reflections on the water are eliminated and, with the right adjustment, colours become more saturated.

No reflections

The polarizer is a useful filter for outdoor filming, especially close to water. It blocks unwanted reflections, allowing you to see below the water surface or through car windscreens that would otherwise be obscured by reflected light – an effect you cannot reproduce in post-production. Use a circular polarizer for auto-focus and manual-focus lenses (rather than a linear polarizer) and rotate it to match the light direction for best effect. This type of filter will reduce light transmission by a number of f-stops, but that isn't normally a problem on a bright, sunny day.

Graduated filters

ND (neutral density) filters come in either solid or graduated versions, with hard or soft edges (SE grads). Solid ND filters come in different strengths of light reduction; they don't change the colour of the light transmission and they allow you to open the lens aperture to control the depth of field. Graduated ND filters reduce the light level in

Above: The ND filter made it possible for this footage to be correctly exposed, both in the far brighter sky and in the darker waves.

one part of your scene only – usually the sky. They can help compensate for lack of dynamic range in your camera and will give you back sky detail that would otherwise be overexposed. Hard-edged versions work well with an abrupt change such as a horizon line; otherwise use SE grads to hide the effect. Slide the filter up or down in the matte box to align it with the horizon.

Right: You can often buy a matte box together with an assortment of filters, like this set from Formatt Hitech.

Matte boxes

A matte box is designed to cut down glare and lens flare by stopping light from reaching your lens from all sides. A top flag is normally used to block the sun or other lights set above, and you may need adjustable side flags to remove side spill. The matte box will generally have several 'stages' for filter holders, which can be both static and rotating (for a circular polarizer) and hold square or rectangular filters. The extra stages allow you to stack ND filters to reduce light even more – for example by adding an ND0.3 and ND0.9 filter to make ND1.2. Make sure you get the right size filters for your matte box as they come in 4 x 4" or 4 x 5.65".

ND values and exposure

Equivalent camera setting	ND filter	f-stop reduction	Light transmission
ND2	0.3	1	50%
ND4	0.6	2	25%
ND8	0.9	3	12.5%
ND16	1.2	4	6.25%

Setting **lights**

Lighting is one of the most important elements in filmmaking for setting the mood and tone of the film and creating depth in the scene. Arranging lights is not a haphazard task: you need to understand *why* each light in your scene is positioned and pointing where it is.

Scene lighting can follow a number of different lighting styles: high-key lighting (generally bright with few shadows), low-key (darker, with deep shadows used more for drama) or something in between like graduated lighting (gradual shading from dark to light). It is up to the director or filmmaker to decide which style they want to use – there are no set rules.

To simplify matters, a terminology has been developed for describing the purpose of each light. The most common lighting set-up is three-point lighting: using three lamps as key light, fill light and back light.

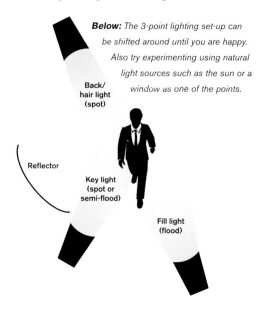

Below: *The 3-point lighting set-up can be shifted around until you are happy. Also try experimenting using natural light sources such as the sun or a window as one of the points.*

Back/
hair light
(spot)

Reflector

Key light
(spot or
semi-flood)

Fill light
(flood)

Three-point lighting

The key light is the main light for a subject – if subjects move about, there may be several key lights in a scene. For static set-ups, like an interview, each subject will ideally have his or her own key light. Traditionally, the key light is triangulated at 45° with the camera and subject and raised up vertically, pointing down at 45°, and will set the main shadows on the face. The key light is normally a hard light source, representing the sun, and it's the brightest light in the scene compared to fill and back lights.

The fill light is used to fill in shadows created by the key light and will normally be placed close to the camera to minimize any new shadows being created. Soft boxes or diffusers are frequently used for the fill to help soften the shadows. The fill light may be the

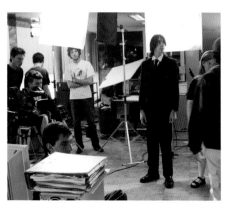

Above: *The 3-point lighting set-up as seen from the back, with the camera on the left-hand side.*

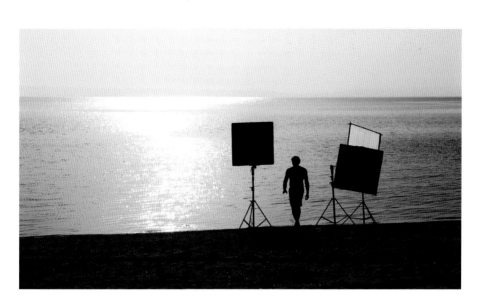

Above: 3-point lighting can just as easily be applied outside, using reflectors instead of lights.

same type of light as the key light but will be reduced in intensity by using scrims, diffusion or dimming, or by moving the lamp further away. Dimmers are used less often as they impact on the colour temperature of the light. By removing the fill light, you get a more low-key lighting set-up.

The back light is placed above and behind the subject and separates the subject from the background. It's pointed at the back of the head and shoulders, and is also referred to as a hair light. It's ideal for interviews, but not always used for drama if you're after realism, unless there is a good 'motivated' source for this light in the scene.

Additional lights

Extra lighting may include a kicker light, set opposite and lower than the key light, but still above and behind the subject. The kicker is similar to the back light and can help separate the subject from the background. A small fill

light might be used to add a twinkle to the eyes as an eye light and is normally mounted on or close to the camera. Set lights can be 'practical' lights (in shot), like a standard lamp or a fireplace or a distant street lamp, and there may be off-camera set lights to illuminate the background, clothing and furniture in the scene.

Useful tips

• Extension leads have higher power ratings when fully unrolled. Don't overload cables, otherwise they may overheat and cause a fire.

• Take care with hot lights – wear gloves for moving barn doors and don't move the lamp until cool to avoid blowing bulbs.

Filming at night

Whether it's a spooky horror film or a modern road movie, you will always need some sources of illumination when filming at night – either by taking advantage of the so-called 'blue hour' at twilight or by using 'practical' lights such as street lights or standard lamps.

For many people, night-time starts when the house lights or street lights are switched on – but if you live where you can see the horizon, you will know that twilight is a long way from darkness. The so-called 'blue hour' at twilight or dawn can last a long time depending on what time of year it is and your distance from the equator, much like the golden hour (see page 61). It's easy enough to start filming in the blue hour and try some day-for-night adjustments in post-production, but if you want proper night filming you must wait until it's completely dark.

Above: If you are after a completely natural look and feel, try building the light into the story and let your subjects sit near a source of light.

Above: This short film was all shot on a Canon 5D MkII using practical lights – streetlights, headlights of cars and a very strong torch.

Practical lights

Camera sensors do not work very well in total darkness so, unless you want to switch on the infrared night-mode of your camcorder, you will need some kind of 'practical' lighting at night. Any sort of light that could reasonably be expected to be visible in a scene is called a practical light and could include moonlight, street lighting, car lights, lights coming from houses or shops or signs, campfires, bonfires, candles, light from a mobile phone or computer screen, a desk lamp, light bulb, car interior light, a standard lamp or a torch.

There is so much light pollution in cities that filming night exteriors doesn't need to be all dark, but you will generally need to add lights to boost the output of your practical lights. The trick is to add extra lights that are off camera and are meant to represent the light from the practical light. As your actor fumbles for the light switch, the gaffer switches on the lights that have been set up to represent the room illumination. The practical lamp is seen to come on and the illusion is complete.

Test first

Some light sources such as sodium-discharge street lamps can create flicker, so be careful to match the frame rate to the mains frequency (25p or 50i in Europe, 30p or 60i in the US) to minimize or remove it; do some test shots first. Large-sensor cameras can operate at very high ISO in low light, but that doesn't mean you shouldn't use lights for night filming. Check the noise levels you will be recording at in advance, too. Judge how much noise is acceptable to you, bearing in mind that the larger you end up projecting your video, the more noise will be visible.

Day for night

If you can't shoot at night for practical reasons, you can try to create a day-for-night look instead. For interiors use blackout blinds and black reflectors – anything to block out as much light as you can. Exteriors are trickier, since you need an overcast day to reduce any give-away shadows. Try filming in the woods so you don't show any sky and avoid dressing anyone in a light colour that will reflect more. You can apply

Above: *When lighting a street scene like this one in Oxford from* Harry Potter and the Philosopher's Stone, *set lights at similar angles to the street lights and use a reflector to illuminate the actors' faces.*

Above: *Although all set at night, the micro-budget short film* Night Vision *was shot mostly during the day in a London apartment using blackout blinds.*

some in-camera picture styles to adjust the white balance for tungsten and then add plenty of ND filters so that you can open the aperture to get a shallow DOF, too. It can be very difficult to get convincing day-for-night just in-camera, so expect to do more work in post-production to adjust the levels and saturation, too.

Get the **film look**

Most digital filmmakers' goal is to achieve that fabled 'film look', which is one part depth of field, one part low-key lighting, one part warm glow and one part cinematic framing and composition. Let's see how that works.

Film has been with us since the dawn of cinema, from early hand-cranked cameras where the frame rate was erratic and action moved either faster or slower, to modern feature films in all their complexity and visual effects. Projecting light through a series of still frames on a reel of film has a certain quality to it. There is an authentic feel to the colour, a visible grain, a wide range of light levels in a scene; scenes have depth and detail and maybe some damage in the form of scratches or dust from the projector or from the camera. This is 'the film look' and we want to replicate most of these qualities, except perhaps the scratches and dust, unless used for effect.

Below: The all-important soft and shallow depth of field is a major part of the 'film look'.

Can you spot video?

Until fairly recently, digital video had been easy to spot when viewed next to film as it tended to have a wide depth of field and a smaller dynamic range (contrast ratio), making highlights more easily blown out in a scene or making images noisy in low light. Video cameras used to shoot only interlaced video, designed for TV, with two fields per frame. The interlacing system worked well for analogue TV and CRT-type displays, giving better motion perception and less flicker, but didn't mimic film motion shot at 24 fps.

What makes it look like film

These differences have almost all disappeared now with the advent of 35mm DOF adapters, followed by video DSLRs and large-sensor video cameras. The larger

sensors meant DOF became available as a tool for the budget filmmaker, using selective focus to isolate foreground from background. True progressive-mode video cameras capable of shooting 24p (and 25p) give the same motion as film cameras, but also have the same drawbacks and more care must be taken with things like panning speed to avoid motion judder. High ISO capability and better algorithms have led to very good low-light performance now, but to make it look like film you will still need to light your scenes in that way – meaning you should use lots of lights if you can.

Dynamic range is still a problem with digital video where there is not enough latitude (the difference between the dark and light areas) compared with film, mostly due to the way digital sensors handle strong light. High-end cameras such as the RED and Arri Alexa, however, have been increasing the dynamic range with RAW processing, clever sensor algorithms and by using HDR (high dynamic range) techniques for video.

Many cameras provide presets and controls over gamma curves (how brightness is distributed across the image) and colour matrix (colour brightness and saturation) to help you get closer to your look in-camera. With cine-look settings and downloadable presets for cameras freely available from the web, it's easy to experiment with different looks before you start filming.

Above: *Shot simultaneously with a camcorder (left) and a DSLR (above), it becomes clear how a shallow depth of field and a colour preset can go a long way.*

Do it in post

Post-production tools for adding grain and simulating colour and gamma curves of various film stocks are useful to help finish your look. You can get filters to add artificial scratches, noise, dust, dirt, water stains and hairs, as well as simulate bad projector effects such as frame sync, weave and flicker.

Above: *Regular colour grading has a big effect on your film; no professional would do without it.*

Above: *The 8mm Vintage Camera app gives your smartphone the beauty and magic of vintage movies.*

Sound basics

Sound is a vital part of any film production, and encompasses spoken words, music, background sound and sound effects. Sound can convey a message, a feeling or a mood – and used by itself, it can even create an atmosphere that will make the hair on the back of your neck stand on end.

Having good sound can make all the difference to your video being regarded as good or just average. If the audience cannot hear the dialogue properly, it won't matter how good the video itself looks. Equally, your choice of soundtrack may put some people off.

We have evolved with the ability to tune in to or tune out of our surroundings. We can still sleep despite (or because of) the ticking clock or the rain lashing outside, but may be awoken by the slightest 'unusual' sound. We tune out a lot of distracting noise even when we are awake so that we can function. A microphone, however, picks up *all* sounds, including those we may have already tuned out, so get used to tuning back in to your environment and listen out for all those sources of distracting sounds. Trying to record dialogue next to a rushing stream may have seemed like a great idea at

the time, but when you're trying to isolate the voices from the background noises in post-production, you'll wish you had thought about it a bit more first.

The principles of sound

Good sound starts with good sound recording, but it helps to understand the principles of sound and some terminology before we delve deeper into sound recording on page 72.

Sound travels in waves, much like the ripples in a pond. Sound waves get blown around by the wind and reflect from objects and surfaces in a similar way to light. Sound moves slower than light, so at a large open-air concert, for instance, video delay is often used with a live video feed to compensate for the music reaching the audience at the back later than at the front.

Amplitude and frequency

Sound waves have characteristics of amplitude or 'loudness' (how big the peaks and troughs in the wave are) and a frequency value representing the time between peaks in the wave. The more peaks per second, the higher the frequency. Frequency is measured in Hertz (Hz); the human ear can perceive sounds in a range of frequencies between about 20Hz and 20KHz. Higher-frequency sounds reflect better than low frequencies but are absorbed quicker, and this impacts directly on how we record sound.

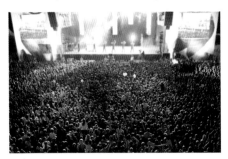

Above: Big live events like this rock concert need giant video screens with in-built delay to compensate for the speed of sound.

Right: In a professional editing suite, the sound is always mixed with the footage shown on screen, and sound designers often have to go over the same scene for days on end before the sound is right, as shown here during the sound mix of Seth Fisher's feature film Blumenthal.

Film sound

A soundtrack is made up of three parts — the human voice, sound effects and music. These have to be balanced out in the final mix to help you tell your story the best way possible.

The human voice

Dialogue helps explain the plot and express the feelings and motivations of a character, in drama just as much as in a family video.

The voice gives the character that third dimension of a *real* person. We remember voices of famous actors and can identify them often without a visual. In countries where foreign (English) films are dubbed, this leads to amusing reactions when, for instance, a German Robert De Niro fan hears the actor's own voice for the first time, rather than the voice of Christian Brückner, De Niro's regular dubbing voice.

Above: Editing software displays the two stereo channels of your recorded sound as a wave form, to help you visually edit the sound for your film.

Dialogue can also be used as a tool to convey an underlying idea or subtext. In Stanley Kubrick's film *2001: A Space Odyssey,* for example, very little dialogue is used, and the little that is said is deliberately banal to contrast with the stark technological might humans are up against.

The Billy Wilder comedy *Some Like It Hot,* on the other hand, uses non-stop, ultra-sharp and fast-paced dialogue that bounces the audience quickly from gag to gag.

Sound effects

Synchronous sounds are matched with the picture; this includes characters' actions, such as playing the piano or slamming a door. Synchronous sounds create realism in film.

Asynchronous sounds originate from sources not visible on screen and are used to enhance moods — for example, background sirens during an emergency hospital scene.

Music

Background music helps with emotion and rhythm. Some is noticeable, but usually music plays almost subconsciously in the background, sometimes signalling a change of mood. Often, dissonant sounds are used to foreshadow approaching danger.

Background music helps to link scenes or establish characters. Musical themes are often used for individual characters — very evident in *Harry Potter* or the *Lord of the Rings* films.

Sound **recording**

Put on some headphones, grab a microphone and really *listen* to the world around you. It's amazing how quickly we tune out background noises without realizing. Learn to listen closely again and you will be surprised at what you hear.

Place your microphone very close to the sound source you're trying to record. Sound dissipates over distance, with the high-frequency portion being lost more quickly than the low, which is why you can hear the bass boom of a neighbour's stereo even if you can't hear any more of the music. When recording dialogue, get your mic close and you will pick up less unwanted background noise (see also page 76).

Above: Get to know all your sound settings and levels to be sure you'll get the best sound possible.

Room tone and wild track

Every location you film in will have its own unique sound. Sound waves resonate around a space; they reflect or are absorbed by the walls, floor, furnishings and ceiling to create a 'room tone' – the sound of silence. Also known as 'wild track', this usually means indoor and outdoor sound recording that you

do independently of video – something you can use later in the edit. You will always need some background 'noise' (think seagulls or ocean waves or urban street or countryside sounds) to add ambience to montage video or just 'silent' room tone to fill in the gaps between dialogue.

Tune in

Get some good-quality headphones and tune back into the environment around you. Use a directional mic (such as a shotgun mic) and listen to the different sounds as you point the mic at different parts of your scene. Adjust the levels on your camera or recorder to boost the gain and adjust the headphone volume to get a comfortable listening level (see page 92 for more details on headphones). Use the audio level meters to make sure the peak sound level does not go too high (see page 92) or use auto gain control as a last resort (see box, page 105).

Right: The iPhone 4 has good video capabilities but isn't great for sound recording. The Fostex AR-4i goes a long way to remedy this.

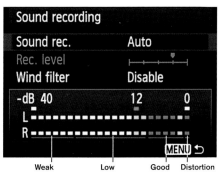

Weak Low Good Distortion

Above: *Many cameras have both auto and manual sound-level recording modes. Use manual levels if possible for drama recording.*

Above: *When filming a live concert, make sure you get there early to check your sound-recording levels properly. Built-in mics do not cope with very loud sound levels, so you may need to use an external mic.*

Testing, testing, 1 2 3

Always record sound tests to make sure that what you're hearing is what you get. Record, playback and check for unwanted noise. If you're recording music or a speaker, ask for a sound test so you can check levels and make sure there are no issues with cables picking up electrical noise, feedback, hum, crackle or pops from faulty mics or cable connections. If you're recording any kind of live event, don't wait until it's too late to change a cable or mic.

Audio sampling

Video cameras or audio recorders convert the analogue signals coming from a microphone into digital ones by sampling the signal at a high rate. The more samples per second, the closer the digital signal will be to the original analogue waveform. Typical sampling rates are 48KHz or 48,000 samples per second, or 44.1KHz (44,100 samples per second, as used for CD audio. Most external audio recorders support both 48KHz and 44.1KHz and some support 96KHz for even higher-quality reproduction. Video cameras typically only support 48KHz, with some low-end cameras supporting a lower-quality 32KHz or 22.5KHz rate as well. Don't scrimp on your audio and always try to record the best quality you can.

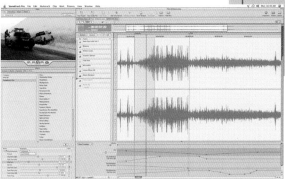

Left: *In Apple's Soundtrack application, you can view audio waveforms and adjust the sound levels after recording, but trying to remove distortion is difficult.*

Using **external microphones**

Excluding unwanted noise and picking up and enhancing the sound you do want is a challenge for any filmmaker. Sound is worth more than half the picture and great sound starts with good-quality microphones and cables.

Built-in mics are not good sources for high-quality sound. They pick up a lot of camera-handling noise and may be too far away to pick up dialogue, or become overloaded when recording live music. For good-quality sound you need to use an external mic attached to your camera, to your client (radio mic) or to a telescopic boom pole. If you're recording sound to an external recorder (see page 32), built-in camera microphones will be useful for sync sound only.

Keep the noise down

All microphones need to be isolated with a shock mount or suspension system, usually made from sets of thick rubber bands that hold the mic in place but keep it separate from

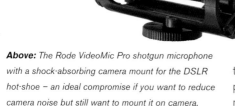

Above: *The Rode VideoMic Pro shotgun microphone with a shock-absorbing camera mount for the DSLR hot-shoe – an ideal compromise if you want to reduce camera noise but still want to mount it on camera.*

the camera or boom pole to reduce handling noise. Mics are fitted with foam windshields for close-up work or when indoors, but outdoors you need a furry wind cover or full 'zeppelin'-style wind system to reduce the effects of wind noise. The outer furry layer and inner sponge help to slow the wind down and reduce rumble and low-frequency noise. Your mic or camera will typically have a low-frequency roll-off switch (low-cut) to block low frequencies, too, although this can be done in post-production. See page 197 for more tips on noise reduction.

Get connected

Your camera will have either XLR or audio jack connectors for microphones, so you need to match the type of interface with the type of mic. Rode make a popular stereo video mic with a 3.5mm mini-jack connector for DSLRs and handycams that fits onto the camera hot-shoe mount with its own suspension system. Most professional cameras have XLR connectors featuring switchable -48V supplies for shotgun mics. They have low-cut filters and variable attenuation (-50 db, -60 db switch) to deal with louder sounds, and some have limiters for very loud peaks.

Recording levels can be controlled on the camera with either auto or manual control per channel. Auto levels may work well for run-and-gun-type shooting with no crew, but

in most circumstances you will want to control the sound levels manually. See page 92 for more on recording sound.

Pick up the sound

Camera-mounted shotgun mics normally point the same way as the camera and are very directional; any off-axis dialogue or sounds won't be picked up very well. Boom poles are the mainstay of drama filmmaking, with a boom operator pointing the microphone directly at the sound source, regardless of where the camera is pointing. Their job is also to make sure that the boom, mic and boom shadow are all out of shot. Boom mics can be tethered to the camera or external recorder by XLR cables, made with coax cable with a braided shield to stop them from picking up other electrical noise and hum. Don't scrimp on cheap XLR cables and connectors and don't stand on your cables.

Wireless

For some types of filmmaking, you need to use a radio mic kit consisting of a small lavalier or head-mounted mic and transmitter attached to your 'talent'/presenter/client. The receiver unit attaches to your camera or external recorder. Radio mics can be tuned to various frequencies in the licensed or general spectrum; a licence is usually required to operate them to avoid interference with TV signals or other signals at events such as concerts.

Right: The Sennheiser G series radio mic transmitters are small battery-powered devices that can be easily worn and hidden on your client for interviews and live recording.

Above: This 'Zeppelin' or 'blimp' from Rode offers a full suspension shock mount system for your shotgun mic. Just add a furry cover (on a boom or handheld) for extra wind protection.

Recording **dialogue**

Clear, easy-to-understand dialogue in a video is crucial and often underestimated by first-time filmmakers. Although not easily achieved, there are many ways to improve your sound-recording results.

Dialogue is used in almost all forms of video production, from advertisements and corporate videos to sport, documentary and drama, using presenters, actors or voice-overs. Our ears can cope with a wide range of sound levels, from whispers to amplified shouting, but if the background sound level is too high we have trouble isolating the dialogue.

Below: Filming in wind and weather can throw up a lot of sound-related problems. You will need a boom-mounted shotgun microphone with a good windshield.

Noise reduction

You can minimize background noise pick-up by getting the mic as close to the mouth as possible and as far from distracting noises as you can. For non-drama work, use a handheld vocal mic or a radio transmitter with a lavalier mic. Shield the mic from the wind by having the presenter stand with his or her back to the wind and use wind-reducing furry covers.

For outdoor drama recording, distracting background noises such as traffic will cause problems when editing together discreet portions of the dialogue, since the background sound will change with each cut and each

Above: By getting your microphone as close to the speaker as possible, you can reduce unwanted background sounds in this noisy outdoor environment.

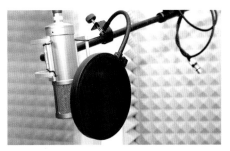

Above: A pop shield in front of a studio condenser mic can help stop unwanted 'plosive' and 'pop' sounds from being picked up on the recording.

reverse shot. The sound person's job is to ensure they are getting a clean recording and they may ask for another take if, for example, an aeroplane flies overhead.

If the background noise is continuous, it's possible to reduce it in post-production (see page 197 for more details), but you will need to record a section of the noise on its own, without dialogue, to help the process. It's best *not* to rely on 'fixing it in post'; choose your locations wisely.

Voice-over

The 'easiest' type of recording to do from a technical standpoint is voice-over. It's usually recorded separately from any video and can be repeated until correct. A vocal booth or soundproof room can be used in a similar way to recording vocals for radio or for a music CD. You can set up a mini sound booth at home, using a pop shield and a wrap-around foam sound booth with a decent omnidirectional mic on a shock mount. Placing the foam booth in front helps soak up unwanted reflections from nearby walls. Many home recording studios use egg boxes or mattresses on the walls to soak up low-frequency reflections, but leave some wall space to avoid deadening all the high frequencies and making the vocal sound flat and lifeless.

ADR

If background noise is very loud or dialogue recording very bad, ADR (automated dialogue replacement or additional dialogue recording) can be used. ADR is recorded in a similar way to voice-over, using a vocal booth. The difference is that actors are trying to match their own on-screen performance dialogue and will watch a video replay and listen to previous noisy recordings to help synchronize the vocal parts. More work is then done in post-production to match the tone of the ADR dialogue to the location (see page 199 for more details).

Useful tips

• If you use two microphones for the same speaker, set the levels 6 dB apart on each to allow extra headroom in case of peaking.

• If you're recording a corporate conference or event using a PA system, it's wise to get a secondary recording directly from the PA mixing desk.

• Use headphone splitter cables to allow both the boom operator and the sound recorder to hear the dialogue.

Your first
film project

In this section, you'll find all you need to plan, create and shoot your first film. We'll be covering:

• **What types of films** you might be interested in, from family videos, sports, wildlife and nature to weddings and live music events

• **How to plan** your first shoot

• **What it means to cover a scene** and how to shoot with the editing in mind

• **How to monitor your sound** and record it correctly

• **Understanding** interviews and reportage

Pick **your genre**

Any film, even the shortest video, stands out from the rest if you give the audience what they want but not in the way they expect. Have a look at the types of films that grab you: see what you can learn, and how you can adopt a similar approach for your own projects.

Feature films are made in a variety of genres and types, from action adventure, animation and romantic comedy through to crime dramas and science fiction. Audiences as well as the film industry have always defined what kind of film it is they are making, selling or indeed going to watch by genre. Highly successful pictures often use multiple genres to give a new spin on a well-worn formula. Quentin Tarantino's box office hit *Pulp Fiction* is crime fiction with a hefty dose of comedy, which has since spawned a whole genre of similar films. Pick some of your favourite films and see if you can break them down by genre.

Filmmaking, though, is not just about making fictional short or feature films. Television needs filmmakers just as much, to work on programmes like chat shows, fashion, travel or holiday shows, DIY programmes, through to current affairs and news bulletins.

TV dramas use the same genres as cinema, but often allow for longer-running storylines as these programmes are often episodic.

Before you dive in, learn some techniques that require little or no crew and they can form the basis of your filmmaking future.

Family videos

One of the easiest types of films to make, and usually one of the first that you will try, is a family video. The birthday party of one of your children might be a good starting point. Family videos can be pure fly-on-the-wall style to give you something to look back on in years to come – like blowing out the candles at a birthday party, a visit to the zoo or the first time on a pushbike without stabilizers. Crucially, these videos don't require much kit – a smartphone or a small compact camera will often do, since quality isn't always paramount. It's unlikely you will make a living from it, but clips from family videos do seem to fuel all the best *You've Been Framed*-style TV shows.

Weddings and friends

Filming friends just hanging out or at an event can help with your camerawork and sound recording. Making a story from your footage can be a lot harder, so try filming at specific

Left: Making a skilful wedding video takes preparation and great people skills, but can be hugely rewarding if you get it right on the day.

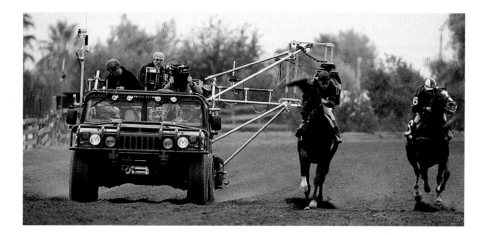

Above: Filming a racing sequence of the film Seabiscuit. Director Gary Ross (left, wearing protective goggles) likes to be closely involved with the action.

events such as a wedding or a walking or cycling trip – something that has the classic beginning, middle and end.

Documentaries

More than just 'talking heads', documentaries take many forms and can cover any subject. Sometimes you might start a documentary project with a plan or a story to follow, much like an investigative reporter covering a news story. Morgan Spurlock asked himself what would happen if he ate nothing but burgers for 30 days, which resulted in the acclaimed documentary *Super Size Me*. Short documentaries are a great way to teach yourself filmmaking and interviewing techniques, and learn how to tell a good story.

Sports and hobbies

Try looking at your own or your friends' hobbies from a filmic point of view, and suddenly a whole new world will open up. Think about a local football match or the

Box office hits under $100k

Primer (2004), US
Budget: $7,000
Worldwide gross: $565,000
Made for pocket money, this sci-fi film about accidental time travel is also a brilliant film.

Paranormal Activity (2007), US
Budget: $15,000
Worldwide gross: $193,355,800
Made in the home of the director, this rejuvenated the high-concept horror film.

The Blair Witch Project (1999), US
Budget: $35,000
Worldwide gross: $248,300,000
This film makes the concept of 'found footage' the central part of the story.

Super Size Me (2004), US
Budget: $65,000
Worldwide gross: $29,500,000
Morgan Spurlock made this documentary about fast-food effects on the human body on a shoestring budget, using his own body as a guinea pig – and the audience lapped it up.

Right: *Great underwater footage can be achieved with a 'bullet cam' or GoPro – it's often the subject that makes it great, rather than an expensive camera.*

dominoes competition in your pub; it's always best to start with something you know about. Consider how the sport is already covered on TV or film – visualize the angles and the way it's 'always seen'. Can you improve on it, make it more interesting? Maybe you can create a niche for high-quality coverage of your minority sport and with easy distribution via the internet quickly build up an audience. Extreme sports force you to learn a whole host of fast-action techniques.

Corporate videos

A potential money-earner for the self-shooter, corporate filmmaking covers both internal and external communications. You may be asked to create visuals for a new advertisement, or document a trade show or a conference to be broadcast as streamed web videos. Corporate communications can come in many forms and cover documentary and news-style filming as well as techniques usually associated with drama and music video productions.

Underwater

The unknown, mysterious realm of the sea has been used for many a drama, like James Cameron's *Abyss* or Luc Besson's cult classic *The Big Blue*, as well as high-earning animations like *Finding Nemo* and *A Shark's Tale*. We are both awed and frightened by the vastness of the deep ocean. Filming under

water needs some specialized kit in the form of underwater camera housings, lighting and breathing gear. But if scuba diving happens to be your hobby, or if you are a snorkelling enthusiast, filming in the shallows can be achieved easily with a small 'bullet cam', or something like the cheap GoPro Hero HD camera. You won't get as much control over camera settings, but you can shoot some astonishing material if the light and visibility are good.

Wildlife and nature

Whether you are taking time-lapse footage of plants growing or trying to film foxes in your back garden, nature is always interesting, exciting and pretty unpredictable. The weather changes very fast and you have to be able to cope with the locations you may be filming at, from seaside to allotment and from jungle to the steppe. You need a lot of patience and knowledge to be a great wildlife filmmaker but the rewards are spectacular, both in terms of amazing footage and a rewarding lifestyle.

Music videos and live music

Music videos tend to fall into two categories: straight performance videos that show the artists singing live or miming to a recorded track, or a form of dramatization to the lyrics of the song — or a combination of the two. Straight performance videos are usually the easiest to film, but bear in mind that you'll need multiple cameras to cover all the angles, unless you're just filming a single music track that can be mimed a few times for different camera angles. Try to find a local band for whom you can produce a performance music video at a live gig. Sometimes your single camera angle video will be better than what they already have, and it's a great way to build up a relationship with the band for doing future work together.

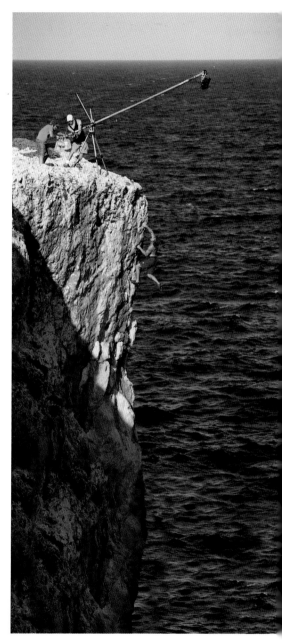

Above: *Conveying the true steepness and height of a cliff can be a challenge. This video with climber Chris Sharma was filmed with a DIY crane.*

A little **planning**

Before you go out to start filming your epic, take a quick moment to do a little basic planning so you can avoid some of these all-too-common mistakes that could potentially ruin your first film shoot.

The amount of planning you need to do is generally in proportion to the scale and complexity of your filming project. If you're only going down the road to film your kids playing in the park, then you can pick up more spares from home or film again on another day. But even simple projects like this can be made easier by checking your kit over first. See the shooting checklist opposite for ideas on what to consider before setting out on your next filming trip.

The basic tips

Know where you're going and keep the contact details of everyone involved in the filming. Use Google Street View or similar to check out an unfamiliar location before you

arrive. Plan how much filming time you'll be doing to ensure you have adequate media (and battery life) or a way to offload cards while on location. To be safe, assume you will need to film longer than you've planned.

Always, always test your equipment before you leave home. Cleaning it helps, too. Make sure you check lenses and LCDs, and preset as much as you can in advance: frame rate, shutter speed, video format, colour presets and white balance can all be preset. Examine all cables for signs of wear and check for breakages, especially on small items such as lavalier mics and on any lighting gear you take. Do a full sound check on your audio gear and preset frequencies and sensitivity levels on radio mics if you're using them.

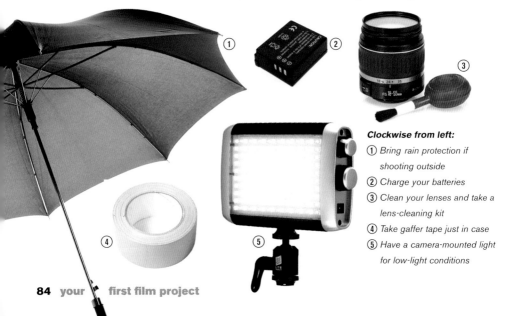

Clockwise from left:

① *Bring rain protection if shooting outside*

② *Charge your batteries*

③ *Clean your lenses and take a lens-cleaning kit*

④ *Take gaffer tape just in case*

⑤ *Have a camera-mounted light for low-light conditions*

Shooting checklist

Smartphone	Offload photos and video first to leave some space. Take a car and mains charger for extended trips. Consider cloud back-ups for data security.
Camera	Remove dirty fingerprints and give your camera a dust over while you have time.
Batteries	Charge them up. You never know when you will get a chance again.
Mains adapter and battery charger	Take a travel socket for overseas trip.
External microphone	Test the mic and cables.
Mic cable plus spare	Cables break easily and spares won't be easy to come by on a trip.
Mic shock mount	Check and replace worn rubbers if necessary before you go.
Mic furry wind cover	Some come with a brush for cleaning, especially if they get wet.
Rain cover	Consider the weather and take protection for yourself and the camera.
Memory cards	It's best to pre-format so you can swap cards quickly.
Tripod plate	Attach to camera or tripod. Take a spare if you have one, just in case.
Lenses	Clean them in advance and take a lens cloth and blower.
Tripod or monopod	Lightweight version for travelling.
Lights	A battery-powered camera top light for night-time can be invaluable. Check all bulbs in mains-powered lighting and take spares of any gel.
Grip	Consider packing some gaffer tape, crock clips, rubber bands, a wind-up LED torch, electrical tape, pens and paper, paperclips.
Food	Bring a packed lunch, drinks and snacks if you're planning to be filming in areas without easy access to the basics.
Clothing	Take spare clothing and be prepared for a range of temperatures.
First-aid kit	You never know when you might need it, so be prepared with at least the basics – plasters, gloves and antiseptic wipes.
Tool kit	It's wise to pack a small kit with at least screwdrivers, a small knife and Allen keys. If there's a loose screw on any of your gear, fix it before you head out.
Make-up	Have a small make-up kit handy to dab any shiny foreheads.

Cover **your scene**

From drama to corporate filmmaking, there are many types of shots and shot sizes needed to provide enough coverage for the editing process, as well as keeping things visually interesting.

There are few worse things than going into your edit, whether it's a family video or a feature film, and discovering that you are missing shots that would really help link a scene with another, or show a reaction or a point of view – so be sure to leave yourself with plenty to play with.

Wide shot

A wide shot shows you the whole scene – a sweeping panorama or possibly just the inside of a room. The wide shot may only get used for an establishing shot, but it's also possible that the whole scene may be acted out as a wide to ensure basic coverage of a scene for the edit.

Full shot

A full shot shows you the whole object, whether it's a person, a building or a vehicle. The shot size depends on the scale of the object – it could be the size of a planet, a spaceship or a mouse.

Establishing shot

An establishing shot sets the scene to show you where you are. This may be the outside of a building connecting you to the interior that follows, or an aerial sequence showing you a city or landscape. A more compelling establishing shot may include extra story detail, too.

Cutaway

A cutaway is a more neutral shot that does not contain any elements that need to sync with audio and can be used to cut between two similar-sized shots. A cutaway can be a safety shot for the edit, like a shot of a clock or a sunset to show the passage of time.

Insert

An insert is usually a close-up of a detail that cannot be made out from a longer shot, such as handwriting or a detail on a computer screen. Or, the insert could be for atmosphere – rain beating on a window.

Left: A wide shot is often used to show the whole setting of your scene. It can also give a great sense of location, especially if you use in-scene dialogue layered over it as an establisher.

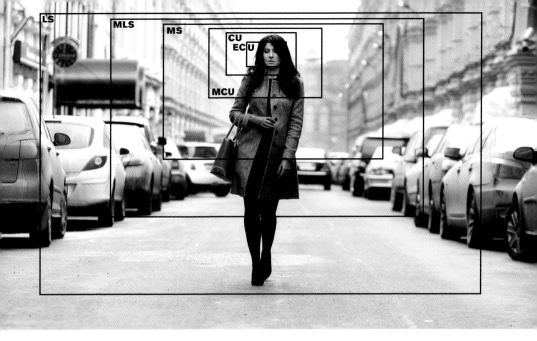

Clean and dirty shots

A clean shot is one that includes one person only – possibly a close-up. A dirty shot is one in which the action is covered partially by foreground, like another actor. A two-shot is any shot that includes two people in the frame. This may include the OTS (over the shoulder shot) – similar to a close-up shot (see box) – but it will include the back of the head of the person the actor is speaking to, literally filmed over their shoulder. An OTS shot is an example of a dirty shot, since part of the frame is covered by the out-of-focus shoulder.

Left: A classic OTS two-shot.

People shot sizes

Shot sizes for actors have their own language and acronyms, used in shot lists and storyboarding (see also page 133). In general, a **LS** (long shot) shows you the whole person, with the **VLS** (very long shot) showing you even more of the background. The **MLS** (medium long shot or medium full shot) is from knee level upwards. The **MS** (mid-shot or medium shot) is shot from the waist up. The **MCU** (medium close-up) is the standard interview shot cutting from between the waist and nipples upwards. The **CU** (close-up shot) is from the nipples upwards, including the head.

A **BCU** (big close-up, big head close-up or tight close-up) shows just the head, with part of the top of the head cut off. An **ECU** (extreme close-up) may be just the eyes and mouth, with an **extreme ECU** being the eyes only.

Shooting to **edit**

Filming is not just about shooting some good scenes; you need to shoot enough to piece together a finished story. This means getting all the coverage needed for the edit as well as shooting your master scene.

I f you're filming anything that conveys any kind of story, from an advert to a documentary, you will normally have a beginning, middle and end. It's unlikely you'll be able to make the video without a single cut – either someone fluffs their lines, some outside noise disturbs the recording or the focus goes out, amongst other reasons. It's a complex task to coordinate a long 'take', so generally you film a series of shots. But you need to understand how you're going to piece together the parts *before* you start shooting.

Below: This master shot of a street scene covers the whole scene including all the actors, from intial positions up to the end of the scene.

The master shot

The 'master scene method' is so named because you shoot the whole scene first as one continuous 'master' shot (usually a wide shot with little or no camera movement) and then shoot the 'coverage' – all the two-shots, close-ups, and so on, from pages 86–7. Continuity of actions, props, clothing and make-up between the master shot and all of the coverage is what's important here. If a character is wearing a hat in the master and it's gone in the two-shot, your continuity has been blown. You won't be able to use the two-shot and may need a cutaway to rescue the scene later on in the edit, so be careful to do proper continuity.

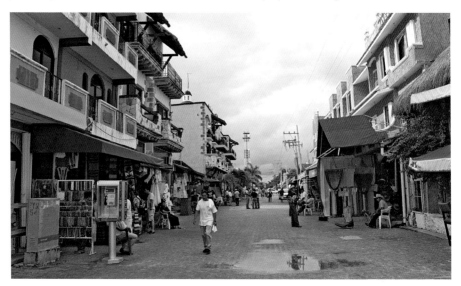

Cut points

Typically you will be working from a shot list and/or storyboard (see page 133) that should list all the shots necessary to edit the story. However, some scenes are only ever shot 'in one' as a master shot for speed and cost-saving. Every master shot should have a cut point at the beginning and end to allow it to be edited with other scenes. If you can fit in more cut points, it will make life easier for the editor to cut to the coverage shots. For example, if an actor is going out of shot or coming into shot, at that point a cut could be made to show the actor emerging in another room, or to show the actor outside, about to come into the master shot. Another typical cut point would be a 'look', where an actor looks 'off screen' and a cut is made to what they are looking at – possibly an insert shot. See page 190 for more on types of cut.

Passing time

Think about time continuity for the edit so that you can link one location to another or one time of day to another. The last thing you want is for a character to arrive in daylight, go inside a house and suddenly it's dark. Equally, having a character leave one town and arrive in another without some kind of cutaway to the journey itself, or some extra story element gained by seeing part of the journey, will leave the audience unclear on how the character arrived so quickly. See pages 174–5 for more on continuity.

Above: As the actor looks off screen you can cut to his 'point of view' shot, showing the derelict room (above) that's he's looking at.

In-camera editing

Most cameras allow you to delete video clips before downloading to your computer; some even allow you to edit the video directly in-camera on a built-in mini timeline. Some also allow you to create 'highlight reels' where you select clips that you want to play back via the camera onto a TV. Although not technically editing, this feature does give you the ability to playback the clips out of sequence. Many smartphones have the ability to trim the start and end of a recorded video, or do a proper edit. This is ideal if you want to upload a short clip directly to YouTube or other websites directly from your phone.

Above: Video editing on smartphones has become quite advanced and now enables you to create complete videos on your phone.

Angles and positions

The moving camera is the main feature that differentiates video from photography, and can be used to create different effects. It's important to consider *when* and *why* you might want to move the camera rather than just *how*.

The camera can take the place of a third-party observer or the POV (point of view) of another actor in the scene and this difference must be reflected in the placement and movement of the camera. A POV camera will have a more limited set of realistic movements but can give a more interactive feel to the scene as we, too, try to place ourselves in the scene. See page 43 for more on high and low shots.

Follow the action

Unless you're filming a stylized video such as a music video or montage, there is normally a motivation for camera movement – a reason *why* the camera is moving. Usually, a camera moves to follow someone as they sit down, stand up or move around a location. The camera may tilt up as they stand up, or rise with them, or take a more objective view showing them moving between rooms with a panning shot.

You can take a POV shot to extremes, as seen in many horror or suspense films, where we see an actor from the POV of an unknown assailant/follower, watching from the shadows: the camera dips down to 'hide' from the actor as he or she looks around, accompanied by heavy breathing and dramatic music.

Tracking

A standard tracking shot is any shot that follows an actor or object (such as a car or helicopter) as it moves. Tracking can be done from a tripod or with a dolly shot or handheld shot, but the essence is the same – the camera is moving to keep the actor in frame, since he or she is the main focus of the story at that point. Dolly shots are normally tracking (on a car or on track) alongside a moving person/object at the same distance (in order to make it easier to keep focus), but they can also be used to 'push in' and 'pull

Shot 1: *Always remember the reverse shots – the point of view of the subject in this shot.*

Shot 2: *To ratchet up suspense, you can hold off before revealing shot 2.*

out'. The camera movement still needs to be motivated by the action of the scene – i.e. someone stands up or a fight starts or a line of dialogue calls for a shocked response. These camera moves become 'invisible' since they are timed to match the action and will go unnoticed by the audience. However, if you fractionally mistime the move it will stand out like a sore thumb.

Above: Tracking a fast-moving vehicle from another is a great way to create tension and pace, especially if you shoot 'dirty', with foreground throughout the shot.

The reveal

A pull-out dolly shot or a zoom-out can be used to reveal extra information in the wider frame, in the same way that a crane shot can be used to reveal something like the other side of a fence, showing all the footballs that have been kicked over. In this way the audience gets to see some information that the actor doesn't know about. A more simple reveal could show the relationship between an actor and his or her surroundings – a

tripod tilts up to reveal the journey left to travel, for example, or the mountain that must be climbed, using a low shot to give the mountain more height and make the task seem more difficult to achieve.

Cutting a scene

Camera moves can be useful when editing scenes together or creating deliberate cut points, as in a typical film ending where the camera tilts up at the sky as the credits roll. Another example might be a tracking shot that is cut into a different scene with a similarly paced tracking shot, using a foreground element to wipe the frame and hide the actual cut. See pages 110–17 for more details on editing techniques.

Monitoring audio

Making sure your audio levels are as good as possible will help you when it comes to editing your film. Monitoring audio levels and adjusting the gain control is a full-time job for a sound person, but if it is just you filming and recording, there is still a lot you can do to make it perfect.

S ound level is measured in dB (decibels) on a logarithmic scale, with a 3 dB change being equal to a doubling or halving of sound levels. When you look at the audio levels on your camera, recorder or mixer, you will see that the highest value is 0 dB. This digital audio scale is referred to as dBFS (decibels relative to full scale), with a maximum value of 0 and all lower values as minus numbers down to -60 dBFS or below. The scale is typically shown as 0 dB, -6, -12, -18, -24, -36, -48, -60 dB.

Peaking

When recording, manually adjust the recording levels to avoid going very close to 0 dB. At 0 dB the signal will be cut off or clipped,

Right: The Olympus LS-100 multitrack Recorder features stereo XLR connections for external microphones and built-in, high-end true stereo 90° microphones. Record multiple tracks in 24bit / 96kHz quality and in Broadcast Wave Format (BWF). You can also edit, tweak and overdub your recordings.

resulting in choppy audio. Generally, you want to set your recording levels to peak between -6 dB and -12 dB. The amount of 'headroom' you leave (below 0 dB) will depend on what you are recording and how much dynamic range (the scale of quiet to loud) there is in the recording. If your recording level is set too low you will need to boost the signal a lot in post-production, resulting in an increase in electronic noise. You can use auto gain control as discussed on page 105, but manually 'riding' the level controls on the camera as the sound level changes is the best way for good audio.

Headphones

For audio recording or monitoring you will need decent professional headphones. Studio-quality headphones reproduce sound without it being 'coloured', unlike headphones designed for listening to music on your mp3 player, which can sound good but may have bass- or treble-enhancing capabilities. More neutral headphones will reproduce sound more accurately.

Be aware of the health and safety implications of wearing headphones while filming in noisy environments such as concerts and music venues. If you're only recording sync sound on the camera, you can turn the headphone volume down – use the levels for accurate monitoring and protect your ears.

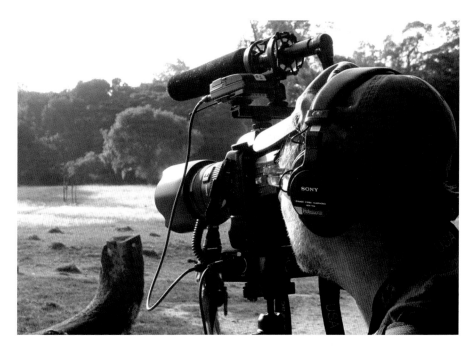

Above: With the latest firmware, you can monitor and manually adjust the audio levels on the Canon 5D MkII DSLR with a 64-step range.

Limiters

Most good-quality field audio mixers, recorders and professional cameras will have limiter circuits built in to try to avoid the extremely high input signals that result from overloading the input stage of their pre-amps. In normal circumstances, with the gain control set correctly, the limiter will not need to operate. As the gain is increased and/or the level becomes too high – above, say, -12 dB or -6 dB – the limiter will start to reduce the signal level to try to avoid clipping (though really high signals will still be clipped). The idea is that small peaks or short-duration peaks will be smoothed out by the limiter circuits and result in a much less choppy recording than you would get with the limiter switched off.

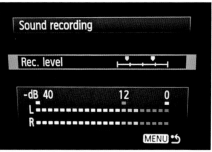

Useful tips

• Always do a sound check first to set your levels, but assume people will talk more loudly once they are 'live'.

• If you are using radio mics, remember to check the levels on the radio transmitter, too, as this can peak before the signal is sent to the camera or recorder.

What the **camera sees**

It's not about how you see yourself, it's about how the camera sees you. Whether it's facial blemishes, a pin-stripe shirt or yellow trousers, the camera can produce unexpected, unwanted results unless you know what to do to circumvent the problem.

Faces

HD video can be very unforgiving to faces. The extreme detail of an HD image shows all the wrinkles and creases you never knew you had. Make-up people hate sharp cameras as they need to do more work to cover up all the moles, blemishes and spots that may not have been so visible on traditional film. You can soften up the image and adjust the lighting to help (see page 64) but it's best to put together your own make-up kit to deal with the basics (see box).

Patterns

Modern cameras create video images by sampling the sensor and converting this to digital data. There are only so many samples per mm of sensor and if the data is down-sampled (made smaller), as in the case of the large sensors in DSLRs, this can lead to an incorrect representation of the image known as an 'alias'. Aliasing effects are most noticeable on scenes with repeated patterns and small details in the horizontal and vertical axes. Brick

Basic make-up

Most women are able to do their own make-up and know what works for their skin colour; they will often bring their own products. For male actors, however, it's wise to put together a basic make-up kit to touch up sweaty upper lips and shiny foreheads.

Basic make-up kit:
- Hand mirror so the actor can see what you're doing
- Cotton balls, napkins or alcohol wipes for dabbing sweat
- Neutral powder puff with a matt finish
- Lip balm
- Hairbrush and comb – get wide-tooth versions to make it easier to pick out any stray hairs

If you need to go beyond what can be achieved with this basic kit, you will be better off getting help from a professional make-up person.

walls, tiled roofs, overhead power lines, patterned carpets and certain types of clothing or fabric with close weave will all cause visible aliasing or moiré (see box). Try to avoid any fine check/plaid/ pin-stripe shirts or herringbone/dogtooth patterns on your 'talent' and also on any furniture in your scene.

Clothes

Bright clothing also poses a real problem for filmmakers due to the way it reflects light and causes issues with overexposure. Avoid bright white or yellow clothes as these act like reflectors and can mess up your well thought-out lighting set-up. The high contrast is tricky for the camera because of its low dynamic range and you often get exposure problems trying to compensate for the over-bright clothing. The converse can be true with very dark clothing on light-skinned people – the contrast between light and dark is too high, so a properly exposed face will leave you with a very dark and featureless shirt. Test different colours on your camera and see how it handles them. Some cameras try to improve or saturate skin tones, which can impact on deep red clothing.

Moiré and aliasing

When you view certain images or video, you will see wavering lines (often coloured) called moiré (pronounced 'mwar-ay') patterns caused by the closeness of the weave or pattern of objects being sampled digitally (see below). These lines appear to change as the camera moves or the object causing them moves on screen, leading to a type of unpleasant strobe effect. This has led to manufacturers making specific anti-aliasing filters to put inside the camera or on the front of a lens to reduce or eliminate the effect. It's almost impossible to remove moiré patterns in post-production.

Below: The moiré pattern on a cushion as seen by the camera.

Above: Be very careful with your exposure when dealing with bright sunlight and bright, reflective clothing.

Above: Most cameras cannot handle the full dynamic range from dark to light, so choose clothing for your actors with care, otherwise detail may be lost.

Family videos

Your first filming project will typically involve your family and friends. They will probably be happy to let you film them day or night, so take advantage of their availability and goodwill to gain valuable experience. Just don't expect them to want to watch all your raw footage.

Your family and friends can be your captive audience, a great option for your cast and can do every job of your crew – especially the catering. Get them involved in all aspects of the filmmaking process to keep them keen. Whether you plan on filming a ten-year time lapse of your kids growing up or just want to capture the first time they ride a bicycle without stabilizers, it's good to have a video camera handy. Smartphones are getting better at video all the time, so there is no excuse to miss any of the action.

Kids' parties

An ideal opportunity to video kids is when they are having fun at a birthday party. Plenty of bright colours – party hats, balloons, party clothes, presents – will brighten up even the dullest interior and lots of hyperactive 'actors' will usually be only too happy to pose for the video. It's best to ask other parents' consent for filming, especially if you're planning to upload the video to a public website such as

YouTube. For fast-moving subjects like kids it's best to use auto-focus (with face recognition, too, if you have that feature) and try to keep lighting high to minimize noise. Get up close if you can and fill the frame. Some kids may be shy of the camera to start with, so try turning the LCD screen round to show them what you're filming (them!) and they may start co-operating and posing.

Day trips

A family day out to the park, a picnic or barbecue, feeding the ducks at the pond, a day out in the country – all opportunities to set up your camera and record the events of the day. From fly-on-the-wall documentary-style video shot in the car (if you're not driving, of course) to cutaway shots of the scenery from a tripod or mini-slider, the choice is yours. Try to think of a way to tell a short story of the trip, as that will make it easier to edit the footage into a shorter piece that your family will want to watch again.

Going away

Longer holidays offer even greater filming possibilities. There's usually ample opportunity to shoot simple montage videos of landscapes, cityscapes and historic buildings. Editing them to local music can be a great way to give a feel of your holiday destination to friends once you get home. If it's a family holiday, you may be shooting lots of kids' activities and need a more rugged splash-proof or waterproof camera that's suitable for the beach. Consider what equipment you can actually take with you. If you're driving you may have space for lots of gear – but airlines usually charge by the kilo for all baggage and this might limit what you can take.

Above: It is often easier than you think to get great and relatively smooth tracking shots. – just try to hold the camera still and as parallel as possible to the ground. Cycling is a great and safe way to explore what is achievable with your camera.

Insurance

Make sure you have adequate insurance cover. Read the small print – you may find that thefts from vehicles are not well covered or the excess is very high, negating the equipment's worth. Even with insurance cover you don't want the thought of a theft spoiling your trip, so decide what's essential to take and what can be left behind.

Filming **action sports**

Sports filming can be a mainstream job or a niche hobby, but it is accessible and a quick way to learn camera techniques and composition. If you already have a sport as a hobby, make that your starting point.

Tell a story

It doesn't have to be done with a voice-over or commentator if your filming shows a logical beginning, middle and end, but try to tell a proper story. Start with shots of the contest set-up or a location time-lapse. Lead into the main event with multiple angles, combining wide shots and close-ups with cutaways of the location, people and atmosphere, with some slow-motion or 'beauty' shots or even a few crashes, and then finish with the prize-giving or the end of the day as the sun goes down. You might grab some sound bites or do proper interviews with spectators or competitors, but make sure you get people's names and contact details and ask for permission.

What kit?

Most sports require the use of a telephoto zoom lens so that you can get a good vantage point for the action. You will need a stable tripod and lens mount to avoid camera shake with a long zoom. It may be necessary to move your gear frequently to set up for new angles, so consider its weight and only take what you can carry. A good-quality monopod may suffice, but a really long lens needs a very stable tripod, especially if it's windy. If you're shooting at the beach or in the mud aluminium is probably the best choice for tripod legs. Rinse all your gear afterwards to get rid of dirt, salt and sand, as this can blow in very easily.

Speciality cameras

Consider using speciality 'action cams' like the GoPro Hero; these can be attached to the sportsperson by means of a harness or mounted on the player's helmet. They can even be mounted on sports equipment – a car, bike or surfboard – for really dramatic action footage. Using multiple angles adds a lot of interest, especially if you can film the same move several times from different angles and different POV shots, then edit them together to give the impression of multi-camera coverage. Consider shooting interlaced (60i NTSC, 50i PAL) video rather than progressive (24p, 25p, 30p) for smoother fast motion (see page 38).

Pay per view

Mainstream commercial sports attract major sponsors, which leads to expensive TV rights negotiations, which in turn leads to blanket coverage with multiple cameras, commentators, fancy motion graphics and

Left and above: Whether it's a mainstream, niche or extreme sport, it's easier to find interesting viewpoints and new ways of filming it when it's a sport you love or where you can get behind-the-scenes access.

high production values. Less mainstream sports attract little or no sponsorship and get much smaller or no real coverage on TV. Market forces dictate how much can be recouped from filming these, leading to many straight-to-DVD productions for sports such as skateboarding, mountain biking and kite surfing. The internet has also had a big impact on this area, with lots of user-generated content on less mainstream sports.

USEFUL TIPS

• Try filming double frame rate slow-motion progressive to get smoother motion footage. Try higher shutter speeds to freeze the action in each frame.

• If your camera has a LANC port, get a remote zoom/focus controller for the pan bar to keep your hands further away from the camera and reduce shake.

• Use silica gel with waterproof housings to avoid fogging caused by sunshine or the camera itself heating up any trapped moisture.

Wildlife and nature

Take nothing but video, leave nothing but footprints, kill nothing but time – but don't forget your sandwiches, a lot of patience, some insect repellent, waterproofs, some more patience, and you will be rewarded.

Spending time immersed in the natural world won't turn you into David Attenborough overnight, but going out into the great outdoors on a video trip can be exciting and highly rewarding. Start off small – in your garden or local park – and build up to more exotic trips once you've found what equipment works for you.

Get up close

You'll be surprised just how much wildlife lives in or visits your garden, especially small-scale creatures like insects. Use a macro lens or

Below: To get great footage of wildlife in its natural habitat you almost always have to use long lenses, so a good tripod or another alternative camera support is a prerequisite.

some close-up diopters on your camera and take a peep at the fascinating world living in your flowerbed. Macro lenses create a shallow depth of field and need more light than normal lenses, but will give the best results. Try putting out some bird feeders close to your house, then set up your gear indoors and shoot through a patio door or window.

Be prepared

When you're ready to venture further afield, do a little research on the types of wildlife you want to see. A trip to the seaside should show you sea birds, but if you go when it's mating or nesting season you're likely to see much more. Aside from the obvious wet-weather or camouflage gear for yourself, you're going to need some protection for your camera

i Lens and camera

Full-frame 35mm DSLRs work well for wide-angle landscape shots using 20mm or wider lenses. Most video camcorders have a focal length of 28mm to 35mm at the widest end, but excel at the telephoto end with 500mm to 600mm as standard zoom. Add on a quality 2x zoom-through lens and you have a very high magnification for wildlife filming. Smaller-sensor DSLRs and Micro 4/3 sensors fare better since the crop factor of 1.6 to 2x increases magnification, but the cost and weight of a suitable 400mm+ lens will usually rule them out. Poor-quality telephoto lenses can lead to chromatic aberrations (colour highlights and ghosting around objects) or vignetting (dark edges) and other types of distortions. Read some reviews and try before you buy if you can.

Above: Any HD camcorder is a good starting point to practise on smaller domestic wildlife before exploring further afield.

and lenses. Video cameras like the Sony HXR-NX70 are designed to be dust-, rain- or splash-proof – but if yours isn't, consider a rain cover. Kata and Portabrace make camera-specific rain protection that gives access to all controls and provides see-through windows to enable you to film outside in adverse weather.

A cheap alternative is a clear plastic bag taped in place, although this won't hold up to continuous use.

Pack your bag

A backpack with lots of compartments is great for carrying gear, but don't overload yourself. A lightweight carbon fibre monopod with fluid cartridge may be enough of a support for a long telephoto lens, but a multi-purpose bag such as the CineSaddle is a lightweight alternative for steadying your lens and doubles as camera protection and a comfy seat. If you're shooting mainly landscapes or seascapes, you may want to take a small slider to add some interesting shots.

Left: The CineSaddle comes in many sizes and works both as a tripod substitute and as a protective camera bag.

Filming **live music**

Live music is good for the soul. If you enjoy going to gigs or festivals, why not combine your love of music with your love of filming? Filming live music is a great way to learn skills quickly.

Bands are usually pretty lively on stage, so you may be re-focusing a lot and re-framing shots to get the best angle. Despite the use of spotlights, lasers and light chaser units, lighting levels for gigs can be much lower than you would like. Small venues such as pubs and clubs are normally quite dark inside and, unless the lighting technician (if there is one) and band have agreed to increase the light levels specifically for filming, you will have to cope with setting your ISO high or your aperture wide to cope with the low light. Outdoor filming at festivals can be easier, although be careful of white balance settings for mixed lighting.

Access all areas

Some venues are very small. You need to get used to squeezing into tight spaces with your camera or being knocked about a bit (it can help if you are tall). It's best to recce any venue first and figure out tripod locations, or you may have to go handheld. Larger venues such as theatres usually have good vantage points; it's worth asking the venue staff for help on camera placement. Organize access to any off-limits areas or any backstage passes you might need in advance.

Below: Recording live music can be loads of fun, but you will need to concentrate on focus and framing and 'getting the shot'.

Left: A way to get good live sound is ask the sound mixer if you can get a live feed from the mixing desk, or, even simpler, a live recording that you will be able to sync with your footage in the edit.

Right: Many music events are filmed using lots of small, remotely operated cameras such as the Q-ball to reduce manpower costs.

Check your sound

There is often a big difference between a track recorded in the studio and the same track performed live by the artist. This is partly due to the noloriously tricky live sound, as well as the general performance ability of the band – or lack thereof. This means you could create a great-looking live performance video, only to find the band hate the sound and don't want it to be seen/heard by anyone. One way to get around this is to film the songs that the band have already previously recorded and use this studio music over the live footage.

Below: You're unlikely to get the best position from within the crowd, but it's a great 'personal' angle that can be easily cut into a multi-camera shoot.

Larger scale

Most professional live music is filmed with multiple cameras, with camera operators on a talkback system. Video can be mixed live to big screens via a mixing desk, or each camera recorded separately for later editing. ENG-style cameras are good for live music, as they have high magnification zoom lenses and can create shallow depth if positioned correctly.

For private use, DSLRs are getting better at longer recording with dual card slots, and are great in low light.

Try to persuade a friend to help on the night. Give him or her a second camera so that you have another angle or set up a wide 'safety' shot with the second camera that you can cut back to from any close-up shots. If you don't have a spare camera, the friend could look after your gear during rest stops or get you a drink – any support is useful.

USEFUL TIPS

• Ask the band to repeat certain strong songs in their set list to ensure you get decent, usable live audio.

• Make sure you cover all angles. Have a 'safety' camera angle (usually a wide shot) to fall back on if all your crew have bad angles at the same time.

• Test out camera positions and sound levels during the band's sound check. You may need extra attenuation on your camera mic for the high levels.

Wedding films

Most people have had to sit through someone else's wedding video. As often as not, it can be a rather long and tedious experience. Here are a few techniques, tips and tricks to make your wedding film the special and fun experience it deserves to be.

Start by planning – you'll know the date, time and location, but you also need the order of service (if it's a church wedding). Attend the wedding rehearsal and meet the vicar, minister or rabbi and ask them for permission to film. Some venues have special camera locations, so look into that in advance to avoid nasty surprises on the day. This is a once-in-a-lifetime event, so the pressure is on you to make a good job of filming the big day and not get in the way.

Check your gear

Make sure you have the right gear, especially for sound recording. Church venues can have very bad acoustics due to high ceilings and stone walls – it might be necessary to hire a radio mic, especially for the vows. You will need enough batteries to cover the whole event and enough memory cards. Using

two cameras on tripods is ideal – have one camera fixed on the crowd for cutaway shots (wide shot) and one camera on the bride and groom. Whatever happens, just keep recording. You can edit out all camera moves and re-focusing later, but unless you're doing a separate audio recording you need to keep rolling for sound continuity.

Above: A twin-headed tripod mount is great at weddings: use one for a wider angle master shot camera and one for telelens portraits and close-ups.

Left: Make sure to keep filming the before and after, and while the official wedding photos are taken – these are often interesting moments of respite during the buzz of the day. If you have a moment to play, try a bit of slo-mo here; it will make for humorous interludes in the final video.

Above: Get behind the scenes to capture all the laughter and tears during the build-up.

Story ideas

You obviously need to capture all the main parts of the wedding, like the arrival of the bride, the wedding vows, the speeches and the first dance. But think about the final edit before you start filming – can you come up with a particular story about the happy couple to base your wedding video around? Perhaps borrow the theme of a film or TV show format, or base it around their hobbies or how they met. If you can get family and friends involved in advance you can film extra segments to slot into your edit and make it more fun. Try filming the bride and groom before the big day for any behind-the-scenes pre-wedding jitters. It's useful to interview the main guests too, sending their wishes to the newlyweds. Get cutaway shots of the venue to use for intro or title sections.

Above: Often, at the 'I do' moment you won't be close enough to pick up those two crucial words; think about renting a set of wireless microphones for the bride and groom to wear – it'll make all the difference.

Auto gain

If you have built-in microphones, you may want to rely on AGC (automatic gain control) when you're very busy filming a wedding or other event. However, AGC can lead to extra electronic noise being introduced, especially if the sound level varies a lot. Imagine as the music fades, the bride arrives and it goes quiet. The AGC on the camera starts to ramp up the gain (and noise), hunting for the sound level it had before. Suddenly the organ music starts again and the camera has to cut off part of the sound as it drops the sound levels back again to compensate. This can lead to choppy audio, with the AGC cutting off the beginning of loud sounds, and increased noise in the quiet gaps as it increases the volume of what should be silence. Always try to control audio levels manually if you can. See page 196 for more on fixing audio in post-production.

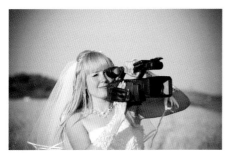

Above: Try to capture even more authenticity by giving the bride and groom a camera and sending them off for ten minutes to shoot their own footage.

Filming an **interview**

Good interview technique is not just about good camerawork: it's also about having a good rapport with your subject(s) and making them feel at ease and not intimidated by the camera and microphone.

I t's always useful to have a helper when filming interviews. Aside from perhaps lending a hand to carry the gear, the helper can be a stand-in for the interviewee while you set up the camera and lighting and can also act as an eyeline for the subject(s) when they answer questions. If you're going to do it all on your own you must be very confident with your camera set-up before you start, as you won't be able to keep checking it and risk losing eye contact.

'What did you ask me?'

Pre-prepare a list of questions or topics you want to cover. Unless you're related to Louis Theroux you probably won't want to be part of the video yourself, so the answers need to stand alone. For example, a question like 'What's your name?' ought to be answered 'My name is Sarah…' rather than just 'Sarah',

Above: If you are filming an interview outdoors, be flexible about location so that you can move if noise or weather dictate it.

as that will be out of context on its own. You may need to do a little coaching, unless your interviewee has already had media training.

Pick your spot

Your location should reflect the style of the video you're trying to make. A corporate promo might feature a CEO standing next to his factory, but a personal interview for a charity could be done in someone's home. If you have a choice of location, do a recce first and look for problems such as noise or potential disruption. If filming outdoors, check the weather forecast. Cloud cover is good for more diffused lighting, but constantly changing light levels over a long interview may make it harder to edit.

Camera position

You want your subject to relax and be as natural as possible, so try using a longer lens and move the camera further away. The longer lens will also help throw a distracting background out of focus. If you are really cramped for space you may have to shoot through a doorway, but be mindful of health and safety and extra noise.

Have I seen that plant before?

A flat, plain background looks bland and boring, so try using extra lighting to separate your subject from the background. Dedolights are useful, with gel filters to add some colour, and can be combined with special lenses to throw a pattern onto the background to

add more interest. You might need to 'dress' the scene with a pot plant or move bits of furniture around to get a good-looking composition. If you use the same location for multiple interviews, don't be scared to re-light and change it around each time.

Covering shots

It's quite common to shoot an interview with more than one camera to help with the editing, since cutting between two cameras works a lot more smoothly than trying to cut one camera. If you only have one camera,

Above: *For interviews, make sure you have your sound synced properly. The easiest way is to feed your mic straight into the camera microphone input, but if you want to try a long-range shot with synced sound you need to use wireless microphones.*

you could try filming some cutaway shots such as close-ups of hand gestures to cover any edit problems. If you have more than one cameraperson, you could try using a slider for slow and subtle camera movements on a wider shot.

basic
editing

In this section, you'll learn how to do some basic editing so that you're quickly able to view your first video, including:

• **How to import your video footage** from your camera to your computer

• **How to select your clips,** trim and cut them together to create a visual story

• **When and how to add music** to your new video

• **How to share your video** offline or online

Importing **video clips**

You've shot your first movie. The next step is to get the video from your camera to your computer for editing. This can be done in a variety of ways, depending on your equipment.

Digital video cameras use a number of different recording formats: digital tape like DV or HDV tape, removable media cards like SD or CF cards, non-removable memory built into the camera, removable SSDs or recordable DVD-type disks. There are two options for transferring the video files to your computer – connect the camera directly to your computer via a cable, or put the removable media into a card reader on your computer and copy files from that. The connections for transferring data will be Firewire or USB – or Intel's Thunderbolt interface for very new cameras. Your PC or laptop may have a card reader built in, or you may need to buy an external card reader to match the cards used by your camera.

Below: Most cameras can be connected directly to your computer via USB cable and allow transferring of video and still image files by simply copying them.

AV connections

Most cameras have AV (audio/video) outputs to allow you to connect straight to a television set and playback your clips. Modern HD cameras have HDMI ports that allow you to connect to HD TVs; others use analogue phono-style or S-Video connections that require a similar connection on your TV. This type of connection is great to preview your clips and show friends, but won't help when transferring video to your computer.

Tape capture

Tape-based cameras will only transfer video from the camera via Firewire, so you will need a Firewire cable and a Firewire port on your computer. You will also need some editing software (see page 112) to control the import of your footage and convert it into video files. The camera needs to be put in playback or 'VTR' mode before capturing the video in real time by playing back from the camera – much like playing back from an old VCR machine. Tapes are cheap enough for you not to have to re-use them, so they can be kept as master

Below: Most laptops don't have built-in SD card slots, but with a simple USB key adapter you can transfer camera files with ease.

Thunderbolt

SATA

USB2

USB3

Firewire 400

Firewire 800

Above: *There are so many standards for audio/video connectivity that it's easy to get confused. Thankfully, each type of connection uses a differently shaped cable end so you can't mix them up.*

copies in case you need to re-capture them again some day, perhaps due to corruption of the electronic file.

Card copy

Card-based cameras like DSLRs store video in discreet files so that you can connect them to your computer via USB and they show up as an external device like a memory stick or disk drive. When you see the device appear in the Finder (Mac) or in Windows Explorer (PC), it's a simple matter of dragging files from the card to the computer to copy them. Some cameras need to be put into a special mode first to allow communication with the computer; alternatively, use a card reader and it will make copying simpler for you. Ideally you should make a back-up copy of the files on another drive, since you will re-use the cards again and this will become the only copy of your precious video.

File space

Ensure you have enough disk space on your computer for capturing or transferring files before you start, or make use of external hard drives. You can get bus-powered drives, meaning they are powered via the cable connection itself and do not need an external power supply – ideal for use with laptops on the go. Firewire and Thunderbolt drives can be daisy-chained together to give you multiple external drives when editing lots of video material.

Below: *These bus-powered Lacie Rugged HDDs use power from the USB and are ideal for use in the field when space is limited on your laptop drive – and you won't need a separate power source.*

Useful tips

• Use the slide lock on SD cards to protect your files from accidental erasure when they are out of the camera.

• Format all your cards *before* going on a shoot, as this will save time and stop you from mixing up new and old cards.

• Make sure data has copied properly from a card, by playing back and checking the content fully before you format the card again.

Cutting it together

Now that you have imported media into your editing application via Firewire or copied files from your camera directly to your computer, it's time to look at the basics of putting a short video together using popular desktop editing software.

You could try using a built-in 'theme' in Apple iMovie, Sony Movie Studio or Microsoft Movie Maker to create your first film. These feature professionally made graphics and audio elements with placeholders for your video clips and photographs, so you can drag and drop your media, then simply re-write the titles and credits sections to suit. Themes are ideal for making short trailer-style films to share with friends and family and contain just enough to give a flavour of a holiday or birthday party. You can apply different themes and preview them before committing to a final choice. Themes offer a shortcut to what you can create directly in more professional motion graphics applications such as Adobe After Effects or Apple Motion.

Timeline

After you've tried all the themes, you may want to tackle a longer edit and import more video clips or photos. A sequence of clips will start to build up on your timeline. Each video clip must be 'trimmed' so that it starts and stops at the right place. Trims and cuts are all non-destructive; this means that the original video clips still exist on the computer and will not actually be deleted or cut, enabling you to go back and make changes later to trim points without having to re-import media. As you put photos on the timeline for a slideshow, you can choose the on-screen duration and

the standard effect being applied to the photo – such as the classic 'Ken Burns' effect which includes a pan-and-zoom effect to add 'movement' to a still image. You can re-order your clips and photos until you're happy with the sequence.

Transitions and effects

Choose how one photo or video clip blends into another on your timeline by selecting

Above: The factory-supplied transitions in Final Cut Pro cover almost any eventuality, and can all be modified to suit your individual needs.

either a straight cut or any number of built-in transitions – from cross-fades, slides and wipes to zoom in/out and ripple dissolves. Each app will have its own set of built-in transitions, as well as video effects such as turning a clip black and white or applying colour changes, adjusting brightness, fixing red-eye on photos, stabilizing shaky footage or adding special effects such as rain, fog or old movie scratches and jumps. Some of these effects are included in the built-in themes, but you will get more control over them if you apply them individually to a clip on the timeline; usually you can keyframe the effect to get a gradual change over time (see page 190). If you later change your mind on any of the transitions and effects, you can come back and alter them.

Above left: Sony Vegas Movie Studio works on Windows and uses the same software technology found in higher-end products like Sony Vegas Pro.

Above: Movie Maker is available for Windows only and can be downloaded free from Microsoft. This application allows you to edit photos and video clips and export to the web to share with friends.

Handheld apps

If you've shot footage on an iPhone or iPad, you can edit directly on these devices using a range of software. iMovie is available with the same touchscreen gesture control as you would expect from apps developed for Apple products, and Avid have a version of Avid Studio available for the iPad, enabling you to film and edit on the same device and upload straight to the web.

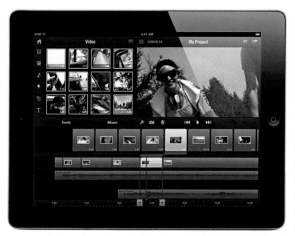

Left: Avid has caught up with the mobile trend and released an app version of Avid Studio for the iPad. It offers users the ability to access photos, video and audio through the device, as well as offering basic and precision editing tools such as frame-by-frame trimming and flexible audio editing. Projects can then be seamlessly exported to Avid Studio on your home computer.

Adding a **soundtrack**

No story is complete without a musical backdrop, whether it's to cover up a noisy background or to set the tone of the video – light and fun or dark and moody. Finding suitable music can be tricky, so why not have a go at making your own?

f you watch any movie closely enough, you will start to hear how music can be woven into the story – from a few bars to underscore a significant event to a whole interwoven music score that returns to similar musical themes throughout. Studying your favourite films will give you a good insight into how music works for specific genres like comedy, horror, action or romance. Usually, fast-paced music is used for sports or action, with orchestral or acoustic music preferred for love stories or emotional drama.

Music choice

Choosing the right music to fit your video isn't easy. You can start by using some of your favourite music, or try royalty-free music (see page 144 for more on copyright). Many NLE packages come with some built-in music that you can drop straight onto the timeline and trim to fit your video. If your software has built-in 'themes' or you have add-on theme

packs, these will usually give you a few genre-specific music beds to try out for kids, sports or wedding videos at least.

Audio dip

Whatever the music source, you will need to do some basic editing to the sound levels to avoid drowning out any dialogue. If you have to trim the start or end of a music track to fit, add a cross-fade and it will drop the level to silent over the duration of the fade. This can also be done using keyframes to set the volume level from 0 dB to −infinity dB or from 100% to 0% depending on your software. The same applies to dropping music levels near dialogue – use keyframes to dip the music down 6 or 9 dB before the dialogue starts and boost it back up after. Adjust the duration of the fade so that it's a subtle change, or go with short music 'stings' that automatically stop or fade in and out after 20 or 30 seconds.

Free sound and music

There are loads of copyright-free and often free sites for sound effects and music. Check out these sites to get you started:

www.freesound.org

www.incompetech.com

www.farawaymusic.org

www.jamendo.com

Above: In Final Cut Pro, as well as in all other video editing programs, you have the option to manually fade your music or audio according to your needs.

Make your own music

Making your own music in the digital age doesn't have to involve playing a musical instrument or even plugging in a MIDI keyboard, although having an ear for music does help. Applications such as Apple's GarageBand, Sony's ACID Pro, Soundtrack Pro (part of FCP Studio), plus a host of freely available software for Mac and PC, give you the ability to craft your own soundtrack or just create a 20-second gap filler with relative ease. Sift through the different built-in music elements or music 'loops', trying out combinations until you're happy with the sound level. You can put together a half-decent

multi-instrument audio track in minutes, although making it sound brilliant can take a lot longer. Some software will allow you to play your video clip while you create the music, to help with synchronization.

The harder method is to create music completely from scratch, using the mouse or computer keyboard, or via a USB keyboard to give you more control over the notes. Software will emulate individual notes – from brass, woodwind, guitars, drum and bass, pianos and organs to strings and choral elements – and allow you to apply effects such as reverb and echo to complete your composition.

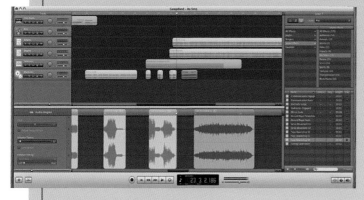

Left: Garage Band from Apple allows you to record your own music into the computer and arrange it, or compose music from scratch with a keyboard.

Left: Soundtrack Pro lets you create a multi-track audio timeline to match your video, using a vast array of instrument samples supplied on several DVDs. You can adjust levels and apply effects for each track as well as overall master levels and effects.

Sharing your video

So, you have shot and edited your first full-HD masterpiece and want to share it with your friends and family. Let's look at some options for getting it out of your edit program so that it can be seen in all its glory.

Simple editing applications such as iMovie have video export presets – ways to export your video in different sizes. There are usually presets to send video via email or to use directly on a computer or smartphone. Presets can save you a number of conversion headaches, although it's likely that you will still have to create several different-sized versions to suit different friends. Not everyone's computer can playback full HD video, so you need to take into account the specifications of the playback devices (see box). If you want to make DVDs or Blu-ray disks instead, see pages 210–13 for more information.

Export presets

Choose your export options in terms of frame size and frame rate – smaller frame sizes and lower frame rates will result in physically smaller but lower-quality files. See page 38 if you need a refresher on frame rates, resolutions and video codecs. With the advent of faster broadband, the size of a file you can create for YouTube or other video-sharing sites has increased; try exporting at different sizes and play the files back to compare how they look. If you don't have any built-in presets for the web or handheld devices, you may need to export your video in 'full quality' and compress it in another program.

Above: *High compression – low quality*

Above: *Medium compression – medium quality*

Above: *Low compression – high quality*

Above: *No compression – full quality*

Compression

If you have been filming and editing in full HD, your 'full-quality' file is likely to be pretty big (in gigabytes rather than megabytes). This is not an ideal size for sharing as it will take a very long time to upload, even with fast broadband. So the next step is to compress your video to strip out unnecessary data detail. For smartphone playback, the web and Blu-ray disks, the common video compression format is H.264 (spoken as 'H dot 264'). This encoding algorithm uses clever maths to work out the contents of each new video frame based on what's in the preceding video frames and can remove 'redundant' information from the video file to make it much smaller.

There are many free software apps that do encoding/compression – Apple iTunes has software presets to match Apple devices, or use an open source utility such as HandBrake or the excellent MPEG Streamclip from Squared 5 to create video files at custom sizes with custom H.264 compression settings.

The Apple-native iTunes can compress audio files to MP3 and AC3 but also does a video compression to fit your video onto an iPhone or iPod.

Left: You can use MPEG Streamclip to open and play most movie formats, including MPEG files or transport streams – edit them with cut, copy, paste and trim; set in and out points and customize your video export settings at most levels to control file size and download speed.

Pre- **production**

Now that you have mastered planning, shooting and editing a simple video, you'll be ready to take it to a more advanced level. In this section, you will learn everything about the professional pre-production stage, including:

- **Developing a great story** by understanding the structures and building blocks that make up a good script

- **How to break down the script** to schedule the shoot and create a shot list

- **Where to go to get finance** for your film project

- **The casting process** and how to organize a good casting session to find the talent you need

- **Art, make-up and wardrobe,** as well as how to arrange locations, insurance and music licences

Developing a **great story**

A great story takes you on a journey and springs from a universal truth – something that can be expressed within a culture, but transcends time and place to be _known_ by the audience to be true. Your challenge is to come up with the intricate detail and original ideas that make a story great.

The audience will connect at a deeper level with a story if it contains insights into real-life challenges. You want audiences to make use of their own emotions, and so the story should move them from happiness and joy to sadness and despair and back up again, exploring their own response to the situations on screen. Audiences want to empathize with the characters; as they watch, they see themselves replayed on the screen. The way the characters interact can strike a chord with the audience as they discover themselves within the story, faced by obstacle after obstacle that they must overcome in order to move the story to a satisfactory conclusion. How would they react if placed under the same duress as the characters in the story? How would they deal with each emotional situation and its dangers? Would they cope as well or would they opt for an easy route?

It's all in the detail

Audiences love to explore new worlds, in terms of culture, time and location, giving them insights into how alike we really are. You need to do thorough research to make the story work, to set it in its correct context. Whether this is something you know already or something you must research from scratch, immerse yourself in the details and draw out the differences that enlighten and entertain.

You may want to start by setting a story in the context of something you know about already – a career you have or a place you once lived. Your stories will always contain elements of your own experiences. Try developing characters from the traits of people you know – but don't be limited by the way they might react to situations. Your world view and your own responses to the world around you will shape your storytelling and give rise to your own unique style.

Around the next corner

Audiences love twists and turns in the plot and suspense — even in comedy — but you will need to be clever to ensure your story is not too easy to fathom and contains too little detail that audiences can guess the outcome. Keep them guessing and on the edge of their seats, wanting to know what will happen next, but don't make the story so confusing that they lose the plot and give up before the end. Getting the right balance is all part of the art of great storywriting.

Original ideas

Do your own research into storytelling — study great stories and great films to see how they work. Examine what it is you respond to, what makes you laugh or cry. Is it what you actually see or is it how your own experiences merge with the story to create an emotional response composed of the two?

There is no guarantee that you will create a good story by copying something that has worked in the past. You can gain great understanding of the technicalities of storytelling — but even if you have all the same elements as a previous 'hit', it will fail if your ideas are not original.

If you can craft a fresh story with emotional connections to the audience, in your own unique style, then you're well on your way to making a success of it.

Collective cinematic knowledge

Since the first moving pictures over a hundred years ago, audiences the world over have consumed films and, with each new film, a little more insight is added to the collective knowledge pool. Everyone is unique; every location on the planet is unique; every culture is unique with a unique perspective on life. So go and find your unique story to tell.

Story **structure**

Structure is the stuff that holds and binds a story together over its course. Like plays, films are composed of scenes, sequences and acts. Once you understand these, everything will fall into place.

Every story has a beginning, middle and end. This is why most films have three distinct acts. The acts are usually split unequally by time, so the beginning (or the story set-up) gets 25%, the middle (or the conflict) gets about 50% and the ending (or resolution of the conflict) gets the last 25%. Usually, most of the effort is put into the end. This is because it's what audiences will remember – and if the story ends well they may recommend the film to others.

Start at the end

Many writers work back from the ending to try to ensure they have a good story, but there is no simple formula for success. Designing your story with a structure to suit your genre is good discipline for you and will help you decide what to keep in and what to throw out.

Above: *The 'inciting incident' that kicks off the story in* The Matrix *comes when Paul Anderson (Keanu Reeves) is given a memorable choice – blue pill or red pill?*

Story arcs

The arc of the story is the way it changes from beginning to end. It's the changed value or circumstance – the conflict that is resolved by the end of the story, the injustice that has been righted, the love lost or love found (depending on the chosen genre). Your characters will have their own arcs throughout the story and there will be story arcs within each act itself.

Follow the beat

The smallest measured part of story structure is a beat – a small but significant event within a scene that moves the story along. A beat can also be a twist in the plot. You could start writing by creating a beat sheet, listing all the events in chronological order and using that to flesh out your scenes. A beat could be a change in behaviour, the discovery of a key fact, the revelation of a lie or the introduction of a new character. All these beats are the foundations of the story – like the bricks in a building.

Structuring scenes and acts

A story itself is built from a number of scenes where something important happens. Every scene serves to propel the story forward. Scenes are not to be confused with camera set-ups, although they can be identical. A series of related scenes then build into a sequence, which normally has a change for better or worse – the ending of a sequence bringing about the largest change.

The three-act structure

The three-act structure is as old as storytelling itself. You can find it in plays, novels, short or feature films and a lot of video games.

William Shakespeare used it just as much as Aristotle, and you will find it in all of Hitchcock's films. It's older than the Greek myths. Hollywood is built on its foundations.

The three-act structure consists of Act I (the set-up), Act II (the confrontation), and Act III (the resolution).

Once you have mastered and internalized the structure, you can play with it – use four or even five acts and they will still normally slot into a three-act structure. You can apply it to a wedding or sportsday video just as much as to a properly scripted drama or even documentary. In short, the three-act structure is a highly accepted and very successful method.

As an exercise, watch any successful film and you will discover the underlying structure: After a short introduction, there's usually an 'inciting incident' that kicks off the story; after about 10 or 15 minutes, plot point 1 will spin the original story into a new direction for Act II, the actual meat of the movie. Now the stakes really escalate and, if the hero is still on the fence, something will happen by the mid-point that will make the goals clear.

Now the heroes are bound to a chosen trajectory until a pivotal moment – plot point 2 – at around minute 75 stops them short and forces them to take action in order to resolve the challenge laid out in the inciting incident. This propels the action into the third and final act, towards the ultimate climax and resolution.

Act I The set-up	Act II The confrontation	Act III The resolution
Inciting incident	Mid-point	Climax
Plot point 1	Plot point 2	

The same is true for acts. Built from a number of sequences, each act ends in a scene that is more powerful than any previous sequence endings and has a larger change in values from positive to negative (or vice versa) than previous ones. For example, the middle act could be composed of a series of sequences that cover the whole confrontation – the initial conflict, the worsening of the conflict, the failed attempt to resolve the conflict – which then builds to the major crisis at the end of the middle act.

Above: *The hugely memorable climax and resolution in* Thelma & Louise, *in which Susan Sarandon and Geena Davis choose the only way out they can see.*

Story **building blocks**

The idea of telling stories is as old as mankind. Studying the essential components that make a good story, defining it by genre and looking at character arcs will help you get to grips with the conventions of your chosen genre and the development of your characters.

You can broadly classify films into genres like, for example, romantic comedy, action, sci-fi, martial arts, sports film, children's film, musical, horror, crime thriller or historical drama. These are just the basic genres; often they will be mixed together to create more interesting stories.

Many films use a sub-genre as the main story idea. For example, a spy film is a sub-genre of the crime story genre. Films such as *The Bourne Identity* mix love story, action and political thriller sub-genres, and Quentin Tarantino's *From Dusk Till Dawn* manages to cross a car-jack road movie with vampires.

Above: *The film* Cowboys & Aliens *mixed two wildly different genres, the traditional Western with a full-blown alien sci-fi – with debatable success.*

Audience expectation

As a movie-goer you know what to expect from the majority of films you see, based on knowing the genre. This pre-conceived expectation imposes some structure on your story: if you go to watch a Western, you expect the film to have cowboys and Indians and to be set in the plains of North America, while if you watch a sci-fi film you expect to see spaceships and aliens. If you don't actually give audiences what they expect to see, you can be in trouble. Audience expectations come from marketing as well as from genre conventions as such. Studying and mastering the conventions of your chosen genre is the starting point to writing a great story.

Know your character

Every story needs characters, and they must be fully formed and three-dimensional to work properly. You need to know them inside out – how they think and react to every situation you throw at them. Characters need a full history, even if most of that history is never revealed in the film. You still need to know their back story, since past experiences make each character unique and affect how they react to their environment.

He's behind you!

Most stories need at least one hero and one villain in order to mirror life. The main villain is known as the antagonist and will devise schemes to oppose and block the main hero – the protagonist. Even if the good against evil plot isn't quite as simple as a superhero crime drama like *Batman*, you can find villains in everyday life to pit against your hero. For

Christopher Vogler's 12 steps that define a classic movie story structure have been widely adopted in modern cinema.

1 – Ordinary world
The hero's normal world before the story starts.

2 – Call to adventure
First encounter with someone or something that requires the hero to leave his world.

3 – Refusal of the call
The hero refuses the call, prefers to stay put.

4 – Meeting with the mentor
Hero interacts with a mentor figure – not necessarily a wise old person.

5 – The first threshold
The hero heeds the call to adventure and leaves his world. Now the story starts properly.

6 – Tests, allies and enemies
The hero is out of all comfort zones and must decide who — if any — to trust.

7 – The approach to the innermost cave
Before tackling the central ordeal, the hero engages in reconnaissance and training.

8 – The ordeal
The hero is put through a life-and-death situation, literally or figuratively, that will generally identify his character flaw and force a change.

9 – The reward
Having scraped past death, the hero is changed and rewarded with a festive or a romantic interlude.

10 – Not yet the road home
Just when things seemed comfortable, the hero gets a reminder that the job is not yet done.

Step 11 – Resurrection
The story reaches its life-or-death climax and the hero proves he has changed for good.

Step 12 – Sharing the elixir
After the hero has overcome all enemies, the wider tribe, family or friends get to share the spoils of his efforts and the hero's journey is completed.

THE HERO'S JOURNEY

12. Sharing the elixir | 1. Ordinary world

11. Resurrection

2. Call to adventure

Act 3 about 25 pages | Act 1 about 30 pages

3. Refusal of the call

4. Meeting with the mentor

10 Not yet the road home

Act 2 about 60 pages

5. The first threshold

6. Tests, allies and enemies

9. The reward

7. The approach to the innermost cave

8. The ordeal

example, a boss character may force your hero to work extra hours and stop him or her from reaching a particular goal.

Arcs

Character arcs – how a character changes over the course of the story – are what form the backbone of your story. Closely related are the story arcs (see page 122); these vary thematically, from the 'redemption arc' where a character changes from bad to good to the 'disillusionment arc' where the character's whole world view changes from good to bad over the course of the story. Based on Joseph Campbell's *The Hero with a Thousand Faces*, Christopher Vogler's book *The Writer's Journey* examines these arcs in greater detail (see box).

Conflict, tension, suspense

Every story has conflict – a conflict that a character must face and overcome or be defeated by. It can be anything from a physical fight to a psychological quandary. Let's look at a few techniques for maintaining tension and suspense in your story.

Conflict can be large-scale and obvious (battling the elements in a disaster movie or fighting to save the world from an alien invasion) or much smaller (getting the right drink from an errant coffee machine at work). Conflict can be against an external aggressor (man, beast, nature, governments, corporations or aliens) or an internal fight within the mind of the protagonist (a moral dilemma). Genre conventions (see page 124) will place limits on the main type of conflict that can be in your story. For example, in a love story the main conflict will revolve around the relationship between the two main characters – will they or won't they fall in love, settle, get married? This type of conflict and the tension it creates – the underlying theme – must last for the whole story.

Engage the audience

Character and story arcs (see pages 122–5) are designed to introduce conflict to drive your story onwards and force audiences to think about the situations in which you have placed your protagonist. How would they react under the same circumstances or if put under the same pressure? Getting your audience to connect with your characters and empathize with them is key to increasing tension.

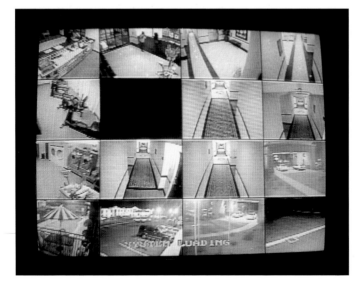

Left: *Andrea Arnold's film* Red Road *uses CCTV camera to great effect to create suspense and a creeping sense of dread. The ultra-low-budget film went on win the Grand Jury Prize at the Cannes Film Festival in 2006.*

Right: Tension can be anywhere: a
life-changing decision to be made,
an argument, a tragic loss or losing
a bet. The possibilities are endless.

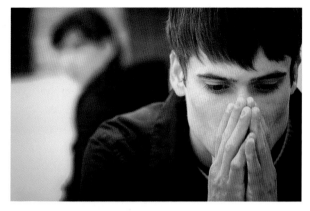

Escalating conflict

Conflict and tension need to
build progressively throughout
the story to maintain the
audience's interest. As the
protagonist tries to overcome
the first challenge, but then
fails or only just succeeds, the
forces against him must be
increased and so, too, must
his effort – but so too must
the risk of failure. But just like
the popular game show *Who
Wants to Be a Millionaire?*,
as you get closer to the final
prize the questions get harder and the risk of
failure becomes greater. Your protagonist can
phone a friend, but he must press on for the
main prize – it's all or nothing.

Above: Conflict as expressed in its most physical
form – a gun battle, as pictured here in Paul
Greengrass's IRA film Bloody Sunday.

No return

By increasing the risk, you increase the
conflict – and this, in turn, will increase the
audience's tension, as they desperately
want to find out what will happen next. As
the story and the conflict build, you cannot
now diminish the level of risk or conflict –
otherwise the audience will notice and their
attention may start to wander. You can have
brief interludes of calm after resolving each
rising conflict, otherwise your audience will be
a complete mess, but you can only go forward
by raising the stakes. Like a fantasy movie
or 'shoot 'em up' game where the monsters
keep getting bigger and harder to kill, your
conflicts and tensions must get more difficult.
Your character must work harder to overcome
each stage or there must be more at stake,
otherwise your audience will switch off.

Finally your audience is dragged along
to the climax of the story, either cheering or
crying at the outcome – that is, unless you
want to end with a cliffhanger that will let
audiences make up their own mind about
what happens next and possibly remember
the film for a lot longer.

Scriptwriting basics

The layout of a movie script is formalized in order to make it easier to be read and visualized by those whose job it is to select scripts for production. Many people love watching films, but very few have read an actual movie script before – so let's look at some of the formalities.

A script separates the action of the character from the dialogue and breaks down each location into a scene to make it easier to further break it down into a shooting script for production (see page 132). The basic formalities include starting the script with a **FADE IN** and ending with a **FADE OUT**. Each scene is listed with the scene number in the left column and then the scene heading, which shows whether it's an interior (**INT.**) or exterior (**EXT.**) shot, followed by the location and time of day (**DAY, NIGHT, DUSK, DAWN**) in capitals and in Courier 12pt font. This is an old convention going back to when scripts were written on typewriters. Sticking to this convention means that each page of typed script roughly equates to one minute of screen time. Once you know this, you know that a 15-page script will be about 15 minutes in film time.

After the scene heading is a brief description of the scene itself, indented with the heading, followed by the dialogue. Any character's names or specific props introduced for the first time are labelled in capital letters, along with the age and additional information about the character. Here's a basic example without dialogue:

```
1  EXT.  BEACH — DAY.

   The sun is high in the sky, casting harsh shadows. The
   beach is full of sunbathers and surfers bob about in
   the waves.

   MARK JONES (20s, surfer, long hair, tanned and lean)
   walks into shot carrying a SURFBOARD. He heads towards
   the sea.
```

All the script action should be written in the present tense as if it's happening right then and there. So write 'a door opens' rather than 'a door is opened' or 'the door is opening'. Avoid adding production information such as camera angles since the director will do this later (see page 132).

Dialogue

When adding dialogue, the format is to show the character's name in capitals (centred) before they speak. You can use their actual name although if it's a small part, they may just be described as **GIRL** or by their occupation (**SURFER #1**). Dialogue is

```
                    MARK
              (laughs)
         That last ride was pretty sweet!

    Mark shakes his hair out of his eyes, gets back on his
    board and paddles out again. SURFER #1 catches a large
    wave in.

                  MARK (CONT'D)
            Woohoo! Great wave mate!
```

formatted with indentation both left and right, so there is less per line. Extra information about the speech is added in parentheses – (grins), (smiles), etc. – although this is only used if absolutely necessary.

(CONT'D) is used to show that the same character continues speaking throughout the action. You can add a pause between spoken

parts using (**beat**) to represent a gap. Other conventions include adding (**O.S.**) or (**O.C.**) next to the character's name to show they are off screen or off camera, or using (**V.O.**) to indicate that the dialogue is a voiceover.

Will it get read?

Most movie scripts are between 95 and 120 pages long. If your script is full of action it might be shorter, as it takes less time to describe the action than it takes to shoot it. If it's too long it may never get read due to the cost of making such a film, so consider carefully what scenes could be cut before you submit a mammoth script.

Software

There are many more formatting rules to consider, including page numbering and page breaks. If your script is in the wrong format with incorrect spacing and layout, it may also not be read. It's wise to use software such as Final Draft or Movie Magic Screenwriter to do the formal layout for you; these programs can keep track of character and location names and let you concentrate on the story.

Learn from the great

The best way to teach yourself screenwriting is to read as many (great) scripts as you can get your hands on. In the run-up to the Oscars, the big studios put the scripts to their Oscar-nominated films online to stir up publicity, and it is always interesting to read the most highly rated in international screenwriting. There are quite a few sites where you can find thousands of free scripts to download. Here are just a few:

www.simplyscripts.com
www.script-o-rama.com
www.simplyscripts.com

Hollywood screenwriter John August's personal site also is full of very useful stuff:
johnaugust.com/downloads

Before the **shoot**

Once you have your script nearly ready to go and a vision as to how you want to make it, as well as how long and what genre, you can start thinking about the practicalities of how to turn your vision into reality. And as with most things in film, this needs a lot of planning.

Once you are ready to go with your film project, you need to set a production date in order to prepare anyone who might be involved with it. These can be friends, owners of an apartment you might want to use as a location, or even a proper camera crew if your budget allows for it. Obviously you must leave enough time for the pre-production phase to be completed before shooting can start, although many screenplays will still be unfinished at this stage. Your start dates will depend on the availability of cast members or locations, or may be delayed if you want to wait for a specific time of year. Sometimes your date is determined by an event you may want to film, so you will have to be ready, come what may.

Before the film comes a script

Most movies will need a shooting script. Even documentaries or a completely ad-lib production will need one, as it contains more than just dialogue. As you have seen in the last few pages, story development and scriptwriting have a language and toolset of their own to allow you to progress from an initial idea to a shooting script, shot list and storyboard (see page 133). The working script provides information on locations, actors, costumes, visual effects, stunt people, extras and props that need to be sourced, booked or hired in advance of any planned shooting dates. Sets need to be built or sourced,

insurance needs to be organized, caterers and accommodation booked, camera and lighting gear needs to be decided upon, workflows tested and key crew members hired. All this planning and organizing comes under pre-production – sorting out all the detail in advance so that filming can go smoothly.

Scalability

For zero or micro budget productions with very small crews, the amount of pre-production may be restricted to casting your actors, organizing costumes and make-up, and getting permissions for location shoots. However, you might still need to follow the full process and create the same paperwork for call sheets (see page 147) and plan the logistics of catering, transport and security – but all on a smaller scale.

Above: *Make sure all your costumes are in order. Take changes with you, as the costumes you have envisaged may not look right on camera.*

For very small video productions such as interviews, promos or event filming with one- or two-person film crews, you can skip a lot of the pre-production phase. In these cases pre-production can be condensed into basic common-sense rules, such as having enough cash on you to buy lunch or having spare media or bulbs for your lighting kit. You may, however, still need to work on a script with your client and get it signed off before you start.

There will always be logistical elements to be considered on any shoot and the more organized you are, the less likely you'll be to forget something important — such as where you're meant to meet your client or who to call for access to a location or building.

In the run-up to filming, hold regular meetings with all the key people involved. If it's a commercial video, make sure your clients are on board. If it's a drama project, work with your producers and heads of department, never without them.

Above: *A rehearsed script read-through is a useful way of finding flaws and weaknesses in the script, as well as getting the actors' perspective on it.*

Shot lists

Even if you work without a proper script due to time restrictions or the small scale of your project, it is still always an excellent idea to at least have a shot list to work from.

Think through the video or film you are setting out to create — if it is a documentary or corporate film this is especially relevant — and try to work out basic story lines. This will then naturally lead to the kinds of visuals you will need, without which the film might just not work. These are the shots that you have to put into your shot list, as otherwise you will often be disappointed when it comes to editing, and you realize you are missing a crucial shot of your key subject. Don't worry about different angles here — a simple breakdown of subjects is more than enough; the angles will come during the shoot.

Planning and scheduling

Once your screenplay has been written or the rights have been acquired to use an existing script, it can be modified to create a shooting script, shot list and production schedule.

One of the director's first jobs is to break the final script down into each physical shot (a shot list) and turn the script into a shooting script as an aid to the cast and crew. The shooting script is essentially the original script with extra details written on, such as annotations of shot numbers and thumbnail sketches that the director and DOP (director of photography) need for filming. Cast members will be able to see from the shooting script how long each take will be by looking at the length of the dialogue or the amount of action described.

Breakdown

Extra information can be added to the scene headings to show whether shots are establishing shots, stock footage or visual

Above: *Make sure you develop all your shots with your DOP as his or her experience will throw up ideas you wouldn't even think of.*

effects. The types of shots are also listed, such as a 'two-shot', 'long shot' or 'close-up' (see page 86). Additional information on how each shot will be filmed – for example, crane shot, jib or panning shot – can be added as well. At this stage of the planning process script breakdown sheets will be created, in which all the shots are broken down into their component parts, identifying in detail what is required in terms of equipment, locations, props, stunts, extras, vehicles, wardrobe, animals and actors. The shot list itself is more of a summary of the detailed breakdown, but still usually includes the scene and shot number, location, actors, duration, camera equipment, shot type and camera movement, as well as the actors required on set for that particular shot.

The camera movements and action in each shot can be pre-planned at this stage – sometimes in intricate detail if the director has a specific vision. Some people, however, may wait until after the blocking phase (see page 156) before finalizing all the action. If locations have already been chosen and are accessible, it's possible to pre-plan exact camera moves and camera angles *in situ*. The shot breakdown usually involves creating a drawn storyboard for each shot (see box) as an aid to production. Software-based storyboarding can be a real bonus here; you can play around with different views to get the look you want before arriving on set, thus saving time and money.

Storyboarding

From hand-drawn stick figures to lush graphic novel-style animation or computer-generated images, a storyboard can be as good-looking as you need (or can afford) it to be in order to visualize the action. A storyboard looks like a comic strip, showing each scene, shot by shot, often with arrows indicating the movement of the camera and the characters, and it is aligned with the shooting script's scene numbering. The director and DOP will work through the storyboard to look for potential problems such as 'crossing the line' (see page 160) or to work out how to shoot seemingly impossible shots.

You may be able to create your storyboard by just drawing small images on the shooting script or by using a more classical storyboard template for each shot. The storyboard sheet contains a few images and additional notes on camera moves, shot action and dialogue to allow the timing to be easily seen. Alternatively, you could use purpose-built storyboarding software such as Frameforge Previz Studio). This has built-in characters, props and locations to help you build the storyboard electronically – pre-visualizing each shot in depth with lens characteristics, depth of field and even lighting.

You could also use video editing software to build your own animatic from a series of drawn and scanned images and add zooms or pans to simulate the movements, or use built-in functions of the storyboarding software to create your movie. These 'technical pre-visualization' movies are often used to help pitch a film before all funding is secured or to help you work out if a series of shots will work.

Below: Part of the storyboard for Magic Boys, *starring Michael Madsen and Vinnie Jones.*

53. David and Zoli encounter Varga...

54. Splendid Ben screeches to a halt in his beat-up Lada

55. David spots Terence in the corner of his eye.

56. Varga charges and Natasha helps him.

57. Terence steps out from behind the tree.

58. Terence and Varga begin their confrontation

59. Varga tries to hold Terence's attention as...

60. ...Natasha pulls her gun and stops Terence.

58. David and Zoli realize it's time to go....and scarper!

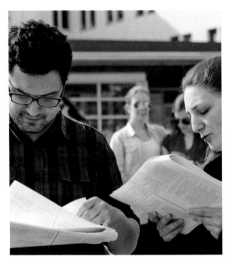

Above: *If your project is a big production and you have a dedicated script supervisor, try to spend as much time as possible with that person when breaking down and scheduling the script in order to benefit from his or her experience.*

Shooting styles

The director will use the shot list to gauge the minimum coverage required for the edit. By shooting the master shot and all the dialogue scenes as over-the-shoulder or close-up shots and then moving on to the more complicated shots, he or she can guarantee the scene is covered before running out of time. Some directors shoot the complicated shots first and then rush to get the coverage afterwards. Some may decide not to shoot a full master shot and shoot perhaps the start and end of the master and rely on the close-ups to provide enough coverage (although this is more risky and needs good script supervision [see page 174] to ensure enough coverage really has been shot).

Whether you use breakdown sheets, shot lists, storyboards or just an annotated copy of the shooting script will depend on the complexity of your project.

Scheduling

Most films are shot out of sequence. Once the shot list has been created, the next step is for the director and production department to arrange the order in which to film the shots, making best use of location time, crew, actors and equipment to fit the budget. Actors may come in for just a few days to film all their scenes, or locations may only be available for specific dates, so proper scheduling is very important to keep a film on time and budget.

It is an iterative process to work out how many shooting days you need, as you may have to tweak shot locations to reduce the number of camera set-up changes in order to keep within your budget. An independent film generally shoots between six and nine pages a day (or more).

The director is responsible for delivering the required amount of completed scenes and must agree with the producer how this can be achieved. It's best to work this all out in pre-production rather than run out of money part way through your shoot.

The director and 1st AD and/or production manager then works on the production schedule with the producer to ensure that enough filming is done each day and that the production budget covers all the shots required. They may create a physical 'production board' containing colour-coded information about each scene, or use scheduling software or spreadsheets to arrange and re-arrange the order of filming each shot within the production schedule. The 1st and 2nd ADs then work out the casting schedule to match and create prop lists, wardrobe lists and location lists. Scheduling software really does come into its own here, as there are many variables and many changes may be required throughout shooting due to unforeseen circumstances.

SCRIPT BREAKDOWN SHEET

Title: **Magic Boys** Director: **Robert Koltai**

Production No.: **005** Scene(s) No.: **73** No. of Page: **92**

Day or Night: **18 night, 55 day** Season: **Summer** Period: **present**

Synopsis: **Two hapless Hungarian factory workers accidentally witness a murder and become male strippers to evade the mob that goes after them.**

Location: **Budapest, Hungary, and London, UK**

Cast: **Michael Madsen, Vinnie Jones, Jamelia Davies, Csaba Pindroch, Gyözö Szabo, Kátya Tompos, Tamer Hassan, Robert Koltau**

Props: **2 guns, 1 Lada, fox-tail for Csaba's keyring, 8-ball for pool game**

Extras: **20 - 25 bikini girls for pool scene, 10 passers-by in Trafalgar Square, 3 couples and 1 small family in hotel scene with Michael**

Set Dressing: **For attn. of set-design Chris. Specially big ballroom scene with dancers and opera singer**

Vehicles: **Old Lada, Vinnie's 70s-style Mercedes, limousine for Michael**

Make-up: **6 weeks, 5 main leads, extras. Talk to Lorraine about details.**

Special Effects: **Night scenes on motorbike**

Special Equipment: **Crane for quarry scene**

Costumes and Wardrobe: **6 weeks, 5 main leads, extras. Talk to Hayley about details. Need also childhood scene with Jamelia**

Miscelleneous: **We need a bear plus bear handler for Jamelia scene**

Money! Money! Money!

They say if you don't ask you don't get, and this is especially true when it comes to sourcing funding for your film. Unless you're paying from your own pocket or getting stuff for free, you will need to find money from somewhere.

Raising money

One of the first places you might try for a loan is the Bank of Mum and Dad. It's best to do this a bit more officially than just borrowing the odd 10 or 20 quid to tide you over. Work out your financial budget and your plan for making the money back before approaching family or friends to invest in your 'sure thing' film project. Be realistic about the likelihood of your film ever breaking even and don't set expectations too high. Family and friends are investing in your career and, if unable to help financially, may be able to contribute in other ways – perhaps helping with the catering, building sets, making costumes or doing make-up. Alternatively, you could try your bank manager, although you will be better off with a fundraising specialist such as a professional producer, as long as your script is good enough.

Free stuff

Try getting some sponsorship from business, both local and national companies. They probably won't give you cash, but they may offer branded goods that can be used for costumes, props, character vehicles or set dressing. You will need to pitch your film idea but, if you have a good script and a good plan, you may find it easier than you think to get a little help from this sector. Approach food and drinks brands for props that can be used for free (or to supplement the cast and crew catering) or ask them to pay specifically for product placement in the film.

Above: Try to convince camera manufacturers to lend you their new products for testing – it will save you hiring some of your kit.

Above: The Greatest Movie Ever Sold *is a 2011 documentary about product placement and advertising in movies and TV shows, directed by Morgan Spurlock.*

Crowd funding

Sites like indiegogo.com or indiemaverick.net provide crowd-funding or crowd-sourcing opportunities for films, amongst other start-up business ideas. This type of site raises money from the general public to fund your film. You enter the specific amount you need to raise and offer different levels of incentives for different amounts of cash – like tickets to the film première or a copy of the DVD, or maybe your investor could be an extra in the film, spend a day on set watching the filming process or have a mention in the credits. You decide how much each of these is worth and offer them as tiered levels of 'investment'. Look at examples of projects that did well on these sites to see what they offer. If you raise your target in the set time limit, you should get the money. If you nearly raise it but not quite, you don't get any of it.

The third sector

The third sector means charities, foundations and quasi government agencies that have funding that can be put towards specific projects – usually documentaries that highlight the cause they are associated with, but which could be related directly to your film script – if the project is linked to a particular disease or topic. You will have lots of hoops to jump through to secure funding, but it should be free of strings and they won't expect so much in return (except to see the film).

Competitions

For short films there are film competitions to enter, some of which guarantee decent cash prizes and exposure in front of distinguished panels of judges. They might even offer to fund a feature film if your short wins. Try places like filmaka.com or enterthepitch. com, or go direct to brands that are looking for cheap (possibly exploitational – you decide) ways of getting ideas for new product advertising from up-and-coming talent.

Left: The Cannes Film Festival has an out-of-competition short film corner for new filmmakers. It costs only $65 and includes a free festival pass – and you can claim your film was 'screened at Cannes'. The festival is the ideal place to raise finance.

Above: Unlike other crowd-funding sites, Indiegogo lets you keep all the funds you have raised, even if you haven't reached your target.

Above: The makers of the 12-minute short film The Barber raised over $2000 on Kickstarter, the biggest international crowd-funding website.

Casting

Casting your film needn't be a nerve-wracking business if you follow simple common-sense rules. Remember that you are just as much 'on show' as your talent is – so be organized and make a good impression.

There are many websites where you can advertise your 'casting call'; the website will then send out regular bulletins to their members (the 'talent'). Make sure the information you provide up front is very clear, to avoid being inundated with responses that do not fit your needs (see box). It's professional to acknowledge receipt of all enquiries (even those who clearly have not read your requirements). Get organized early and separate the 'match' from the 'do not match', then start by looking at online show reels, photos, audio reels and experience before drawing up a shortlist. If your shooting dates are subject to outside influences such as last-minute availability of a location, camera or crew, you will need to be flexible on casting to ensure that you have enough back-up in case an actor drops out at the last minute.

Set up your sessions

Once you have a shortlist, it's best to set up casting sessions to meet prospective actors and actresses rather than just rely on the show reels. That way you will also be able to judge if you can work together. It's useful to get potential lead characters together to see if the required chemistry is there, too. You may want to send out a copy of part of the script, or ask your actors to bring something they are familiar with to perform.

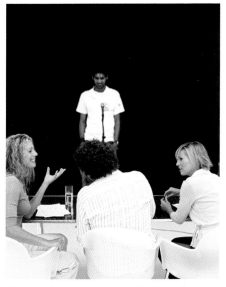

Above: Relax your actors and don't discuss their merits and weaknesses in front of them, even if you think they're perfect – wait until you're sure.

On the day

Whether you do one or multiple casting days depends on the number of roles you're casting for. Ensure you have supplied information on how to find and contact you on the casting days to minimize delays. Try to separate the waiting area from the main casting area to give everyone some privacy. Ideally, offer refreshments and changing/toilet facilities (you may need to hire some cheap space for the day). Stagger the call times into 30-minute slots and make sure you stick to your schedule to avoid anyone having to hang around too long. It's best to record the casting sessions so that you can remember who's who at the end of a long casting day.

Left: Organize your casting into small groups to avoid queues and long waiting times, which can be disheartening for actors.

Casting information

Some websites may have mandatory information fields, but make sure you include the following information when posting a casting call:

- **Be explicit about the person required:** if experience is necessary or not (how complex the role is), gender, age range, any specific traits such as hair/eye colour, build, height or ethnic background.
- **Type of role:** describe the role in the script and give some background on the type of film you're casting for, including the genre and duration of the film.
- **Duration of role:** how long the shoot will be and any specific dates or date ranges.
- **Location:** where you will be shooting and whether you will pay travel expenses.
- **Wages:** whether the role is paid or unpaid, or varies based on experience, or is based on a union rate or not.
- **Extras:** if you cannot pay a wage you may offer other incentives for someone starting out, such as a DVD of the finished film or graded footage to use on a show reel.
- **Information about the production:** the overall budget, whether you have insurance coverage, the type of production (professional or student film), what you expect to do with the film (festival circuit or a specific use like an advertisement).

Above: If you're auditioning children, keep the atmosphere relaxed so that it feels more like a fun game.

Art, make-up and wardrobe

You may think you only need crew for lights, camera and sound, but lots more goes on in the background to put the finishing touches to a film. Actors need to look 'in character' with the right clothes and hair, and set designs must reflect the director's vision.

Art

The art department works with the production designer, who is responsible for designing the overall 'look' of a film (although sometimes the department works on its own on smaller shorts). The art department is involved in coordinating the building and decorating of sets and 'set dressing'. You may find them running around with a can of dulling spray trying to remove any shiny bits of set that catch the lights, painting stuff for future scenes, or making sets look as lived-in or as pristine as the overall art direction requires. The production designer will be heavily involved in the pre-production phase and work with the director, DOP and producer to help create the artistic vision of the director.

Make-up and hair

From dusting down a shiny head to full-on prosthetic face changes, the make-up department can transform an everyday face into that of a glamorous movie star. Hair and make-up usually work together to get the required 'look', whether its '70s glam rock or something much more subtle and natural-looking. Basic make-up skills will be enough to cover up spots and blemishes or de-shine noses, but experience and research will be needed to create period looks, horror make-up or to reflect the director's precise vision for the film.

The director or production designer may need to reference other films or photos or create artworks in order to communicate their requirements; otherwise you will have to go for a trial-and-error approach. Continuity is key when shooting out-of-sequence scenes to ensure that hair and make-up match up, especially if there are long gaps in shooting. Your shot breakdown sheet (see page 135) will indicate what the hair and make-up should be, so take plenty of high-res stills photos for reference.

Left: If you're planning to shoot a period piece, be aware that the make-up will often need the skilled attention of a trained make-up artist or enthusiast, who will know exactly what's needed.

Left: *Once your set has been decided on and designed, careful continuity will become paramount if your shot of this scene extends over a few set-ups or even a few days – otherwise you might lose track of props and dressing used in previous takes.*

Wardrobe

Always on set with the de-fluffer roller – getting rid of any stray hairs – the wardrobe department works tirelessly to keep your actors looking 'in character' and to match the production designer or director's requirements. Whether designing and sewing costumes from scratch, altering outfits to fit different-sized extras, washing or ironing or dyeing costumes, they are constantly busy.

Remember that if you cast actors very late in the process, the wardrobe department may have trouble altering or making costumes to fit in time. The actors themselves can supply everyday clothing such as jeans and T-shirts, but the continuity of wardrobe is still important from shot to shot when filming out of sequence. You may also need multiple copies of some of the costumes to allow you to do more than one take – especially if some get ruined due to make-up (blood, gore), the location (dirt, grass stains) or action (fighting, torn clothing).

Props

On small productions the art department will deal with props, but they are normally handled by the property manager/master and, as they are special items, they will be listed in the shot breakdown sheets. Although essentially part of the set dressing, props such as a teapot or crucifix also interact with a character in a special way – they are picked up or used and moved from one part of set to another. Props can break, too, so it's a good idea to have plenty of duplicates or be able to source more, otherwise your scene continuity could be ruined.

Above and left: *Sourcing props and costumes can be a lot of fun, but also time-consuming. If you want to be as authentic as possible consider using a costume and props person, who can also deal with issues like licences for replica guns.*

Location and insurance

Choosing the best location for your scene can be tricky if you haven't written with a particular place in mind. Then there's the issue of payment. Here are some tips on finding locations and keeping costs down.

Above: *The Hawaian island of Kauai has been used as a 'tropical' location in films like* Jurassic Park, Raiders of the Lost Ark *and* Lilo & Stitch, *amongst others.*

One aspect of the pre-production phase is location scouting – finding ideal locations to fit your script. You may have started out with a specific place in mind, but not secured access within your budget, or you might be open to a location that offers more filming flexibility over looks. Location scouts usually have a database of special locations within their own country or geographic region, including 'film-friendly' places and really scenic locations that are accessible enough to film in. Location managers will help find and then negotiate location access on your behalf. They will generally liaise with the location owners for any extra services or facilities that need supplying or fixing along the way, such as electricity, water and accommodation.

Production insurance

Projects of any size require third-party liability insurance cover in the event of property damage or personal injury. The producer will be liable if this is not in place, so it's well worth buying a per-production or annual policy. If you are employing staff or crew you will need employer liability cover, too, in case of injury or death to your employees while at work. A more comprehensive production policy might cover costs incurred in the event of injury or illness to named cast members (non-appearance cover); media loss cover in the event of theft or destruction of your original media (tapes, hard drives, film, and so on); technical equipment cover for damage or theft and cover for on-going hire charges in the event of you having to replace broken or stolen equipment, either hired-in or owned by the production. You can also get cover for damage or theft of props, sets, wardrobe, vehicles and production-office equipment. A full producer's indemnity policy will cover costs if filming is postponed or stopped as a result of a major event such as theft or damage to any part of the production equipment.

Fees and charges

You may need to choose locations where you can get free or very cheap access. For example, maybe a hotel is undergoing a refurbishment but their garden is available as they cannot use it for paying guests. There are many reasons you could get special rates. Some owners are happy with a donation to a charity instead of a location fee, but most locations will charge based on the scale of the production and how the filming might impact on the local area (extra noise, traffic or bystanders, etc). Price is always a negotiating point, so don't be afraid to ask for discounts.

Below: With cheaper production costs and great tax incentives, the Canadian city of Vancouver has stood in for dozens of North American cities like New York, Chicago and Philadelphia, in films as diverse as Juno, X-Men: The Last Stand *or the US TV series* The Killing.

Location release

You may be surprised how many bits of land, rocks and beaches are privately owned. All private locations need a signed location release or location agreement form giving you permission to use the location. The form will generally grant you access to the location for specific times and dates and will form a contract for any location fee. The release form will also give you full rights and permission to use the video recording that contains the location for any future means. This is a very similar type of agreement to a model release form used to secure full rights for using the video likeness of anyone appearing in your film – actors, extras or perhaps interviewees in a news or documentary film.

Music and licensing

Music can add so much to a film – increasing dramatic tension and suspense or changing the mood. Whether you can afford a complete orchestral score or just a recording of your mate on his guitar, check who owns the copyright – even for a dodgy rendition of *Stairway to Heaven*.

G enre conventions (see page 80) will dictate the sort of background music people will expect to hear. It's worth researching your genre not just for story but for musical influences, too. Film directors such as Quentin Tarantino have made music part of their style, using their favourite tracks to underscore the action and to time scenes in the edit. Music can be 'practical music' – music that is played in a scene on a radio or jukebox or at a 'live' gig – or it can be completely incidental and used just for dramatic effect.

Copyrighted music

Negotiating the rights to use well-known music in a film isn't always difficult, but it usually comes down to cost. Essentially, you need to find out who owns the master rights to the music recording (mechanical recording rights or publishing rights), as well as who owns the copyright to the actual music and song (synchronization rights). Copyright is usually owned by the artist or composer, but may have been assigned to someone else.

Clearing rights

Start by looking on a music CD or online for the publisher and copyright owner of a track – denoted by P & C or P & ©. Identify the record label and who might have then bought out the rights later (if it's an older piece) and contact them. They may need to contact the artist's estate, too, to get clearance for your film. The track may have been pre-cleared for certain types of use and be available from licensing organizations like PRS/MCPS in the UK or ASCAP in the USA.

Left: The best way to realize your musical vision for your film is to commission a dedicated film-score composer to create it for you. This doesn't have to cost much – or in fact any – money if you ask an enthusiastic and technically versed music student who is keen to work for expenses and a credit on the international movie database IMDb.com.

Above: The licensing sites www.prsformusic.com and www.ascap.com will help you obtain music licences.

How much to pay

Music licensing costs can be as much as 15% of the whole film's budget – or may even exceed it. The record company may offer a flat fee for the full track use or for, say, 30 seconds of use, or prefer to work out rates based on the type of film you're making and the territories you're distributing it into. It's impossible to tell until you try, so you really need to clear permission before setting your heart or your edit on one specific piece. Try not to use copyrighted music in your edit before you know you can obtain the rights to it, as it will be harder for you to accept alternative, original music afterwards.

ℹ **Low-cost film music**

Even if your film is only heading for the internet or a few film festivals, it's still unlikely that record companies will let you have music that's cheap enough to use. But the internet has changed the way some things work (for the better) and companies such as Rumblefish have pre-cleared music lists for social media sites such as YouTube and Vimeo, allowing you to use a wide range of music tracks on a pay-per-track basis. Another alternative is to get a score written – not always as expensive as it sounds, as composers have to start somewhere and may want to collaborate on your film. You can also try royalty-free 'buy-out' music – pre-cleared music especially composed for use in films. You pay once and use it as required, online or in theatres worldwide. Some companies provide music that can sound similar to well-known music, usually with no lyrics, and their websites have searchable databases to help you find music and sound effects easily.

Above: If you record a local band, you still need to secure copyright for their songs.

Right and above right: Recording out-of-copyright music can be a cheap way to create a great classical score. Musical copyright in the UK expires 70 years after the end of the calendar year in which the composer died.

Preparing **the set**

Getting ready to film involves planning and paperwork. The call sheet contains the day's schedule for cast and crew, but other important arrangements need to be made too, such as catering and transport.

Equipment and people do not miraculously arrive on set, on time. You need to plan ahead. Usually runners are employed *because* they have a car and are able to take cast to and from train stations, hotels or airports or ferry people and stuff to and from set to unit base. Lighting, grips and cameras normally need dedicated transport (vans of some kind) and secure storage for equipment when they're not in use. The more locations and the further afield they are, the harder the transport logistics can become, and possibly the shorter the filming days, too.

Catering for everyone

They say an army marches on its stomach – so will your cast and crew. The only memory some people have of a particular film production (and therefore the producer, director or production company) is how good or bad the catering was.

Feed people properly and they might not moan too much about other logistical problems or delays. Feed them badly with poor quality and/ or not enough food and you can be sure of problems. Catering need not cost the earth, but it should be varied and nutritious and be able to offer vegetarian and vegan options, cope with food allergies such as gluten or wheat intolerance, and serve decaffeinated drinks. Feedback needs to be taken seriously so that dishes that go down badly are not repeated. If you wouldn't eat it at home, then you probably won't want to eat it on set either.

Scheduled stops

A daily film shoot will include breakfast, lunch and dinner, with drinks and snacks too – especially if the crew has to work late. Catering needs to be factored into the schedule to ensure that there are adequate breaks and enough time for cast and crew to travel back to unit base or to get food and drinks brought to set if it's a location shoot. If you bring in outside caterers, they may 'live in' in their mobile kitchen truck, cooking up meals on set or boxing up food to be driven into less accessible locations. Or you could make arrangements with local restaurants or hotels to do the catering in specific locations – usually whichever is cheaper.

Left: Good caterers often leave a little something out for the crew to grab a quick snack or drink on the go.

CALL SHEETS

The production office will create daily call sheets, showing the times to set, make-up and wardrobe for cast and call times for crew. Usually created by the 2nd AD and production manager, the call sheets will include the crew contact details (phone numbers and roles), main location addresses with contact details, and the unit base address where meals will be available. The call sheet is the main schedule for each day and will include information on the scenes to be shot, locations, and the cast needed for each shot. The travel logistics will be included, with details on drivers and parking, plus information such as the closest hospital, on-set first aider contacts, sunrise and sunset times, tide times if relevant and weather forecast details, too.

Call sheets for the *next* day are normally distributed just before wrapping for the day and allow people to see where they need to be in advance. As many people now have smartphones, it's usual to send call sheets via email as well as handing out paper copies.

Scheduled

Magic Boys --- BUDAPEST - GG-36
SHOOT WEEK #9
5 days version
Working Hours = 06:00 - 18:00

#	INT/EXT	Location	Time	Pgs	Time	Cast	Description	Loc
78	EXT	SZEGED PRIVATE AIRPORT	Morning	6/8 pgs	1:15	12,13	Vilzer and Árpád are watching the missed airplane.	Dunakeszi Airport
							company move back to the studio	
155C	INT	WARDROBE ROOM CORNMILL THEATRE, LONDON	NIGHT	2/8 pgs	:15	1	Very close on yards of fabric draped all around as it flies through the eye of a sewing ma	Fót, Costume Store
162A	INT	WARDROBE ROOM CORNMILL THEATRE, LONDON	NIGHT	1/8 pgs	:20	1	David charges along a corridor. He spots an ornamental sword on the wall. He grabs	Fót, Costume Store
							lunch break 12:00 - 13:00	
A132	INT	TERENCE'S OFFICE, LONDON	DAY	3/8 pgs	:20	6	Bad News sits at a little desk next to Terence's huge desk	Fót, Mániszy Studió
180B	INT	TERENCE'S OFFICE, LONDON	DAY	3/8 pgs	:30	6	BNB is on the phone with Terence... He shakes it. Something rattles. He opens the tub	Fót, Mániszy Studió
184	INT	TERENCE'S OFFICE, LONDON	DAY	1/8 pgs	:15	6	Bad News Brown laughs as he hangs up.	Fót, Mániszy Studió
155B	INT	STAGE, CORNMILL THEATRE, LONDON	NIGHT	1/8 pgs	:05	6	A hand slips the envelope under the place cards. We see it is Bad News.	Fót, Mániszy Studió
							15:30 - 18:00 REHEARSAL OF THE NEW "FILTER ROOM SEQUENCE"	
							ROBI has to leave for the Theatre Performance at 18:00	
							INSERTS	
12	INT	CORINTHIA HOTEL, TERENCE'S SUITE	NIGHT	1/8 pgs	:05		INSERT: Ashtray, joint, hands holding lips sucking joint, DOUBLES	
35A	INT	SZEGED, ANNA SPA BATH, LOCKER AREA	NIGHT	1/8 pgs	:10		INSERT of letter Varga is writing. The Magic Boys are engaged by Terence Anderson (
157AA	INT	STAGE, CORNMILL THEATRE, LONDON	NIGHT	1/8 pgs	:05		INSERT: A handwritten note and a copy of an old newspaper article. Hand Double for	Fót, Mániszy Studió
							End of Day # 37. -- Sunday, September 5, 2010 -- 2 4/8pgs -- 3:20 min	
							Working Hours = 07:00 - 19:00	
157A	INT	CORNMILL THEATRE, FILTER ROOM - LONDON	NIGHT	3/8 pgs	1:00	5	Cherry stands in the middle of the room, panting. She is preparing her act.	Fót, Mániszy Studió
166pt1	INT	CORNMILL THEATRE, FILTER ROOM - LONDON	NIGHT	1 4/8 pgs	2:00	1,3,4,5	THE NEW FILTER ROOM SEQUENCE	Fót, Mániszy Studió
							lunch break 13:00 - 14:00	
							End of Day # 38. -- Monday, September 6, 2010 -- 1 7/8pgs -- 3:00 min	
							Working Hours = 07:00 - 19:00	
166pt2	INT	CORNMILL THEATRE, FILTER ROOM - LONDON	NIGHT	2 pgs	2:30	1,3,4,5	THE NEW FILTER ROOM SEQUENCE	Fót, Mániszy Studió
							lunch break 13:00 - 14:00	
							Time Permitted	
175pt	INT	BACK STAGE CORNMILL THEATRE, LONDON	NIGHT	1/8 pgs	:30	3	Terence is watching the couple	Fót, Mániszy Studió
							End of Day # 39. -- Tuesday, September 7, 2010 -- 2 1/8pgs -- 3:00 min	
							Working Hours = 07:00 - 21:00	
127B	INT/EXT	SAND QUARRY - VAN, LONDON	DAY	1 6/8 pgs	2:25	4,5,10	Varga and Natasha are torchering Cherry	Fót, Sand Quarry
							company move back to the studio	
							lunch break 13:00 - 14:00	
131A	INT	LONDON, HIGHPOINT	DAY	1/8 pgs	:10	4,10	Natasha watches Cherry through binoculars. Hands come into the shot and fondle her	Fót, Mániszy Studió

Above: A shooting schedule lists all the scenes planned for each day, as well as breaks, set moves

the
shoot

In this section you'll learn everything you need to know about how a film shoot is organized, including:

- **The jobs on set,** what the director does, what an AD is, and who will call 'action!'

- **How to go about blocking scenes** and do dry rehearsals before you start rolling

- **Eyelines, headroom** and what it means to go back to first positions, setting up and turning round

- **Focus pulling, continuity** and the importance of thorough script supervision

- **Documentary filmmaking** and planning

Film jobs explained

Do you know your best boy from your dolly grip, your gaffer from your 2nd AC? Here is a breakdown of all those production jobs you always read on the rolling credits. Who knows, you might be one of them yourself soon...

Photography

Aside from the roles of director, ADs and producer covered on pages 152–3, there are many other jobs in movie production. The DOP or DP (cinematographer or director of photography) is the person responsible for giving directors what they want. This includes the framing of shots, the lighting set-up and the 'look' of each shot. The DP also chooses all the technical elements of the camera set-up, including exposure, lens choice and shutter speed, although the director may select some of these, too.

The DP manages the camera crew, the electricians and the grips, and liaises with the production designer to make sure a set will give enough space for lighting and camera placement.

Cameras

The camera crew normally consists of the camera operator, the 1st AC (first assistant camera operator), the 2nd AC and possibly a 3rd AC. On smaller shoots the DP will operate the camera for framing, with the 1st AC acting as focus puller (see page 166) and also physically setting up the camera for each shot. The 2nd AC will put down focus marks for actors' feet, fetch lenses, filters, batteries and any kit required by the DP, and will also use the slate (see page 175) to mark the scene number and other information at the start of each take, then liaise with the continuity person for recording camera information.

Below: The 'boom' is a highly skilled microphone operator who works together with the sound recordist.

Above: The dolly grip carefully pushes the camera dolly on its tracks as the best boy helps bring up the camera cables so that it doesn't get snagged.

Lights

The electrical department consists of the 'gaffer' or chief lighting technician and the 'second electric' ('best boy electric' or assistant lighting technician), plus electricians ('sparks'). The second organizes all the electrical equipment in the lighting truck and is responsible for electrical equipment, placement of generators and managing the electricians who actually put up the lights and adjust them to how the DP wants them. On very small sets you may have only a gaffer and sparks, but it's usual to have at least three people in the electrical department, as waiting for the lights to be rigged can really slow down production.

Below: The 2nd AC or clapper loader operates the clapperboard at the beginning of each take and notes down all corresponding detail on the clapperboard. The 2nd AC is also responsible for all camera logistics such as location transport, hard disks and memory cards.

Grips

The grip department rigs up the physical aspects of the camera (in the US they also rig up some of the lighting, like scrims and nets and flags). They lay the dolly track and level it, mount cameras to cars, set up scaffolding and set up jibs and cranes. The 'key grip' is the head of department, with the 'best boy' (or second grip) second in charge. There may be a 'dolly grip' only responsible for pushing the dolly and making sure it moves smoothly and hits the marks exactly. The key grip is responsible for general safety on the set, with the gaffer responsible for electrical safety.

Second units

Second unit crews are used for shots that don't involve the main actors and don't require any significant lighting. The DP is still responsible for the second unit, although it will normally have a second unit director, grip, camera operator (or second unit DP) and camera assistants, too. Second units are typically used for crowd shots, stunts and establishing shots (and sometimes also for special-effects shots).

Right: The 2nd AC uses multi-coloured electrical tape to mark the actors' positions on the floor.

PRODUCTION *MAGIC BOYS*
DIRECTOR *ROBI KOLTAI*
CAMERA *LAZI SCEREGI*

DATE	SCENE	TAKE
22/10/11	11	3

The **director's job**

Most people who want to work in film aspire to become either a director or a producer. But what exactly do they do, and what responsibilities do they have on and off set?

Director

The director has a wide-ranging role, from working out what shots need to be done to coaxing the best performance from the actors. The director works with the DP (director of photography, see page 150) to specify the camera placement and movement for each shot. It's a very important partnership that depends on mutual trust and respect. The

Below: Rowan Joffe on set of Brighton Rock *in 2010. With feature-film sets employing on avarage over 50 staff – sometimes hundreds – it's important to keep calm and in control without being controlling.*

director works with the actors on 'blocking' movement within the scene (see page 156) and dictates the emotional tone of the scene.

Directors get known for their own style of filmmaking – think of films by Ridley Scott, Alfred Hitchcock, Terry Gilliam, the brothers Ethan and Joel Coen, or indeed the Wachowskis; they are usually the creative visionaries and main driving force behind the film. They typically write and often cut the film, too, as well as being involved in selecting crew, actors and locations. These type of directors lead from the front; they are invoved with the project long before everyone else,

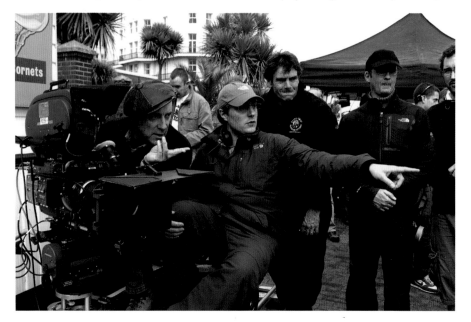

Right: *If you are fortunate enough to be a first-time director on a bigger budget film, make sure you're given a director's chair, so you can keep it and treasure it for ever.*

and stay with it all the way through post-production, financing and ultimately selling the finished film. The director is the boss on set, although the real boss behind the scenes is the producer as he or she controls the money (see box).

Assistant directors

As well as the director there are a number of ADs (assistant directors), although these roles don't normally progress to a job as a director as they are mostly non-creative roles. 1st ADs (first assistant directors) are responsible for the day-to-day running of the shoot. They liaise with the DP for time estimates for each new scene and set-up, maintain the schedule on set, and manage the other ADs to ensure cast are through make-up and arrive on set at the correct time. They usually shout the loudest and maintain time order by calling out what is delaying the shoot – for example 'waiting on costume' or 'waiting on camera'. The director will find out what's happening on set from the 1st AD. The 1st AD also works with the production manager for day-to-day planning and budgeting.

The 2nd AD is responsible for creating call sheets, scheduling, and liaising with production management for all 'backstage' functions and is more likely to be in the production office than on set. The 3rd AD liaises with the 1st and 2nd ADs to move the actors to the set, and manages any extras and crowds on set.

The producer's job

The producer is involved from day one and controls the financing and delivery of the completed film through all stages, including rights acquisition for the script or initial script development. Producers may finance the film through pre-production themselves until other finance is in place. They drive the process of delivering the completed film on schedule and on budget. Sometimes the producer is also the director and the writer of the film – think Steven Spielberg or Quentin Tarantino. Producers may also direct and star in their own films, like Clint Eastwood or Mel Gibson.

Above: *Quentin Tarantino tends to produce most of the films that he writes and directs.*

Executive producer roles are normally given to producers with a specialist skill or those who bring specific expertise to the production. They may work on a number of projects at once and usually have a lot of experience in other aspects of filmmaking, such as directing, writing or financing. An executive producer can 'buy' a 'paid-for' front credit by being a financer of a film or supplying equipment or services, but normally he or she plays a major role in making sure the film actually gets into production.

On **set**

Most professional crew members will have a specific job and be split into their departments, as described in other sections of this book. However, if you have a very small crew, some will inevitably have multiple roles to perform. Let's look at a typical set-up for the start of a shoot.

The daily call sheet that the line producer's assistant (on a bigger budget) or more realistically you and your producer will have prepared (see page 147) will tell everyone, including you, where and when to be on set – usually at your unit base for breakfast. Actors will typically be in make-up, hair or wardrobe first thing in the morning, while the set is being prepared.

Below: The camera and lighting teams set up first to give time to get lights and camera angles correct before the actors' positions are checked.

Jobs on the day

The director goes through the basic scene blocking first (see page 156) to allow time for the DOP and the gaffer to set up the lights and for the grips to set up any grip equipment such as track, crane or jibs. With a much smaller low- to no-budget crew, the DOP may rig the lights and camera crew may set up track or grip equipment. The DOP usually wants a camera up and running as soon as possible in order to view the scene lighting through the camera and to get a picture up on a monitor for the director to see.

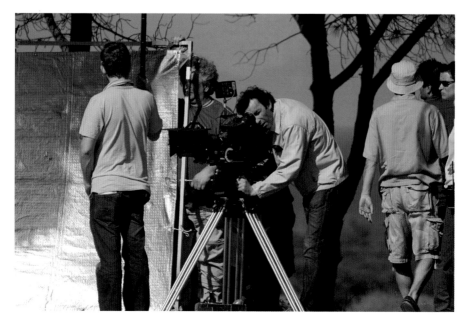

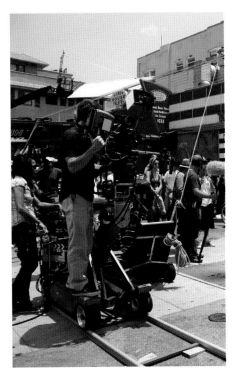

Left: Your first day on a busy set will be intimidating, but don't let that hamper your experience – all crew are normally equally excited to start work on a new project.

The 1st AD controls the set until the director arrives. The cast usually arrive with the director, as they may have been rehearsing during make-up or waiting at unit base for the set to be ready. The 3rd ADs will be busy with any extras, or managing equipment or cast travelling from base to set. The camera team will be setting up the camera (or multiple cameras) with lenses and monitors. The 2nd AC will have the slate marked up (see page 175), checking with the continuity supervisor (see page 174) on slate numbers if required. The boom swinger will be testing out audio gear, checking cables and mic pick-up with the sound recordist and waiting for the blocking phase to get boom positions correct. The art department will be making last-minute changes to the set, adding extra set dressing and checking how the scene looks on the camera monitor if possible.

The producer's job

You may just be starting out and getting to grips with being a one-person crew, but if filmmaking is to become your career you will work with a larger crew at some stage. Remember some simple rules and you will at least make it through your first day on set:

- Respect the crew – they have probably been doing this job for a long time and will know a lot more than you. You will have to earn their respect by your actions, so don't assume you know everything already because you won't.

- Some obvious ones: don't arrive late to set, don't get in shot, don't move around while filming is in progress or catch actors' eyelines and mess up the shot.

- Don't touch any gear without permission, especially other departments' gear.

- Your boss is in charge of you – you are not the boss, nor are you the director.

- Don't bypass the reporting order. It's there for good reason – to avoid overloading the boss's boss with trivial problems that can be dealt with by others.

- Make sure you introduce yourself to everyone you can. Don't be shy, but try to keep your head down to avoid being singled out as a newbie.

Blocking and rehearsals

If you have planned loads of great shots on your storyboard, the next step is to work through them with the real actors, taking them through the scene and 'blocking' in their actions before you start filming.

Blocking is a term used to describe working out the precise movements in a scene for both actors and camera. The word comes from the original theatre process of planning stage productions using wooden blocks on a miniature stage. The blocking will be dictated by the action required in the scene to progress the story and by the physical limitations imposed by the set, but there will be leeway for a wide range of movement.

Creative control

The director has the ultimate say over what he or she wants to see. Some directors will control *all* the action, knowing exactly what they want and how to film it – especially if the screenplay was also written by them.

Depending on how complex a scene is, much of the planning may have been done in the pre-production phase using storyboards or 3D software to fine-tune the actions, but a real location will *feel* different and may present problems or opportunities to try new things.

It's usual to have a script read-through with the cast on location and give them the opportunity to move around in character and act and react to the dialogue. Some productions may have been rehearsed well in advance – especially choreographed pieces with stunts. Less complex scene blocking can be worked out on the day, with slight adjustments made during rehearsals. Blocking enables the director and DOP to look at camera set-ups and tweak the positions of actors to create the shots they want.

Rehearsals

Once the blocking phase has been completed, the set will be lit and the cameras put into position. The crew will start to do a 'walk-through', using available crew to sit in for cast. This allows the following: the 1st AC (focus puller) to get focus marks for each position as the character or camera move in scene (see page 166); the DOP to check the lighting; the grip to fine-tune dolly or jib movements; and

Above: *The program SketchUp lets you work out your blocking before you get on set, which can save a lot of shooting time.*

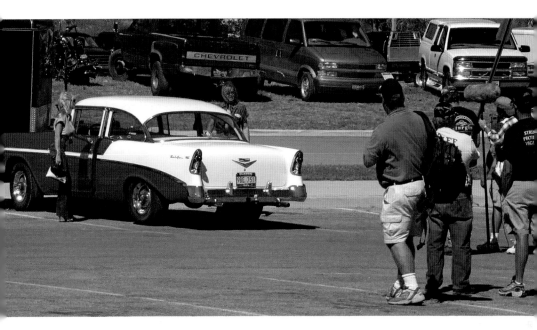

the boom swinger to check that the boom position will not be in shot during filming. As the set is finally prepared, the 1st AD will call the cast back to do rehearsals – usually a slow 'technical' rehearsal first so that everything can be checked again, followed by a final costume, make-up and hair check before the first take.

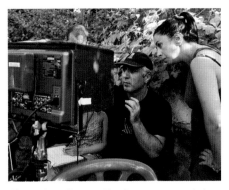

Above: As well as watching the actors on set during the takes, re-check each take carefully on the monitor.

Above: During the camera and sound recording set-up, walk through the blocking with your actors. You might even find some time for a few rehearsals as well.

Print it

In the final rehearsals and first take, the full-speed action and camera moves will be closely monitored. You may need a number of takes to get the movement and focus correct, depending on the shots' complexity and length.

The director will talk to the cast to let them know how the performance looks and make minor adjustments to movements. Any technical problems are ironed out until you have the first take that you're happy with. This is called a 'print' (from film terminology). It's wise to shoot a couple of prints for safety. You will usually playback each take on set to double-check there are no problems and then move on to the coverage, focusing on any areas you weren't that happy with from the master shots.

Setting up / turning round

Every set-up for camera, grip and lighting takes time that must be estimated and factored into the daily shooting schedule in advance. If you don't plan the coverage fully, you may have to cheat to get your shot.

Each shot needs to be set up with lighting and camera, dolly or jibs as required by the shot list, with lens choices noted for the reverse shots that will come later. The DOP, director and 1st AD estimate the set-up times, with the 1st AD keeping track of how much time each camera set-up is taking so that he or she can update

Above and below: *A standard OTS shot with its reverse. You may need to cheat the male actor's position to have enough room for the camera for the reverse shot, but the lighting can probably remain similar for both shots. Be careful to maintain continuity of the liquid level in the glasses, too.*

the director. If you're following a master scene method (see page 88), you will film the master followed by all the coverage. By shooting your widest shot first, you may be able to use existing lighting positions when you come in for dialogue two-shots, OTS (over-the-shoulder) and close-up shots. The idea is to try to minimize any changes to the lighting, grip and camera set-ups in order to speed up the whole production process.

Turnaround

You don't normally shoot an OTS from one side and then switch straight to the other side, as too much time is wasted moving cameras and lights. It's best to finish all the coverage on one side and *then* move the camera and lighting. This is called the turnaround and consists of all the answering close-up and OTS shots. You need to make sure that the camera set-ups on each side are exactly the same – especially the lens focal length and depth, camera height and angle. The idea is to match the perspective and relative size of people's heads in an OTS or close-up with its answering shot the other side.

Cheating

If an obstruction such as a table, chair, window or wall physically prevents you from positioning the camera for the turnaround, you may need to 'cheat' the shot. You could move the actors slightly to allow room for the camera as long as the background doesn't change too much, or

remove objects that won't be missed from the shot. Learning how much you can get away with is largely down to experience and trial and error.

Matching shots

You will need to leave the audience with something from the wider shot to help link them back in to what they are seeing in your cheated two-shot. If you have had to move a table to get the camera in, you could use a smaller table or a box (out of shot) that can lift a few foreground items back into place to avoid the audience getting 'lost'. Cheating can also be applied when matching doorframes and windows from wider shots to close-ups. You may have to film the close-up in a different location altogether or build your own doorframe for a stunt, but as long as the frames look similar you can get away with it. If the backgrounds are very dark or nondescript, you might even be able to cheat the reverse shots by moving the actors and the camera position but not changing the lighting set-up.

Above: In Billy Wilder's iconic 1958 film Some Like It Hot, *this memorable bathroom scene was famously cheated. In the master shot the bathtub is butting up against the wall, with Marilyn Monroe kneeling at the side of Tony Curtis, lying in the tub. In the turnaround perspective we see the two actors from where the wall was in the master shot. As it was shot in a studio, the wall was removed for the camera for the turnaround.*

Above: Time must be allocated for both set-up and turnarounds. You can use apps such as Shot Lister for iPad or iPhone to update the schedule while on set.

The **stage line**

Early films were shot just like a stage play, with a definite 'line' between audience and stage. The camera was static and the relationship between stage and audience remained static. With a moving camera you still have a line that creates screen direction, but you need to follow some rules to avoid puzzling the audience.

Imagine two characters having a conversation face to face. There is an imaginary 'action line' between them, and the camera can go either side of that line. Once the camera shoots from one side of the line this creates 'screen direction', such that character A (Tony) is now on the left and character B (Fiona) is on the right. You could choose to film a wide shot like this with both of them together, followed by a close-up of each character. But you cannot now cut to a shot from the *other* side of the line, since you will reverse the positions of Tony and Fiona and cause temporary confusion among the audience. This rule is called 'not crossing the line' and allows the camera up to 180 degrees of movement. If the camera itself moves in the shot you can defy this rule, because the audience will see the changing spatial relationship as it happens.

The 180-degree rule

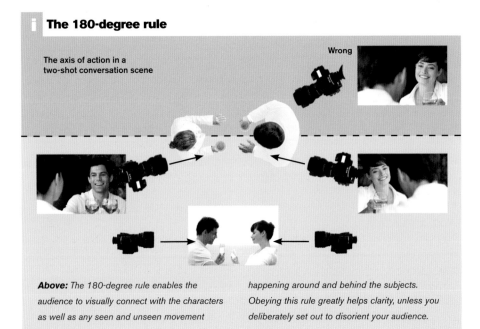

The axis of action in a two-shot conversation scene

Wrong

Above: *The 180-degree rule enables the audience to visually connect with the characters as well as any seen and unseen movement* *happening around and behind the subjects. Obeying this rule greatly helps clarity, unless you deliberately set out to disorient your audience.*

Just one look

The line can be created by a look. Imagine we have a close-up of Fiona looking off-screen to her right, then a POV shot showing her sister Sarah waving from a distance. There is now a new line between Fiona and Sarah, so we can place the camera in more positions relative to the new action line. This new line does not replace the line between Tony and Fiona, which must be maintained for shots showing just them – unless we see them move in a wider shot into new positions and thus create a new line between them. The same is true if we cut to a completely different scene, such as a flashback or parallel timeline – once you cut back, the line can be re-established anywhere you need it to be.

Spatial relativity

The line is relative to the observer, so anyone on the same side of the line will see the same screen direction for left and right. Tony and Fiona will both see a car driving by from right to left, and this movement creates another action line for the car. If your shot shows the car exiting the frame on the left and you

Above: In this memorable interrogation scene from the Batman film The Dark Knight, *director Christopher Nolan consciously crosses the stage line to show that neither Batman nor the Joker is in control. As he cuts across the line, the Joker utters the words, 'Tonight you're gonna break your own rule', linking it directly to the breaking of the 180-degree rule.*

want to cut straight back to the car, you must show it entering the next frame from right to left – that is, going in the same direction – to maintain the screen direction continuity. This rule can be broken if you see the car turn around in shot, or if you cut to another completely different scene and then back to the car again, or if you cut to a neutral wide and high shot showing both the car and our characters in the street. Similarly, if you see actors go through a doorway and exit the frame on the right, you expect to see them come out of another doorway on the left in the next shot, still heading from left to right – even if the doorway is in another building or country. The line is created by the direction of travel and by the geography of the location.

Eyelines and headroom

We naturally notice where someone's eyes are looking, because we are faced with this type of body language every day. When matching shots together in video, you need to maintain the spatial relationship of the eyelines to avoid confusing the audience.

For interviews in documentaries or corporate videos, it's important to consider how the eyeline affects the way a viewer feels. A neutral eyeline is one looking close to the camera in both height and direction – this is normally where you place the interviewer. The further away the eyeline is from the camera, the less engaged viewers feel – as if being that far away from the speaker's gaze will cause them to be unseen and outside the conversation.

Matching eyelines

In drama productions, eyelines must match up between shots, especially for POV shots and standard OTS shots (see page 158). If you shoot a character whose eyeline is looking down on an object and then shoot their POV shot looking at the object from a different angle or direction, the audience will get confused and stop following the story while they try to figure out what they are looking at. Eyelines between characters must match shot for shot, and with eye-sweeps – when one character follows an off-screen character with his or her eyes – the reverse shot must match the eyeline height properly.

> ### i Headroom
>
> Headroom is the amount of space left *above* the head when framing your shot. The amount of headroom you have is a compositional choice, but normally you should leave the minimum amount to avoid the shot looking too cramped. Too much headroom will jar with the audience and make the subject look lost in the frame – although this could be a deliberate choice for emotional effect. If there is no extra information being added in the headroom space, then there is probably too much – but consider TV safe areas (see box on page 163), as this can reduce headroom considerably.

Below: Using the rule of thirds to help you compose your shot will also give you the correct headroom (right) with the eyeline aligned to the upper horizontal.

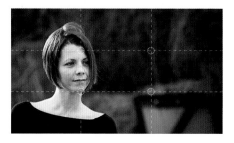
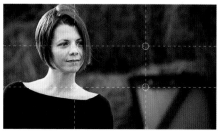

Below: Some programming is still delivered at the 4:3 aspect ratio, usually cropped (pan scanned) from a 16:9 wide-screen source, so be aware of action occurring outside the centre safe area if delivering in this way.

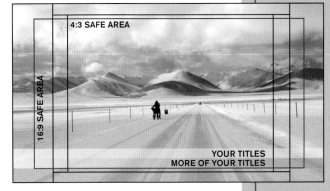

TV safe areas

Typical TV screens made from CRT (cathode ray tubes) cannot show the full TV signal – the edges are distorted and cut off. This gave rise to the standard use of a 'safe area' or border all the way round the edge of the frame so that action ('action safe') and any titles ('title safe') could be seen without distortion and with a bit of a margin. With the rise of LCD and plasma screens the margin required diminished, and typically TV stations now put graphics and text just inside the larger 'action safe' area.

For cinema projection or internet, this safe border is not relevant since the whole frame can be seen. However, you may want to take TV safe areas into account to avoid anything being cut off if your film is transmitted on TV or shown on DVD. Some cameras and external video monitors give you on-screen markers for title safe and action safe.

Virtual eyelines

Maintaining the correct eyeline for CGI-heavy scenes can be problematic if the actors don't know where to look. Some productions make use of motion-capture suits to replace the 'monsters' so that the eyeline is still physically in place. Otherwise, for POV shots or reaction shots the director and DOP will need to supply the actors with the correct eyelines for the imaginary off-screen character or place a mark in the matte box to help with the correct eyeline.

Right: The 2012 film Cycle uses a lot of CGI and motion-capture and the actors were routinely required to look at 'things' that were as yet invisible and would be stripped in during post-production. A self-fashioned eyeline stick was used throughout filming to direct the actors' eyelines.

Camera rigging for cars

There's a wide range of options for shooting a car scene: from full CGI vehicles and backgrounds, through studio-based vehicles with back projections and lighting effects, to real-world shooting with low trailers, and finally to fully rigged-out cars with multiple cameras attached.

Safety is a prime concern when shooting real-life car scenes and any method you choose must be planned carefully. You will need permission to film on the road, especially if you need to close it while filming. Private roads are the easiest to work on, since permission will be part of the location agreement. Some large productions such as *The Matrix* have gone to the lengths of building their own roads in order to achieve repeatable effects safely.

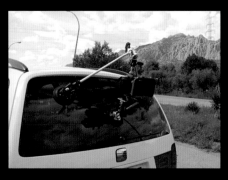

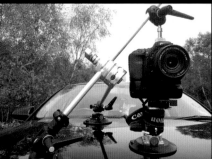

Camera angles

The most common camera positions include shooting from the bonnet/hood pointing into the car to give a wide two-shot for the master and then angling the camera to give two clean single shots as coverage. If you have two cameras and can rig up both singles at the same time, it will save time re-rigging for a dialogue-heavy scene. It's normal to shoot through the windscreen using a polarizing filter and to have microphones inside the car for recording dialogue. Another common external camera position is the so-called 'hostess tray' angle – shooting through the side windows to give you a two-shot each side. Consider the camera angles and vehicle size if you need anyone monitoring sound or video from inside the car to be out of shot, or use wireless senders to monitor remotely from another vehicle.

Rigs

Unless you have a tricked-out camera car with bolted- and welded-on camera platforms, you will need a removable camera rig. Most car

Top left: *Mounting any camera on a car can be tricky, but generally the lighter they are, the more solid you can make the support – and it needs to be solid to eliminate engine vibrations and bumps.*

Left: *A simple suction-cup tripod is used here to mount the camera on a chaser car.*

rigs use suction cups for gripping onto the shiny paint surface without causing scratches, but they will also need to be ratchet-strapped down to give extra security for the rig and the camera itself. There are plenty of attachment points, such as the bonnet/hood and the wheel arches. You can buy small rigs containing three or four suction cups with grip rods and knuckle joints, usually with a small camera platform that can be adjusted to different angles or with a bowl mount to fit a standard tripod head. Interior rigs are usually lighter in weight since they need to be smaller to fit into a smaller space, but all rigs should be able to take the weight of your camera easily. If in doubt, bring in a professional grip technician to supply and set up your car rig; it may well save you time and money in the long run.

Cutaways

As well as your master and coverage, you will need some extra cutaway shots to help with the edit. Plan these shots in advance for transition story points, such as leaving and arriving. Filming general drive-by shots on different roads will

Above: An ambulance can be used to create tension in an unrelated scene. Use the sirens as background, then a quick cutaway of the ambulance screaming past.

help when cutting the dialogue. You could add in shots from a following vehicle overtaking or being overtaken by the main vehicle, or interesting shots from other mounting places on the car itself. All these extra shots will help cut lengthy dialogue together and can add more duration to a road trip scene.

USEFUL TIPS

• Consider the sun's position when filming to avoid problems with cameras and mounts casting shadows or reflecting onto the windscreen or actors inside. A dull, overcast day is much better than full sunshine.

• Unless it is essential for the story, try to avoid bumpy and potholed roads — it will make the shoot much smoother.

Focus-pulling basics

The job of the focus puller or 1st AC is not particularly glamorous, but it's important. Get the focus wrong and, despite the best performances from your actors, the shot will be unusable.

Above: Use a tape measure to determine the distance from the focal plane to various marks in the scene for your actors to hit.

Above: When focus pulling, match focus marks on your FF dial with parts of your scene, especially if your lens distance markings are too small to read.

The focus puller maintains framing and focus and moves the camera into different positions. If you're working with a small crew, the focus puller will also be the camera operator. Good focus pulling takes practice and you need to know your kit well.

Tools for the job

You will need a manual-focus lens, or an auto-focus lens that can be switched to manual mode. Ideally you will have an FF (follow focus) device that is attached to your lens via a gear system and rod mounts, so that you can operate the focus ring of the lens from the side of the camera. An FF will have a white markable disc and an indicator arm and possibly hard stops that can be set for either end of a focus pull. You will also need a good-quality HD monitor attached to the camera, ideally with focus-assist features.

If you have the budget you could try using a remote FF, which allows the focus puller to be further away from the camera. Remote FFs have been made for popular DSLRs that connect via USB and make use of the lens motor for focus shifts. Some can even operate via Bluetooth from your smartphone. More typical remote FFs use a separate motor system attached to the lens in the same way as the mechanical FF. Either way, most electronic remote FFs can be programmed with focus stops to help you dial in and go back to the exact focus point time and again.

Above: *A fabric or steel tape measure is an essential tool for a focus puller to measure distances between the actor and the camera; just as handy is a laser measurer for larger rooms or distances.*

Above: *A typical lightweight follow focus from Zacuto USA, with 15mm-diameter rod mounting holes and with an 0.8mm 'cine' pitch gear wheel to match lens gears and cine lenses.*

Rack focus

To perform a basic rack focus – changing or pulling the focus between two distinct parts of your scene – set your focus on a foreground object and make a mark on your FF ring, then turn the lens focus ring to a specific object further away in the background, set a new mark, and pull back to the original foreground object using the mark on your FF ring. That's it. See how smooth you can make the focus shift between the two marks, then try doing it really fast.

Focusing on action

Keeping your scene in focus as either the actors and/or the camera move isn't always easy, especially if you're using a shallow depth of field due to artistic considerations or lack of available lighting.

If you're filming improvized action or a live event, ride the follow focus dial and use it as a convenient way to adjust the focus – watching and following the action on the monitor. The drawback is that you're always attempting to maintain focus *after* something has moved and must try to anticipate the action. Pre-set marks on your FF dial for different distances or for different marks in your scene.

Floor tape

During the blocking you can set marks on the floor with tape for the actors to hit (assuming the floor won't be visible in the scene). Use different-coloured tape for each actor to avoid confusing you and the actors. If the floor is visible you will have to pick other parts of the scene to set as your marks, such as a doorframe or a tree. Practise the scene blocking with any spare crew members and make sure you know what the director wants kept in focus before you start filming.

Useful tips

• If you're riding the focus wheel and having trouble keeping the scene sharp, try shooting with a wider DOF by using a wider focal length lens or stopping down the aperture.

• Practise and get used to the direction you have to turn the FF for moving the focal plane closer to you or further away from you.

• If your actors walk past the camera and you're panning with them, see if they can walk in an arc to maintain the same distance to you.

Special effects make-up

Horror films are an ever-popular genre, especially at the low-budget end, but you will need special make-up to turn your average actor into a flesh-eating zombie or blood-sucking vampire!

Some special effects materials were not originally designed for film or theatre use. Nose wax or nose putty, for example, comes from embalmers, who use it to rebuild the faces of the dead after nasty road accidents. This popular modelling substance can be used on other parts of the skin as well as areas of the face. You blend it in with a spatula or your wet fingers and then dab with sealer before applying make-up to make a seamless prosthetic. You may need to use spirit gum or similar to get the wax to stick to the skin. Other wax-based products can be used for covering eyebrows before modelling new brow arches for sci-fi aliens or scary monsters.

Gelatine and latex

You can buy latex to build up prosthetic and fake skin, but gelatine (used as a gelling agent in food) is the cheapest stuff and looks more realistic. Put some gelatine in hot water for five minutes until it turns into liquid, then apply it to the skin and blend it in with a spatula. For a simple scabby burn look, apply a few layers of gelatine, add one ply from some tissue paper, add another layer of gelatine, and then powder it. The tissue paper will disappear, but you can use tweezers to pull some of it out and make it look like a nasty hole in the skin. Use black make-up in the hole to give it depth and use colours to match the look of burns, scabs or bruises. Silicone rubber works well, too, but it needs to be make-up silicone rather then bathroom sealer.

Above, top to bottom: A gruesome fresh wound, if well done, ups your production values instantly (top). A little bit of silicone rubber and a few shades of red will create an effective cut (middle). Third-degree burns need to come with secondary bruises to make them more real (bottom).

Fake blood

The normal mixture for fake blood is red and black food colouring mixed with golden syrup. If you can't get black food colouring, try mixing in a little coffee to darken it, with a little peppermint oil to taste. For any black-and-white-only scenes, you can get away with using chocolate sauce. You can buy blood capsules to put in your actor's mouth; these mix with saliva to make fake red blood when bitten – useful to add extra blood at the point of impact, when your vampire or monster is tucking in to someone's neck. If you want more realism you need to rig up a transparent plastic tube with a big syringe full of fake blood (off screen) so that you can create the effect of pumping arterial blood. For instant cuts that appear on camera, you can use blood powder – transparent powder that reacts to moisture. When you run a wet 'blade' over it, you get an instant trickle of blood.

Bloodstains

Gelatine can also be stained like blood and then moulded on a flat surface such as a mirror until it goes hard. Peel it off and put it on a carpet as a blood pool to avoid having to ruin the carpet. Spray with glycerine to give it a shine and make it look fresh. You can use this technique to create dried blood streaks, or try other fake blood products that set instantly, including scabs and fresh scars.

Above: To create realistic-looking bloodshot eyes, it's best to use custom (expensive) contact lenses that are pre-painted for HD. A cheaper option is 'eye blood' – it's quite bloody so don't use too much.

Oil- or alcohol-based

Professional effects make-up from the likes of Kryolan is either oil- or alcohol-based. Greasepaint is oil-based, but the more expensive alcohol-based products blend better into the skin, leaving just the colour after the alcohol has evaporated. With either type you can add fake blood without ruining the look underneath, allowing for multiple takes, but the alcohol-based make-up will generally last longer.

USEFUL TIPS

- Remove fake blood stains from skin using shaving foam – it's better than soap.

- Fill a small piece of sponge with fake blood and put it up your actor's nose. Time a face punch to when they breathe out of their nose for an instant nosebleed on screen.

- If you're not entirely happy with your supernatural horror make-up, try to keep the lighting for that character and scenes low and moody – it will cover up a lot of mistakes.

3D filmmaking

3D has been resurrected yet again with the advent of new technology and blockbuster movies such as *Avatar*. Is it just the latest fad – or will 3D still be here in another ten years' time?

The concept of 3D has been with us for nearly 100 years. It is a technique used to provide more depth to a 2D image or video by trying to imitate how our eyes work. Our brain naturally processes depth information by comparing the view from both our eyes at the same time. Try closing each eye in turn and you will see how each eye presents a slightly different image, especially of objects closer to you. Our eyes rotate in relation to each other and converge when focusing on an object – try focusing on your finger as you bring it closer (warning: you'll end up cross-eyed).

Left: The Sony Bloggie 3D, the world's first 3D pocket camera to capture 2D or 3D videos at full 1920 x 1080 high definition.

Mimic

3D systems try to mimic our stereoscopic vision by using two cameras set up at the same distance apart as our eyes (the 'inter-ocular' distance). They have an adjustable 'convergence angle' to be able to focus on close objects (smaller angle) or objects further away (wider angle). This causes a problem for big cinema cameras, as they are too big to be positioned close enough together, but a system is then used to allow each camera to shoot through a mirror and the inter-ocular distance can be as small as required. Newer consumer and prosumer 3D cameras have quickly caught up with this technology.

Below: Traditional anaglyph 3D can be created automatically in YouTube or using available software tools like 3Dfier. The amount of separation between the red and cyan parts creates the apparent depth.

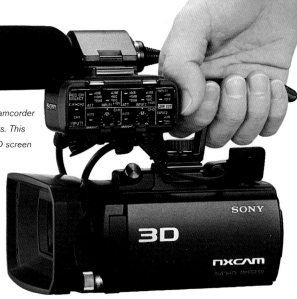

Right: The 'ready to go' Sony NXCAM 3D camcorder with dual HD lenses and dual CMOS sensors. This prosumer camera features a glasses-free LCD screen for easy 3D content creation.

3D viewing

To make the 3D effect work on playback, each of our eyes must see only the video recorded from the corresponding left or right camera. Anaglyph 3D is a popular method, especially for still photos, using red and blue (or cyan) colour encoding and then cheap red and blue glasses to view the encoded video. Anaglyph images still retain colour information, but the red and blue filters in the glasses separate the two camera views and give us depth perception from the overlapping image. Modern movie theatres use light polarization systems with specially adapted projectors, special screens and polarized 3D glasses to keep the two video streams separated. This method causes fewer problems with colour grading but is more costly, as two versions of the film must be projected. 3D television sets and 3D field monitors are coming on the market, both with and without the need for glasses, but this whole area is still under much development.

The future?

3D television channels are available from Sky Sports, amongst others, so 3D appears to be here to stay for some time, with even YouTube offering free 2D-to-3D conversions of your videos at upload time. Things may improve if James Cameron and Peter Jackson get their way on higher frame rates for 3D (*The Hobbit* was shot at 48p for 3D, although it may not

get projected that way); this may reduce edge-fringing problems and give you a better 3D experience. However, let's not forget that it isn't just the latest technical advances that entice people to the movies and, if you're immersed in a good story, you really don't want to be jolted out of it by an eye-straining reminder that you're watching a movie.

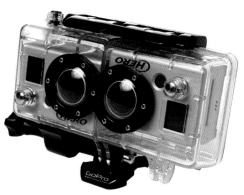

Above: The GoPro 3D HERO system allows you to combine two HD HERO cameras into a single housing to record 3D video while simultaneously recording in 2D. A synchronization cable plugs into the rear port on both cameras to join them together.

Chroma keying

Green and blue screen or 'chroma' keying has been used for decades in special effects to blend several different images or layers together to create a composite – just like a meteorologist doing a TV weather report, standing in front of a map.

Green or blue

The basic concept of chroma (or colour) keying uses a single, flat colour for the background to allow software to remove or key-out that colour range from the image or video. Any background colour will do as long as it's not present in the foreground that you're trying to isolate, but green or blue are typically used since they are the furthest away from skin tone colours (blue can key better for Afro-Caribbean skin tones, although green is used mostly these days). You can buy background drapes or mix up special chroma paint and build yourself a mini green-screen studio for very little money these days. If you want to key full-size people, including feet, you will need to cover the floor, too.

Lighting

The background itself must be lit evenly to help the keying software remove the background (to 'pull' the best key). Too much light and the background may be washed out with over-exposed areas; too dark and it won't be green enough to key properly. Natural light outdoors can work well, especially if you're filming an element that will be used outside, as the lighting will match. Be careful to avoid harsh shadows, as these will need to be removed later; if you intend to use the shadows for added realism make sure they fall fully onto the green screen. A cloudy, overcast day is better than full sun, if possible.

Left: The classic weather report uses chroma keying to replace the green screen with a weather map video or motion graphics. The reporter learns where to point and rehearses each weather report before running live.

Right: *LED light rings, such as this blue LiteRing from Reflecmedia, which attaches via a step-up or step-down ring, are available to fit most video and DSLR cameras.*

Video quality

The quality of the video camera plays a part, too. The more compressed the video codec, especially with its compression of colour, the more chance it won't give you a good colour key. See page 21 for more on colour space and compression. Fine detail such as hair will not show up well with compressed codecs such as H.264 either, so it's worth comparing camera outputs beforehand if you intend to do a lot of green-screen filming. You need to be careful of 'light spill' – green light reflecting back from the green screen onto your actor – although this can be colour-corrected in post-production (see page 202).

Virtual sets and tracking

If you're working on the next sci-fi blockbuster you will undoubtedly need to build virtual sets – 3D sets built on a computer that can be used as background replacements for your characters. The most basic form is a still image of a location that you can use to drop your characters onto – ideal if the camera does not move or is locked off on a tripod. You can use single-point tracking software such as Apple Motion or After Effects to match basic tripod pan/tilt movement, with a couple of markers you can stick onto your green screen as reference points so that the background image appears to be shifting appropriately.

Match moving

As soon as you need a moving camera that isn't locked off, you will have to use specialist tracking software such as Mocha Pro, MatchMover or SynthEyes to match the movement of the 3D camera with the real-world camera. This technique is referred to as 'match moving'. The 3D software helps build a realistic-looking scene, using lots of computer power to render the lighting, shadows and textures.

Below: *Chroma keying lets you simulate depth of field by setting backgrounds out of focus, but the initial filming should have both foreground and background in focus to help with the keying process.*

Continuity and script supervision

The continuity or script supervisor is responsible for maintaining continuity throughout the production process. This key technical role links the post-production with the production teams by making sure there is enough coverage to edit the film together.

The work of continuity or script supervisors starts in pre-production with the shooting script. They compile continuity reports so that the crew can maintain the film's notion of time when it's being shot out of sequence. They will know what time of day a shot is meant to be and what time a clock in a scene should be set to. They will also check for the elapsed screen time between shots – so that someone can't drive three miles in 20 seconds of screen time without enough coverage or a cut to another scene. It's easy to get confused when you shoot out-of-order scenes, especially after a long day. They also know all the scene numbers used to slate the audio and video (see box) and are constantly checking the script itself as a scene is played out, ticking off completed shots when they're marked as good takes to feed back to the production team later in the day.

Which hand?

Continuity supervisors must be very vigilant when keeping track of 'movement continuity' between a wide master shot and the close-up coverage. They must check that actors do the same thing each time for each set-up – that they use the same hand to pick up a prop or perform the same action at the same place on set on each shot. They make notes on eyelines for any 'looks' off-screen to ensure shots will cut together properly with other coverage or inserts. (The crew look out for these things, too, but are usually too busy to notice every detail.)

Left: Almost every film has continuity errors – even James Bond. In Casino Royale, *during the sequence when Bond and Vesper Lynd fall in love in Venice, he types up his resignation email on his laptop on their boat. When he starts to type, he's wearing a watch with a black strap. Moments later, as he finishes and closes his laptop, his watch has a silver strap.*

i The clapperboard

The clapperboard or slate is like a blackboard used to record the film name, scene number and take number so that the editor can keep track of the shots. The clapper stick on the top makes a loud noise designed to be heard on the separate audio recording, thus enabling synchronization of the audio and video in post-production. Most clapperboards also feature the director's name, camera/DOP name, date, day or night, and 'MOS' (whether the video has sound or not). Legend has it that MOS derives from a German-born Hollywood director in the early days saying 'Mit out sound' instead of 'without sound'. The term stuck.

Detailed notes

Script supervisors require detailed information on everything including wardrobe, make-up, props and sets, and make copious notes. They need to make a record of all camera set-ups in case a scene has to be shot again for more coverage, or for matching an insert shot later, or for visual effects post-production when matching in CG elements. The camera crew (usually the 2nd AC) will record and pass on the camera ISO setting, frame rate, lens and aperture used for each shot and any extra information on the way it was shot and the script supervisor notes it all down in the script notes next to the scene description. The continuity person is the official timekeeper on set and is the authoritative figure to ask on how a scene was shot, how many takes it

took, which was the best take and what colour tie 'Fred' is supposed to wear on a Tuesday. It's handy having an extra script on set in case someone forgets a line. These days it often happens that the script supervisor doubles up as the continuity person.

Left: The script supervisor is in charge of the script. Every shot is logged off in the script log and marked up on the script, with each camera position and change noted.

Documentary filmmaking

Documentary filmmaking uses 'real life' to tell interesting stories about factual events. From propaganda to well-balanced viewpoints, documentaries have been around for many years to educate, inform and enlighten us on wide-ranging subjects.

Many documentaries start with a simple idea, the desire to find the truth behind a story, or the wish to present a more balanced view of a certain historical event. Documentary is very popular, with many types of television programming fitting into the broad documentary category: wildlife and natural history, current affairs, science, religion, ecology and cosmology, travelogue and especially history programmes.

Money-making

Modern documentary can be on any subject and the rise in box-office success of films such as *Fahrenheit 9/11*, *Super Size Me* or *Touching the Void* has led to more awareness amongst filmmakers and funders of the opportunities to make money. Working in this genre costs less than drama and can be very rewarding creatively, giving you a lot of scope in the interpretation of the story. Documentaries can range from something as simple as a lecture-style 'talking head' narrative to a complex film full of re-enactments and dramatizations of past events and locations, using CGI and motion graphics.

Starting out

You may start with a particular idea, but after some research you may well unearth a different, more interesting story that becomes the main subject. You need to remember that you won't necessarily know the answers in

Below: Kevin Macdonald's Touching the Void.

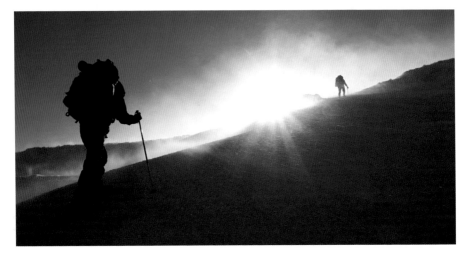

advance – you will be discovering them as you make the film. This can also mean that you might have to abandon a project part way through if the story doesn't go where you hoped it would. It's best to research as much as you can before committing to filming, and film this research, too, since interviews will invariably lead off in different directions.

Here and now

Some types of documentary start by 'documenting' an event as it happens – like the first ascent of a mountain, or the building of the local skateboard park. The story doesn't always end where you think it will, since what makes the story more interesting may be the social angle – the background behind the events and what led up to them. With the skate park, for example, the community is brought closer together and the story may centre more on multiculturalism. Or perhaps some dramatic events occur during the filming itself: with the mountain ascent, extreme weather could lead to hardship and the story becomes more about extraordinary courage and leadership in the face of adversity.

Field notes

Whichever way you choose to start your documentary project, it's best to create field notes as you go. In the digital world this is more commonly known as 'meta data', which can be added electronically to each video clip. Meta data or field notes should contain all the information about a video clip or interview, such as geographic location, date, interviewee details such as name, address, telephone number, email, and the same for all crew involved in the filming (for later credits), since these people may come and go over the lifetime of the project. You will also need to get signed permission forms (model release forms) as well as location release forms signed at the time of filming.

Top 20 documentaries

Making a documentary is often less expensive than making fiction drama. This also reflects on the film's success at the international box office. Here is a list of the 20 most successful documentaries at the box office at the time of writing, with the current lifetime gross takings.

	Title	Gross
1	Fahrenheit 9/11	$119,194,771
2	March of the Penguins	$77,437,223
3	Justin Bieber: Never Say Never	$73,013,910
4	Earth (2009)	$32,011,576
5	Chimpanzee	$28,856,904
6	Sicko	$24,540,079
7	An Inconvenient Truth	$24,146,161
8	Bowling for Columbine	$21,576,018
9	Katy Perry: Part of Me	$21,464,212
10	Oceans	$19,422,319

advanced
editing

In this section, you'll understand the more advanced editing techniques needed to take a longer project all the way to completion, including:

- **Getting to grips with non-linear editing software** such as Final Cut Pro X and Avid Media Composer

- **How to set up your workstation** and organize your workflow

- **Synchronizing sound and pictures** with timecode, automated sync or clapperboard

- **Cleaning up sound and using Foley** to give your film a more professional finish

- **Colour grading** your final edit so that it stands out from competing projects

Non-linear editing software

NLE (non-linear editing) software packages are not all alike, but they share a lot of common features. Which to choose? The answer – whether it's open source software or top-of-the-range professional applications – will ultimately come down to what best suits your needs.

All modern editing systems need to be able to import video clips, audio files and graphics files, allow you to preview and trim each clip and then assemble them into some logical order on a timeline. Once you have a rough assembly edit, you might want to add transitions between clips and do some colour correction/ matching before adding titles and other text, such as credits. Dialogue and music need to be synchronized and cleaned up and audio levels tweaked before exporting the finished video. Most NLEs will do all these tasks in one program, although some assign advanced colour correction or audio cleaning to other specialized apps within a suite of programs.

Clip library with clip bins Browser window to view clips Browser window to view the play head position

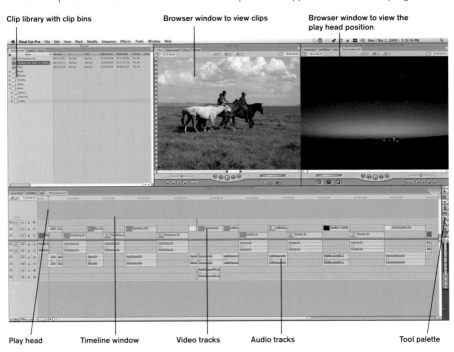

Play head Timeline window Video tracks Audio tracks Tool palette

Above: *The standard set-up for NLEs such as Final Cut Pro includes:*

What is non-linear?

'Non-linear' refers to the fact that you're able to edit your media clips in a random way, meaning that you can clean up your audio files, try out some colour grading options with a few clips or create your titles and then work on your main edit in parallel if you want.

All the main NLEs – from Apple's Final Cut Pro Studio, FCP X, Avid Media Composer, Adobe Premiere Pro, Sony Vegas Pro to open source software such as Lightworks – have ways to import and organize media to help get you started (see page 184). Most require that you choose very specific settings for each timeline or sequence/edit you create – selecting the frame rate, frame size and video codec to suit your material.

Some allow you to mix multiple different frame rate clips and multiple video codecs on the same timeline without rendering, although eventually you will need to render some effects or transitions to keep playing back your edit in real time or to export your finished sequence. It's worth checking how well an NLE supports the main video codec you're using, especially if you're shooting highly compressed codecs such as H.264 or AVCHD.

Effects and plug-ins

NLEs have a range of built-in functions for resizing, rotating and cropping clips, changing opacity or aspect ratio, speeding up or slowing down clips and the ability to use keyframes to modify these parameters over time. They also have a set of built-in effects for functions such as colour correction or sharpening and built-in video transitions that can be applied between clips, like cross-dissolves and wipes.

Video effects and transitions can be supplemented by downloading or buying plug-ins from third parties. The availability of built-in effects or specific plug-ins may ultimately influence your choice of NLE.

Round-trip

At a certain point in your filmmaking, you will need to collaborate with others on a larger project – to have audio edited by a professional audio designer, for example, or to have your video colour-graded on another system (see page 203). This is where some NLEs can fall down, as they lack the ability to 'round-trip' (export and re-import) the necessary audio and video file information in either an EDL (edit decision list) or a more useful OMF (open media framework) file containing audio and video information, or an XML (extensible markup language) file, to enable you to share your edit with someone else using another system.

Before you choose which NLE software to use, download and try out trial versions, read as many user comments and video reviews as you can, and decide which features you really need for your own video projects.

Workstation and workflow

It's wise to test out your whole workflow from end to end to ensure you're not left with footage you can't use. Your editing system must be up to the task, too, so that you don't get stuck further down the line.

If you're setting up a workstation in a room just for editing, consider the light sources, colour of the walls and ambient noise level. Neutral grey works well for walls (especially directly behind the screen), and you need enough backlighting to see your desk and keyboard. Avoid harsh lighting onto the screen and use black-out blinds to stop reflections from windows. If you're investing in decent monitoring speakers, you may need to add foam (or egg boxes) to improve the acoustics, or buy good-quality headphones instead. A large HD TV is good as a playback screen if you cannot afford a broadcast monitor, although you cannot guarantee colour accuracy on this.

Above: *It's wise to invest in good-quality seating, lighting and hardware. Many editors prefer a pen and tablet to a mouse for editing and motion graphics work.*

Below: *Your NLE software can generate colour bars that are used to calibrate and set up external monitors to ensure you're seeing the correct colour information.*

Workflow choices

For TV broadcast you might choose to shoot interlaced footage at 50i or 60i, or 24p for drama – but make sure you decide on your codec and frame rate *before* you start filming and not halfway through a project. If you're mixing footage from different cameras convert it to your codec of choice in one step (see page 184). Test your end-to-end workflow to ensure you can import media and export media in the formats you want *before* starting your project.

If you're using picture styles or presets (see page 58) on the camera, film some test shots first and load them into your NLE (non-linear editing system) to see how well they can be 'fixed in post' before you commit yourself. It's important to get accurate colours, as this will save many hours after the shoot trying to recover correct skin tones.

Editing gear and back-ups

You can easily edit HD with a modern laptop or an all-in-one computer like an iMac while using external drives for capturing footage. Have a separate high-speed drive connected just for render files, since your timeline may be running from render files most of the time. Keep back-ups of your original footage, as you never know when you may want to re-visit and re-edit a project or use some for stock footage on a new project. Keep spare drives

off-site with friends or family in case of theft, fire or storm damage or use a special fire- and flood-proof data safe (though these are not cheap). Consider backing up your original video data to DVD or Blu-ray dual-layer disks (BD50 fits 50GB per disk) or back up to a fast tape drive such as LTO for even larger amounts of video.

Peripherals

NLEs have many shortcut keys that you will learn over time, but to speed up the process you can get program-specific keyboards with colour-coded keys and symbols as well as USB jog-shuttle controllers to allow you to scrub through footage. NLEs come with a lot of tools that all need screen space; having a very large monitor (27"+) or a second monitor for editing gives you space for all the meta data and logging information windows, video scopes and colour-correction tools as well as the main timeline and preview windows. For professional work, it's essential to have a broadcast monitor to give you a constant output on a colour-calibrated display. These are not cheap and usually require an SDI card to output the video signal.

Importing your media

When you capture or transfer clips to your NLE, you can add important meta data to help you find the clips later – essential if you're working on a complex project. But before you start editing you may find you have to convert your video into another format as well.

Many NLEs work with a mix of different video codecs on the same timeline, but not many will playback properly without having to render some or all of the clips, thereby slowing down the edit process. If you have shot in H.264 on a DSLR or GoPro or shot AVCCAM or AVCHD or other new HD codecs, you will probably have to transcode the files to Apple ProRes for FCP (Final Cut Pro) or Avid Media for Avid Media Composer to allow you to edit the video. Adobe Premiere Pro 6 allows the mixing of codecs and even frame rates on the same timeline without transcoding and this may, for some users, be a good enough reason to switch NLE.

Transcode video

NLEs offer 'transcode on import' facilities to help speed up the process. FCP has a 'log and transfer' utility to help import and convert footage from many cameras. When you plug in a compatible media card or camera, or point it to a folder containing a compatible file system, it can be converted to various flavours of Apple ProRes and you can rename and add some basic logging information (meta data) to each clip. Alternatively, you can use external apps such as VoltaicHD to batch-transcode your source files before you start editing.

Right: FCP Log and Transfer lets you preview clips in their native codec before importing and transcoding chosen clips. It's wise not to rename clips at this stage to help re-capture later if necessary.

Left: The new AMA (Avid Media Access) architecture allows you to bypass transcoding and work with your media in its native format.

More conversion

The same rule applies to audio files and stills. Audio files take less time to render than video, so it's easier to get away without converting MP3 or MP4 audio files to uncompressed AIF or WAV or changing the sampling rate from 44.1KHz to 48KHz to match your video timeline. If you load huge 21-megapixel stills onto your timeline, expect render times to go through the roof; re-size them to match your timeline before importing. Many NLEs can import layered Photoshop files directly, but it can help to convert the layers you want into individual PNG or TIF files with alpha channels to speed up the edit.

Get organized

If you're working on a large and complicated project, you will generate a lot of footage and files that can soon become overwhelming if they are not organized well. How you organize your files is a matter of choice, but NLEs offer some tools to help. If

Above: When using multiple cameras it won't take long to create a complex editing timeline, as shown in this video in FCP. Using colour and good clip naming will help you manage your project better.

you drag in media files or capture files into an edit project, you can generally re-name the files in your NLE without affecting the real external clips. You can create multiple folders (or clip bins) to store collections of logically similar clips or keep track of your media by date or shot number. You can use colour to tag certain types of clips, marking good or bad takes. More meta information can be added – for example, descriptions that will help you search for clips later on. FCP X has some good search features where you can assign keywords to clips, search for clips containing some keywords and not others and even save these searches in a similar way to using a folder.

Synchronizing sound

Synchronizing sound and picture gets harder when you have multiple cameras, but there are techniques you can use in the edit suite to help with this. Just make sure you have some sound on your audio track...

Timecode sync

If your camera and audio recorder support timecode, they can be synchronized on your timeline almost automatically. Professional cameras allow you to sync the timecode between multiple cameras ('genlocking') before you start filming. DSLRs do not support timecode, but you can use a clapperboard with a timecode generator that all cameras point at to act as a sync point at the start of the take.

the same part of the video where the clapper comes down, set another marker at that point on the video track and now slide the video track so that the two markers align. The video and audio should now be in sync, though you can adjust by a few frames either side until it sounds right.

If you didn't use a clapperboard or think about sync in advance, it's still no problem if you have some sound on your camera track. It helps to adjust the audio levels of the camera sound temporarily, so that they reach a similar level to the main 'good' audio. Follow the instructions above – but instead of searching for the clapper sound, search for the start of a bit of dialogue where you can place a marker on the video and do the same for the good audio. Then slide the video track to synchronize

Above: Timecode can be 'burnt on' to video clips as shown here in Apple's Compressor program, adding timecode to DVD rushes.

Clapper sync

If your audio recorder doesn't have timecode, drop the audio onto your timeline, switch on the waveform view and zoom in to find the clapper or handclap at the start of the recording. If you can place a marker on the audio track at exactly that point, it will help sync the video. Drag the video track onto the timeline, find

Above: The Movie Slate app for iPhone, iPad and iPod can receive timecode from, and send timecode to, cameras, sound recorders and timecode generators.

Below: Shooting with multiple cameras gives you lots of flexibility in the edit, but sometimes it's a difficult decision choosing the best angle.

them – the markers can be anywhere in your clip and not just at the beginning. If your camera track has no sound at all, you will have to try lip-syncing the video manually. Note to self – try to avoid this next time!

Automated sync

If you want to speed up the sync process, you can try a software tool that does the hard work for you. PluralEyes from Singular software works for many NLEs, including Adobe Premiere Pro and Final Cut Pro. It takes your audio and video clips and creates new sequences containing the automatically synchronized clips. You do need to have camera sound on your clips, though, and it cannot always sync up everything correctly – but it usually saves a lot of time if you shoot with DSLRs.

Multi-camera editing

If you shoot video using multiple cameras, remember that the sound still needs to be properly synchronized. This is almost always done with synching software nowadays. You still need to choose which angle to show in your edit. Some NLEs give you the ability to synchronize multiple angles into a single multi-camera clip and let you do a 'live' mix in your timeline. They playback all camera angles simultaneously while you choose the angle you want for the main video clip at that instant of time using the keyboard. Your 'live' edit is 'recorded' onto a new sequence by playing back the multi-cam clip; if you want video 1 you press 1 on the keyboard, for video 2 you press 2, etc. This is a quick way of making a rough cut that you can re-edit in the multi-clip mode. The alternative is to create a nested sequence of synchronized camera angles manually and then perhaps edit out the bad bits of each track, leaving you with fewer decisions to make. The more camera angles you have, though, the longer this process takes.

Below: Software can automatically synchronize audio from multiple video and audio clips by analysing the audio waveforms and matching them up.

Frame rate conversions

The frame rate you use when shooting HD will depend on the country you're living in and the camera you're using. But if your delivery format needs to be different from your recording format, what can you do?

Interlaced or progressive

Typical TV transmission systems use a method of 'interlacing', so that instead of, say, 25 discreet frames per second, you have two 'fields' per frame, to give you a 50i signal (2 fields x 25 fps = 50i) in Europe, or 60i signal in the USA. You get a more fluid motion with interlaced footage and it's often used for sports as there's a more natural motion blur between the two fields each second than between progressive frames (see pages 98–9).

Modern LCD and LED TVs can show both interlaced and progressive footage, but some have hardware algorithms that remove the interlacing and try to show a progressive signal, for better or worse.

Below: Fast-action sport can look better shot using interlacing and will certainly show up any conversion issues if converted to progressive formats.

24 to 25 and beyond

The Blu-ray standards support 24p (actually 23.976 fps), 50i (25 fps) and 60i (29.97 fps), so if you've shot 25p you can't go straight to Blu-ray. 25p to 24p is a very subtle change and is easily achieved in Cinema Tools on a Mac or by using After Effects as well as most NLE software. If done correctly, each frame is left unchanged but your film is made 4% longer. The audio will also be slowed down by 4% to match, which is quite difficult to notice, but you can use 'pitch shifting' in an audio editor to bring it back to the original tone if you really want. The same method is used to go from 24p to 25p if you need to conform to PAL for DVD output, although you can make 24p DVDs for the US and European markets.

Telecine

To go from 24p to 60i for NTSC TV transmission or DVD you need to do a 3:2 pulldown or 'telecine' instead of a straight

Above: Peter Jackson is filming The Hobbit *at 48p (48 fps) for 3D to provide a more natural look to the film. This may be the start of a new era of productions being made at 48p, 50p, 60p and 120p and the death of one aspect of the 'film look'.*

speed-up, as a jump from 24 fps to 29.97 fps will be too noticeable. The 3:2 pulldown (also called 2:3 pulldown) means that the first frame is stretched into 2 interlaced fields, the next frame is stretched into 3 fields and so on, resulting in a 2-3-2-3 conversion that stretches 4 progressive frames into 10 interlaced fields of TV signal to fill in the gaps. Some DVD players can detect when 3:2 pulldown has been applied to a DVD and remove it automatically, to revert 60i to 24p for a judder-free playback on a modern TV.

25p to 50i uses a 2:2 pulldown to create 2 fields for each frame. Most NLEs can do this for you by rendering your progressive video on an interlaced timeline, although results will vary. Nattress makes a good standards converter plug-in for FCP that works well for PAL-NTSC and vice versa.

De-interlacing

If you have shot material at 50i or 60i and want to edit this into a progressive sequence, you will need to de-interlace it to remove the fields first. Most NLEs have built-in de-interlacing filters that can merge the two interlaced fields together, or just ignore one and use the other field (resulting in loss of resolution). The best results come from using an optical motion compensation algorithm that creates new frames in a clever way, but don't expect this to be a quick computation since you're creating brand new frames rather than simply merging fields. After Effects does a good job as does Apple's Compressor, using optical flow re-timing to create the new frames and introduce new motion blur to simulate the different shutter speeds between 50i or 60i and 24p. You can achieve some frame rate conversions in hardware such as the Matrox MXO2 and various capture and play-out cards from Blackmagic Design and AJA, but you will need to record to a deck or another computer over SDI.

Transitions and cuts

Editing comes with a language of its own, where shots are cut and spliced together to make seamless or very obvious transitions. The digital world has added complexity to the options available, but the reasons for cuts remain the same.

Every film has cuts between shots – the basic 'content cut' allows you to go from a wide shot to a two-shot to a close-up, for example. Cuts can be 'hard', where the scene changes immediately from one shot to a completely different shot, or 'soft', where two scenes overlap for a while and one fades or 'transitions' into the other. Basic transitions also include 'wipes', where a shape like a circle or a straight line with a soft edge is used as a stylistic device to wipe one shot out as the other one comes in, as used in films like *Star Wars*. Directional 'push' transitions work well, when the action in the incoming clip continues at the same speed and direction as the push transition itself.

Below, left to right: A wipe can be used very effectively to give your transition a natural feel. The wipe here goes with the movement of the passer-by – walking through a rainy London street and ending up on a Sydney beach.

Transition timing

The most basic transitions are fade-in or fade-out from black (or another colour) and cross-fade between two shots. You need to plan transitions, as you must have enough footage to last the transition time. If you have to cheat in the edit, create a freeze frame of the last frame and extend it on your timeline as long as you need. Cross-fades or cross-dissolves work best when you clear the frame before the transition, by having a darker part of the outgoing shot match the position of the lighter part of the incoming shot, so that the fade effect lingers and doesn't get too confusing as the new shot comes in.

Types of cut

Cuts between shots need to be done for a reason. A cut can be motivated by a look off screen to a POV or inset cut, or by an action – where an action started in one shot is finished in another. For example, we see a wide shot in front of the casino with 'Stanley' arriving in his old car, then we cut to a closer shot of the door opening and him getting out. You need to overlap the action when filming to allow more options in the edit for exactly when you can make the cut between the two shots; otherwise you could end up with a gap and need to do a 'jump cut' instead. A jump cut fills a gap of time by forcing two shots side by side that might have had a longer time gap and is an obvious transition that is noticeable to the audience (and which may be deliberate). A 'cross cut', where you cut between two different scenes that are running in parallel to heighten the suspense of the story, is similar.

Above: A famous match cut in 2001: A Space Odyssey joins a bone thrown into the air with a drifting spaceship in a thematic and aesthetic connection.

Match and zero cuts

Wipes are used more often these days as a seamless cut (a 'zero cut'), where someone or something goes in front of the camera deliberately. The frame goes black for a split second and then the next shot is revealed. As long as the next shot is a match for lens, camera angle and direction, this can be used to transition seamlessly without being jarring for the audience. You can fake a zero cut wipe in the edit if you're careful, or use a 'match cut' instead. A match cut is where two shots are set up to deliberately match each other – for example, an overhead shot of the roulette wheel spinning and landing on Stanley's number, then a match cut to the spinning wheel of a car, followed by a shot of Stanley driving a shiny new car as the camera pulls out.

Editing techniques

Editing is an art. When it's done right, everything flows – the action, the dialogue, the music and the sound effects all combine to invoke an intense emotional response from the audience. Learning this art takes time and practice, but with increasing experience creativity will flow.

A fresh approach

If you've thought about the edit during the planning, you should have all the coverage you need to edit the film. Once you have all the clips on your computer, all nicely labelled up by scene, shot number and take number, it can be a relatively easy task to do an 'assembly edit' or rough cut just following the script. The edit stage is a good time to take a fresh look at the story and maybe create quite a different piece to that originally envisaged.

Major changes can be made in the edit, such as hiding information that was revealed to add more suspense or removing slow sections that don't move the story on enough. Sometimes the changes create the need to re-shoot whole scenes (though it's best to re-edit to avoid this unless budget is no concern) or perhaps just add extra cutaway shots. A simpler change, such as overlapping the dialogue more closely in a scene, can create tension between characters that wasn't planned. Or the editor might cut together the front and back of different takes to improve the flow, which could lead to using additional angles that would not have been possible if the director's original choice of takes had been used. However, it's usual for the director and editor to work together to create something that fits the director's vision, at least after the first rough cut.

Rhythm and music

One technique is to start with a music track and try to fit the action around the music, matching cuts to the beats so that the scene rises and falls with the music. This technique can work very well for short sequences or montages but, unless the music has been scored specifically for you, it's unlikely to match any complex emotion and any lyrics soon get in the way of dialogue.

The rhythm of a scene is dictated by the pacing of the cuts, how tight you leave the pauses in dialogue between speakers, and how long you linger on each shot before cutting to the next shot. It's more usual to start editing to match the pace you want, and then score the scene with music afterwards – perhaps tweaking the shot lengths to match

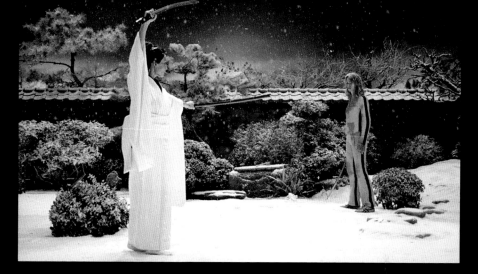

the music. Some people prefer to use a temporary music track to help them visualize a finished scene, although this can cause problems if it's music you cannot then license easily (see page 144).

Corporate editing

If you're editing material such as interviews or business promotional videos, you will be more concerned with the overall message that comes across, and the pacing will be geared towards your target audience. This means that you will have to create several versions of different lengths to satisfy different audiences and different usages of essentially the same video. You will generally use more cutaway shots to cover over 'talking heads' and have more scope for using stylized transitions and motion graphics if that fits the style of the organization you are editing for.

Above: Quentin Tarantino is well known for using music and sounds to create pace. In Kill Bill he merges his samurai and Western influences beautifully with a Spanish guitar disco piece during the famous face-off in the Zen garden.

Below: Cutting a fast sequence to music is very effective if you use fast cuts with very little transition time, to allow for perfect timing with the beat of the music. Using complex music gives you more chance of matching a cut to a music beat.

The **sound edit**

Already edited and synchronized your video? Let's now look at sound and the ways you can normalize audio levels, clean up dialogue, and add music and sound effects.

Normalize

The first stage is to do a basic audio level 'normalization' on all dialogue clips. This means bringing up the levels of all clips closer to 0 dB, or -3 dB if you prefer, so that you can hear the dialogue properly and listen for anything that needs to be cleaned up further (see page 196). You may have already completed this stage before choosing clips for the edit, since this is one of your selection criteria – to listen out for background sounds that can ruin a take. Most NLEs have tools for automatic audio normalization, allowing you to just click on a clip and normalize the level (by

adding a calculated amount of gain). These tools speed up the sound edit dramatically by giving you a rough cut with sound levels that do not exceed the maximum level of 0 dB.

Organize

It's usual to edit and clean up your dialogue first and then add music and effects later, rather then trying to edit all of them at once. If your video timeline supports multiple audio tracks, it's good practice to split dialogue and music and SFX (sound effects) onto different tracks, so that you can keep on top of the edit. You will need several tracks for dialogue if your edit contains 'J' or 'L' cuts (where the dialogue overlaps the video slightly). You can choose to see audio waveforms on your timeline to identify different sound clips by eye (with practice), but some NLEs let you use colour to

Above and right: *Normalizing dialogue is an iterative process to increase the overall sound level while minimizing any abnormal peaks, as shown in these before (above) and after (right) waveforms from Soundtrack Pro.*

Right: A digital VU meter with colours and a peaking feature helps you see where the master audio level goes above 0 dB, shown here on the far right in Soundtrack Pro.

Left: Use keyframes to modify the audio levels to ensure that the master audio does not exceed 0 dB, shown here in Adobe Premier Pro.

differentiate clips – you could colour all music in red and all SFX in yellow, for example, to help you manage a complex sound edit.

Keyframes

If you plan to do all your sound editing in your video editor, you will probably need to use keyframes to bring the levels up and down instead of just using a single gain value for the whole clip. Adobe Premiere lets you modify and 'record' the audio level slider as your timeline plays back, as well as allowing you assign keyframes manually (like Final Cut Pro) so that you can drop the levels either side of a really loud piece of dialogue or noise and use a clip-level gain setting, too.

Export

NLEs have a wide range of built-in audio filters for adding audio effects such as delay, compression and reverb, but these generally need to be rendered first to playback in real time. It's more usual, therefore, to 'send' your audio to an external audio-editing application such as Logic, Soundtrack Pro or Adobe Audition to give you more control over levels. So your work schedule becomes: export your timeline audio to a file, normalize and clean it in an external sound app, then re-import it and turn off all your original audio.

Finalize

Once your dialogue has been cleaned (see also page 196), it's time to add SFX, Foley sound (see page 198) and music – referred to collectively as M+E (music and effects). You need to adjust the audio levels of all your different tracks to avoid peaking and do a final mix with dialogue and M+E tracks. Keeping dialogue and M+E tracks physically separate is good practice that will help when delivering movies for dubbing into foreign languages later.

Sound **clean-up**

Even if you have been extremely diligent while recording sound, there will always be 'clean-up' tasks to perform in post-production. Let's look at the most common problems and solutions.

Sound of silence

One important task for the sound edit is to patch in any gaps in dialogue with the corresponding room tone or wild track – either generated from real gaps in the dialogue or from a wild track recording (see page 72). It can help to tag on some wild track to the end of your video timeline before sending it to your sound editing app, so that it's available in your sound editor more easily and can then be cut and pasted as required and trimmed off later in the video edit. Some editing apps allow you to select a region of the audio and assign it to a special paste buffer especially for this task (called 'ambient noise print' in Apple Soundtrack Pro).

Below: Audio apps such as Soundtrack Pro let you apply complex audio effects and assign sections as ambient noise to help cover any gaps in your dialogue.

Background noise

Once your dialogue has been normalized (see page 194), you may still need to match the background noise levels of clips within the same scene – this applies to room tone audio as well. If you used dialogue from different takes within the same scene, each one may have had a different level of gain applied, or have been recorded with a different audio level in the first place. Play back your dialogue and listen for any major discrepancy in background noise across a scene. If there are any big changes, you have a couple of options: try to reduce the noise for parts of the dialogue (see box) or add some extra Foley sound, music or SFX to the whole scene to cover up the problem. If it's really difficult to remove the noise, you will have to search for alternative dialogue from another take or use ADR (see page 77).

Unwanted noise comes in many forms, from discreet chunks of noise such as a door slam or an aeroplane flying by, to small errors such

Above: *Suspected clicks and pops highlighted in red can be automatically fixed – but be careful not to remove real sounds.*

as clicks and pops, or more continuous noise such as a lawnmower or air-conditioning hum. Some of these are fairly easy to get rid of with automated tools in sound editing apps. For example, clicks and pops are characterized by a short duration peak that is out of step with the rest of the sound and you can normally find and remove these automatically.

Noise reduction

Other types of nearly continuous noise such as air conditioning are trickier to remove and you will need specialist tools built into Soundtrack Pro, Adobe Audition or an external application such as iZotope Rx. In these apps you pick an area of your noise with no dialogue in it. The noise is analyzed and can then be used to remove similar noise from the whole scene. It's processor-intensive, and be careful to adjust the parameters to avoid getting a 'bubbly' or 'gurgling' soundtrack.

EQ filters

Continuous 'hum' can be reduced using an equalizer or EQ filter, which can notch out any hum at specific frequencies like 50Hz or 60Hz caused by the frequency of the mains power. You may need to reduce the gain at the harmonics of these frequencies, too (that is, at 2x, 4x and 8x the frequency) until it's all gone. The level of all the lower-frequency sounds (below, say, 80Hz) is usually reduced using EQ filters, too, since most TVs and sound systems do not reproduce this range, and that's where wind rumble is found.

Above: *These two spectral displays from Izotope RX shows the frequency spread from a small section of audio with some bad low-frequency noise, both before and after removal using a cutting tool.*

Sound effects and Foley

We generally take for granted the sound effects heard in films and television, but the art of the Foley artist is alive and well. Why not create your own sound effects? It can be loads of fun and very rewarding.

Foley artists create special SFX (sound effects) to match the action on screen: footsteps, zips, fridge doors closing, bags rustling, kettles boiling, snowballs being scrunched, punches landing – pretty much anything that was either too hard to record on set, or came out too quiet or too loud or just didn't sound right at the time. You can create your own Foley sounds by listening to real noises and finding ways to reproduce and record them.

Stock sounds

If you don't have time or access to a tray of gravel for those crunchy footstep sounds, then luckily most NLEs have built-in SFX clips to cover a range of scenarios. Soundtrack Pro, which comes bundled with Final Cut

Studio, has a good range of stock SFX clips, from balloons to bubbles and from chickens to crowds cheering. You can also buy a collection on CD or individually from online stock libraries such as sounddogs.com. Some SFX are provided as surround-sound (see box) audio clips to cover location sound, too – for example, on the beach or at a rodeo or football game; this is useful if you didn't record enough wild track on location or need to completely replace the location sound.

Below: Special microphones such as the Holophone make it possible to capture true surround sound for Foley and SFX, as used extensively in the Danny Boyle movie, Slumdog Millionaire.

Surround sound

5.1 or 7.1 channels of sound (or more) have been the mainstay of the cinema experience, bringing extra realism to live action and blockbuster movies and putting you in the middle of the soundscape. The standard surround set-up includes a stereo front left and right, with dialogue in the centre channel and a left and right surround channel in the rear. The .1 refers to the sub-woofer channel for those deep, seat-rocking, sub-bass frequencies. Two more channels are added for 7.1, with a left and right mid-speaker giving a more rounded experience.

If you're planning on creating surround sound mixes for your own film, you will need surround monitoring in the edit suite as well as in playback to see how well the effect works. Professional movie sound mixes are done in studios where you can hear the sound exactly as you would in a cinema, but you can build a decent home-theatre system on a modest budget.

Left: Foley artists such as Karina Becker find ever-new ways to create sounds that reflect what you see on screen – in this case, the crunching of bones in the film To Rest In Peace.

Sound design

Sound editing software such as Logic or Soundtrack Pro gives you full control over audio frequency and equalization, reverb and compression and has a built-in 'space designer' filter to allow you to modify your SFX clips or re-recorded ADR (automated dialogue replacement) dialogue to help them 'fit' properly into your scene. You can add or remove echo and reverb to simulate the sound of a massively echoing cathedral or a tiny cupboard full of stuff that deadens the sound dramatically.

Some sound effects require only basic changes to dialogue or SFX – for example, simulating the sound of someone on the end of a telephone. First you record both parties speaking separately, then you add effects to the speaker on the other end of the line. To make it sound as if they really are on the phone, remove some of the high and low frequencies that wouldn't be transmitted over the phone's lower bandwidth. You could also simulate the phone ringtone or replace it with a different SFX clip. Or why not try to simulate the sound of a mobile phone signal breaking up mid-conversation?

Above: Soundtrack Pro comes with a good library of SFX clips, many in surround-sound versions, with a search tool to help find the effect you need.

Above: The space-designer plug-in for Soundtrack Pro has loads of presets, from woods and mountains to small rooms and car interiors, to help you match the echo and reverb of a location.

Using **stock footage**

If you need a shot of Mount Everest or want a hefty explosion to add to your no-budget action film, it's unlikely that you will be organizing a special fly-by or bringing in the fire brigade and a stunt team just to get that one shot. Welcome to the world of stock libraries.

Stock libraries exist to satisfy a need for affordable images, video, photographs, still and motion graphics, sound effects, music, fonts and specially shot material on green screen or with an alpha channel to enable simple compositing with your footage. Stock has been around for years, with many production companies shooting their own material and saving it for other productions – cutaway shots of locations, people or processes – although sometimes it's never used. Much old newsreel footage has been scanned, cleaned up (or not) and made available from archive libraries. If you want more up-to-date material, new stock companies are creating quality compositing aids in HD to 4K, with fire and explosions or smoke, gunshots and blood splatters to fill a gap in the indie action and horror film markets.

Below: A stock clip of a real petrol explosion will add realism to the CGI helicopter to 'sell' the shot.

Where to find stock

Don't look for images or videos on Google or YouTube and download and use them as stock; they are subject to copyright. Some may be subject to CC (Creative Commons) re-use, but this will be explicitly stated (see page 208 for more on CC licensing). Go online and search for stock footage from the likes of istockphoto.com, artbeats.com, footagefirm.com or Getty Images, or search for the very specific shot you need and you may come across some sites with very specialist niche videos, like underwater (oceanfootage.com) or aerial shots (skyworks.co.uk) or compositing elements for action films (rampantdesigntools.com). Some of these websites give away free stock clips or images as a marketing tool, attempting to draw you in to buy from them in the future. Some clips are much cheaper than others, but you generally get what you pay for in terms of quality and uniqueness.

> **i Start your search here…**
>
> There are a lot of stock libraries of varying quality around, but if you are after something less common than aerial shots of New York, these libraries are a good starting point:
> www.bbcmotiongallery.com
> www.corbismotion.com
> www.gettyimages.co.uk/footage
> www.sonypicturesstockfootage.com

Left: *If you've just come back from your holiday in some far-flung country or nature reserve, why not turn your own footage into downloadable clips on sites such as iStock.com or shutterstock.com?*

Above: *Archive footage like this is ideal for creating a period 'newsreel' for a WWII movie, but will probably get more use in a documentary or historical film.*

Make your own stock

If you can't find what you want, some sites will allow you to post requests and have videographers bid to produce the clips you need – ideal if you have some budget but not enough to travel to the required location. It's possible to make a living by just producing stock clips to order; investigate if any of your old unused material might fill a gap. Sites usually pay in arrears for any purchases made of your material and there is a pre-selection process to check that it's good enough or unique enough for the website.

Other sources

Many applications come with built-in stock clips and sound effects that are part of templates; these bits can usually be pulled out and used independently, too. The new Apple iMovie 11 software comes with a fun 'trailers' feature with built-in themes such as 'superhero' or 'fairly tale' that might give you elements you could use in more professional projects – if you find a way to use them creatively or out of context. You can also buy add-on templates for motion graphics packages such as Apple Motion and extra DVD menu themes, if you can't create your own yet. Plug-ins from sources like FXfactory.com generate good-quality motion graphics backgrounds, with a lot of parameters to give you the flexibility to re-use them.

Colour **grading**

Colour choices can be made in-camera during filming. However, most are made during the final phase of the edit to correctly match clips from different shots and to give your video a unique look.

The first phase of colour correction is to fix issues with WB (white balance) and exposure that were created during filming. Maybe you forgot to set the WB or just need to tweak it a little. You need to match shots from different cameras if one has a different colour temperature setting or one is a lot darker than another. Cutaway shots may have been filmed on a different camera or you may have some stock footage that needs re-sizing and colour matching to fit the scene lighting. The aim of this matching and correcting phase is to get all of your footage to look similar *before* you apply the 'look' or colour 'grade' that you want.

Tools

The most common filter for colour correction in all major NLEs is the three-way colour-corrector tool. You can control the value and colour of the shadows, mid-tones and highlights, plus the colour saturation, all in one tool. Start by correcting a master clip for each scene, adjust the level of the shadows and highlights and the mid contrast, and then try colour changes in each section to make it

Above: A frame taken from a RED One in its RAW state (top) and after grading (above) shows just how much scope there is in a well-balanced colour grade.

Right: Apple's Color lets you apply filters as a series of connected elements that can be linked in any number of ways to create different effects. Choose built-in colour effects or create your own 'looks'.

look correct. You're not trying to create a 'look' here yet, but you are concerned with contrast and white balance. Once you're happy with the master shot, you can match other clips in the same scene to it. Many NLEs have split-screen comparison tools to allow you to view several clips side by side, plus vectorscopes and waveform tools to give you more detail on the colours and levels in each shot.

Plug-ins

Once the clips are all matched you can start building your colour grade, using another three-way filter or built-in colour tools such as gamma, Luma and RGB curves, or saturation, brightness and hue controls. The filters can be applied one after the other, but will increase render time.

If you want more options, download some free plug-ins or purchase from a wide range like the Magic Bullet suite, GenArts Sapphire or FxFactory plug-ins, amongst others. Stand-alone grading applications exist as well, such as the Color application as part of FCP Studio, and Blackmagic Design now offer a free version of their fantastic DaVinci Resolve grading software. You can even get a plug-in from The Foundry ('MatchGrade') to automatically match the grade or look of one clip with another.

3D LUTS and RAW

When you shoot using a very flat camera profile such as the Technicolor Cinestyle DSLR in order to try to squeeze dynamic range from your camera, or shoot RAW footage on the RED or other cinema cameras, it can look rather dull and lifeless before you grade it. These types of footage need to have special colour 3D LUT filters applied that use gamma and colour curves designed for the profile. The Cinestyle profile can be graded using a Technicolor 3D LUT to give the correct gamma S-Curve or the free Magic Bullet 'LUT Buddy', although the Nattress 'S-Gamma' plug-in can give very similar results with more control.

Left: FCP has a great three-way colour-correction tool with histograms and vectorscopes to help you visualize the light distribution in each scene. The frame-matching tools make it simpler to match each shot against a master.

And **roll credits...**

This is usually one of the last jobs you do, but one that can take a disproportionate amount of time to get right. Watch the credits on a few of your favourite films for inspiration – and beware of flickering text.

Credit sequences vary wildly, from complex animated 3D text in a style to match the title sequence to simple scrolling names on black or static text faded in and out. As long as you get the correct spelling of cast and crew's names, you have a lot of scope on how you display the information. If you're producing something for a television channel such as the BBC, they have very strict guidelines on what goes in the credits (names for crew positions, for example) and how they look on screen, but in general there are a few commonsense rules.

Text location

Credits need to be on screen long enough to read either as a set of static pages or as a list scrolling slowly – but not so slowly that the audience gets bored. Credits are normally centre justified and scrolled as white text on black. Take care to keep titles inside the title-safe area (see page 163) and also within the broadcast-safe colour range (see page 203). You can choose to start the credit roll before the end of picture fade, but the credits still need to be readable and may need a slight outline to the font. Some people like to have extra video pop up throughout the credit sequence, maybe in small boxes or in gaps between credit plates or credit rolls – this can work as long as it doesn't distract too much from the credits themselves or make them last too long.

Flickering fonts

Try to avoid very thin fonts, as these can create annoying flickering as they scroll. A bold sans-serif font of at least 20pt will give the best results, but you will need to experiment with font size and style to see what works for you. Many NLEs have built-in title generators that

Left: Final Cut X offers a wide variety of credit templates, from a simple scroll to animations, to let you create original sequences. Before you get too fancy, though, think about where you want it to go. Broadcasters are very strict about centring titles either as scroll or single cards in the broadcast-safe area (left, top).

Left: By extending the title sequence along the main timeline, you will make it run longer, and – depending on the amount of titles it contains – it will also run slower.

allow scrolling (horizontal movement) or crawling (vertical movement) credits to be simply dropped onto the timeline and edited as a separate sequence. These generators work well, but can still induce flicker after rendering. You can adjust the length of the scrolling text element and this will normally change the scroll speed, although some plug-ins allow these to be independent of each other. You might want to time your credits to match a music track or fade the music at the end instead.

Long credits

It can help to lay out your credits inside an application such as Adobe Photoshop, especially if you need to embed any logo graphics or you have a very long list of credits. Create an image file the same width as your video (say 1920 pixels for full HD), but make it extra tall to contain the full list of credits and logos. When

you import this image into your NLE, it should be brought in either as white on black or with an alpha channel transparency (like PNG or TIF) or as a PSD vector image file. You then use standard key framing to make the image appear to scroll from top to bottom, adjusting the scroll speed as required to make it readable.

Useful tips

- Always create your credits sequence in the best codec you can – an uncompressed codec will usually give the best quality.

- Play back your credits and make sure you have enough time to read each name.

Below: Once you have created your credit scroll, carefully pick a font that stands out enough, or choose one of the many font themes that Final Cut X offers.

Going
live

In this section, you'll find all you need to know about what to do with your work after completion, including:

- **Media-sharing websites** and their potential use for your project

- **How and where to release your film** – online, offline and through festivals

- **How to burn your film to DVD** and create menu and interface for the user

- **Advanced DVD and Blu-ray authoring**

Media-sharing websites

The internet has made it easy to self-publish your video for all the world to see. Make the most of this free resource, but be sure to read the small print before you post your precious masterpiece.

User-generated video-sharing websites abound, from Facebook to Metacafe and Vimeo to YouTube. These easy-to-use sites give you unlimited free storage space, your own unique URL, a certain amount of customization and the ability to communicate directly with your audience through comments, 'likes' and ratings without any coding required. You get the ability to geo-tag, date stamp, describe and add custom tags to your video to generate SEO (search engine optimization) that the likes of Yahoo and Google use in their normal search results to help others find your video online.

Too good to be true

This all sounds great, so what's the catch? There aren't many catches really, as most video-sharing sites make their money back from advertising on pages where your videos are shown. If your video gets lots of hits, you will find adverts being tagged on before anyone can watch your video – similar to how many on-demand TV channels are run online today.

Who owns my video?

You still own your own content, but you're allowing the video-sharing sites the rights to exploit your video and make money from it worldwide. You are usually also giving away the rights for the creation of derivative works (in the case of YouTube), so read the small print.

Some sharing sites give you the choice to assign a special Creative Commons licence to prevent others from making derivative works or to allow non-commercial use, for example. Once your film is online, it's much harder to remove it – and protecting your copyright can be difficult if someone else pirates your film and uploads it.

Above: *YouTube allows you to customize your own channel, building multiple playlists and managing your subscribers and user comments.*

Above: *French-run Dailymotion follows a similar model to YouTube, with millions of hosted videos. Become a MotionMaker to upload 1080 content with no limits.*

Extra features

Some sharing sites allow you to add password protection or only allow your video to be shown to specific users – useful if you want to share a rough cut of your video with collaborators. Many sites cross-link videos, so you can upload once to YouTube and your video will also appear in your Facebook feed. Most sharing sites allow you to embed your video into other websites or blogs, too, but they don't like you downloading the video files directly. However, many browser plug-ins and apps exist to bypass these restrictions, so always assume that once your film is online it can be copied easily, and don't put anything online that you intend to keep confidential.

Sites that suit you

A site such as Vimeo is known for hosting high-quality HD videos from indie producers and so tends to get constructive comments

from other filmmakers. YouTube has so many videos that you may get lost in the crowd or get annoying and ignorant user comments – but the SEO advantages are great and the potential for getting a share of the advertising revenue if your video goes viral can be very attractive. There are countless stories of videos shot on mobile phones creating a fluke worldwide buzz.

Encoding

Video-hosting sites will re-encode your video to fit their platform. Many sites now accept uploads of full 1080 HD video and will automatically create smaller versions for smartphones or for lower bandwidth play-out. It's best to upload the highest quality you can and let the sharing site re-encode as required. Check each site's duration and file size restrictions, as you may be restricted to 10 minutes or less unless you buy a premium account.

Above: Vimeo tends to attract filmmakers uploading short films, music videos and showreels rather than talking-dogs videos or family-holiday films.

Above: Blip.tv offers a platform for web-based drama as well as integrating with social media, and offers a 50/50 revenue split with content producers. This site is aimed at the semi-professional market.

Burning to DVD

Online video is a great way to share your film, but you can't beat having physical media like DVD – a prerequisite for most festivals, clients, or even just family and friends if you want to give your video for Christmas. But before you burn it, there are a few things you need to bear in mind.

The DVD format has been around a long time to allow SD video to be played back on computers, DVD players and some games consoles at a rate of up to 10Mbps for the audio and video combined. In reality, most DVD players cannot cope with quite that high a data rate – so when encoding, you must adjust your rates and test the finished playback for any problems. DVD encoding can be a black art, but most DVD-making software will give you some controls or presets to choose for video and audio. The more you compress your video, the more you can fit onto a DVD – but at the expense of quality.

DVD types

The standard blank DVDs you buy will be 12cm in diameter, single sided, single layer in either DVD-R or DVD+R formats. These are also known as DVD5 and can take approx 4.7GB of data or about 90–100 minutes of high-quality video. Avoid DVD-ROM disks for video, as these are designed primarily for data. Dual-layer DVDs (DVD+DL or DVD9) are available with a capacity of 8.5GB to allow you to fit on more video and are useful when you have a long film or lots of extra features. Dual-layer blank media costs more than single layer and you can sometimes hit compatibility issues for duplicated dual-layer disks. These compatibility issues go away for disks replicated from a glass master (like Hollywood DVDs), rather than disks duplicated at home or at work.

Compression and files

Your DVD software may hide the file compression process from you when you import your finished film, but it will have to do a lengthy compression process at build time

Left: Off-the-shelf DVD-burning software offers a huge range of options to help you build your DVD, with built-in encoders and templates for menus and buttons to support subtitles and multiple languages.

- DVD menus – especially motion menus – will take up space, too, so factor this into your calculations when encoding your film.

- DVD space calculator tools can be found online and as smartphone apps to help you calculate the best encoding rate for your DVD.

- Try super-quality 'watershield' disks for a waterproof and smudge-proof glossy print finish.

- Consider a tower burner if you need to make large quantities of disks – these save loads of time and burn multiple disks at once with easy auto-verification.

unless you import the correctly formatted files. HD files will be down-converted to SD, too, as part of the compression. DVD video files use the MPEG-2 format and audio is normally compressed using a Dolby™ encoder to AC3 format. Many PC burning applications exist, including Roxio Toast and Nero, which work with uncompressed or finished assets. On a Mac you can use the Compressor app to create your MPEG-2 and AC3 files prior to importing into DVD Studio Pro or Adobe Encore or use iDVD or Toast to do the compression in the background.

Printing and packaging

Most inkjet photo printers come with a DVD tray or caddy for printing straight onto the disk. Avoid using any stickers or labels as these can come off in a DVD player or cause a wobble in playback that stops the laser being able to read your disk. Check the types

of disks you are buying, as thermal printable disks exist as well as inkjet printable disks, and they are not cross-compatible.

Consider your DVD packaging, too. So many options exist – from basic plastic wallets or cardboard sleeves, digipaks, through to standard DVD cases in a range of colours with insert sleeves, slim-line cases, half-sized cases, clam-shell hard cases and foam dots to allow you to attach your DVD to a flyer or poster. Initially, it may be easier to just use a CD/DVD marker pen to write on your disk.

Right: You can buy smaller or larger quantities of DVD packs and design your own sleeves to slip into the provided sleeves, or you can get an online service to print a batch for you, often at reasonable prices.

DVD authoring and Blu-ray

Have you finished a special-interest video that you now want to sell, or a short film for festivals, or do you just want to give HD versions of your family videos to friends? Let's look how you can package up your film professionally with the more advanced DVD and Blu-ray options available.

No digital format is ever completely copy-safe, so the industry has always aimed at making each new format as secure as possible. DVD regions were conceived to protect markets, and you can use these to your advantage.

Region coding

The DVD format allows for region coding in an attempt to protect the market, so that a DVD made in the USA (region 1) won't necessarily play in Europe (region 2) and vice versa. Many DVD players are now sold as 'region-free' or have instructions on how to play any region-coded DVD. You can build a region-coded DVD yourself in more advanced programmes such as Adobe Encore and DVD Studio Pro or let your software create it as 'all regions' or region-free (region 0), which is more usual for compatibility. Don't forget about choosing PAL or NTSC versions for your standard definition DVD (see page 38).

DVD copy protection

DVD piracy is a big problem for content owners worldwide (which now includes you) and DVD encryption called CSS (content scramble system) has been built into the standard since it was created. Manufacturers have tried to add extra protection to make DVDs harder for the casual user to copy or 'rip'; solutions exist from Patronus, CopyBlock (Macrovision) and others. CSS only works for disks that are to be replicated and is added by the replication facility – you enable CSS in your authoring software, but must supply a DLT (digital linear tape) master or ISO image file as a master instead of a plain DVD-R to the replicator. The Patronus solution works for duplicated and replicated disks alike and can be added to an ISO image of your master disk before being made. Unfortunately, no copy protection is 100% guaranteed to stop the most determined hacker.

Blu-ray disks

If you want to make a Blu-ray disk of your content, you will need a Blu-ray burner plus software like Roxio Toast (with their BD plug-in) for a basic auto-play disk or Adobe Encore for a fully featured disk. The Blu-ray format includes 12-cm disks that can contain both standard and high-definition content, with advanced pop-up menus, picture-in-picture options as well as standard menus similar to

Above: *Some models of the Matrox MXO video i/o device have MAX H.264 encoder hardware built in to allow quicker-than-real-time H.264 conversion for web and Blu-ray delivery.*

Above: DLT digital tape drives such as this 40/80GB drive from Quantum are used for delivery of masters to replication facilities (especially dual-layer).

Above: Sony Vegas Pro, with their DVD Architect Pro, enables advanced DVD and Blu-ray authoring with advanced scripting for controlling menus and interactivity, region and CSS coding, subtitles and multi-language support.

DVD. Blu-ray disks can contain up to 25GB for a single layer BD-R or 50GB for dual-layer BD-R DL and come in rewritable BD-RE formats, too – useful while you're testing. More space means more content and also higher-quality content, with more bandwidth for audio, too. Encoding is either H.264 like web encoding or MPEG-2 similar to DVD, with AC3 Dolby audio. Blu-ray content at 1080 (1920 x 180) needs to be 24p, 50i or 60i to be compliant and so you will need to conform any 25p to 24p material before encoding it.

Advanced protection
To add the more robust Blu-ray equivalent copy encryption – AACS (advanced access content system) – you need extra software like Sonic Scenarist BD Pro, Sony's Blu-print authoring package or BluStreak Tracer from Rivergate, which can be used to fix authoring problems and create a disk image for replicating rather than just duplicating Blu-ray content for professional releases.

i Useful tips

• Computers are more forgiving than DVD players, so always test your menu buttons both on your computer and on a DVD or Blu-ray player before making multiple copies.

• DVD scripting is easier than it seems, so persevere and use online tutorials to build extra interactivity into your DVD menus.

• Motion menus are easily made in your NLE and imported as a menu background.

• Photoshop integrates with many DVD and Blu-ray authoring programs for building menu buttons.

Above: Apple's DVD Studio Pro offers a complete package for DVD authoring, with built-in templates, transitions and button styles, as well as advanced scripting, slideshow creation, encoding and DLT output.

How to **release your film**

How can you get your film noticed? There are many good films being shot these days, but the challenge has swung sharply from how to get a film *made* to how to get it *seen*. Here are some marketing ideas.

If you didn't have the budget to cast any big stars or couldn't persuade any to come onboard for free with your fantastic script, then it's unlikely a distributor will immediately jump all over your film. You will need to build up some critical acclaim through film-festival wins to draw attention to it and then try to sell it to a distributor at a sales event like MIPCOM in Cannes. MIPCOM is *the* event for selling 'entertainment' content and attracts buyers and sellers worldwide.

Above: *Arranging a screening in a small cinema is a great way to present your film to your audience for the first time and bring everybody together who helped you realize your dream.*

Sell sell sell

Selling is *everything*, and generating interest and publicity for your film is all part of the sales process. Film festivals (see box) are useful for getting your film seen by critics and for generating interest and (with luck) good reviews. Register your film on the Internet Movie Database (imdb.com) to ensure it can be found easily. Look for places where you can send press releases or articles about your film, plus new reviews and any festival wins. Try print or internet-only magazines or online blog authors, as well as trying to generate your own audience by building a website for your film and using social media. This constant selling campaign goes on until you can attract a sales agent or distributor; by generating interest in your film through your own marketing efforts, you might find that industry buyers are more willing to take it on. Alternatively, you could try self-distribution and sell DVDs directly to the public.

Screenings

Multiplex cinemas tend to show only blockbuster movies, but some will use off-peak slots to show independent films. You might be able to negotiate a cheap or even free screening slot if you organize a première and can 'guarantee' a capacity audience. You may still need to pay a third party to convert your film into a standard DCP (digital cinema package) for playback, unless a Blu-ray or digital version will suffice. Screenings can also be arranged in all sorts of non-cinema locations, such as historic buildings, cafés, local village halls and even 'movie buses' – especially for smaller audiences. Make sure the sound system is good enough for the dynamic range of your film's soundtrack, as this can have a major impact on the audience's perception of the film.

Film festivals

There are literally thousands of film festivals throughout the world where your film could be screened at any one time. Choosing the right festivals, though, can be tricky and time-consuming. First, you need to research which festivals major in your genre and then check the dates and locations to ensure that you can visit and see the audience reaction firsthand. Second, you must match the delivery format with the festival's screening formats before the submission deadline. A lot of festivals charge for each film submission, with so-called 'early-bird' entries attracting less expensive fees. It's not a cheap process if you pick major film festivals, but these attract the most media attention and the most influential people and buyers.

Submitting your film to a festival is no guarantee of being accepted, and if your film is not successful you won't get your money back. Choose your festivals carefully, therefore, to get the best value from this part of your marketing effort. Many filmmakers use withoutabox.com to help them select and submit to a multitude of festivals. Create an entry for your film on the website and upload all necessary details and sales information. You can even upload completed films for electronic submission, or for self-distribution via createspace.com (a site that manufactures DVDs on demand).

Right (from top): The glamorous Cannes Film Festival is a great place to see the international film market at work – it also offers the 'Short Film Corner' where amateur filmmakers can screen their shorts for a small fee; the Berlinale is more industry focused and less intimidating for first-timers; the London Short Film Festival is an ideal platform for your short; and even Los Angeles boasts its own great short film competiton, 'LA Shorts'.

Glossary

1st AC / 2nd AC 1st and 2nd Assistant Camera operators are part of the camera crew and work together to set up and position the camera and cabling for video monitors. The 1st AC will maintain focus on the camera during the shoot, whilst the 2nd AC (a subordinate role) will set marks for actors' positions, lay cable, fetch equipment and mark the slate before each take.

1st AD / 2nd AD 1st and 2nd Assistant Directors have very different roles on set. The 1st AD is on set and responsible for the day-to-day running of the shoot, making sure things run to time. The 2nd AD spends more time in the production office generating paperwork like call sheets and schedules.

ADR Automatic Dialogue Replacement

AGC Automatic Gain Control

Clapper/Loader The name given to the person responsible for loading and changing the film reels on a 35mm film camera and for operating the clapperboard – usually the same person does both of these roles.

CCD/CMOS Charged Coupled Devices or Complementary Metal Oxide Semiconductor sensors both convert light into electrical signals and are now similar in terms of noise handling and quality. CCD sensors are usually made with three CCD chips – one each for red, green and blue light and suffer from vertical light smearing where bright point sources cause vertical streaks. CMOS sensors consume less power, are cheaper to manufacture especially at a larger size, but have problems with image skew and wobble caused by using a rolling-shutter to scan data from the sensor, so care must be taken with fast movement.

CRT Cathode Ray Tube was the original television and computer monitor before LCD and LED displays emerged. CRT is a vacuum tube using three electron guns that fire electrons onto a fluorescent screen coated with a grid of red, green and blue phosphor.

CTB/CTO Colour Temperature Blue / Colour Temperature Orange gels are the main gels used to change the colour temperature of tungsten or daylight lamps for video. CTB gels convert tungsten light to a daylight colour temperature whilst CTO gel converts daylight lamps to tungsten equivalent colour temperature.

DAT Digital Audio Tape

dB The decibel is a logarithmic unit of measurement originally developed for telephony. The dB is used in many fields as a power ratio and is used for comparing sound levels for audio recording. It provides a very wide range of sound levels with a convenient small number, since a change of 3 dB is equivalent to halving or doubling the sound level.

DCP Digital Cinema Package is the standard format of files created for displaying a film in a digital cinema. This includes audio files in PCM (uncompressed) format and video in the JPEG2000 or MPEG-2 format. The A/V files are packaged together with an XML (Extendable Markup Language) file and encrypted with a key.

DIT Digital Imaging Technician is the name given to the person technically responsible for getting the right 'look' from modern digital cinema cameras. They work with the DOP, who may be transitioning from a film background, to ensure the digital workflow produces the desired result. They will organize the end-to-end workflow and manage the media to make it easier for the editor to take over.

DOF Depth of Field refers to the amount of a scene that is in focus.

DP/DOP The Director of Photography or Cinematographer is responsible for creating the 'look' of the film. They work with the Director and head up the camera and lighting teams to ensure the film is lit properly and shots are composed correctly. In TV this role is also referred to as a lighting cameraman.

DSLR stands for Digital Single Lens Reflex and refers to a digital camera with inter-changeable lenses that can show a live preview of the actual scene via the viewfinder or built-in LCD screen. DSLRs have shaken up the video camera market by producing beautiful video clips in low light, with a shallow depth of field due to their larger imaging sensors.

DVI Digital Visual Interface is an update from the analogue-only VGA connector, a standard for

interconnecting computers to displays or television sets, and can support analogue and/or digital signals depending on the DVI specification used. There are dual-link, single-link and mini-DVI connectors.

ENG Electronic News Gathering

FF Follow Focus is a mechanical or electronic device used for controlling focus on a camera. Consisting usually of a white circular disc to allow you to draw on marks for focus positions, the FF has a geared or electronic connection to the lens focus ring. Cinema lenses have geared focus rings; other stills lenses can have after-market lens rings attached.

HD video High Definition video or HDTV (High Definition Television) refers to the video system with a resolution of 1280 x 720 (known as 720p and the minimum for HD-ready TVs) or 1920 x1080 known as 1080i (interlaced) or 1080p (progressive). HD video also covers larger video sizes such as 2K and 4K although these are usually referred to directly as such.

HDD Hard Disk Drives are made from multiple platters of magnetic material that spin at high speed. Data is read and written via a moving head to provide random access. HDDs suffer from mechanical failure over time with some disk sectors becoming unreadable. They can suffer from catastrophic failure if moved suddenly whilst reading or writing.

HDMI High Definition Multimedia Interface is a standard for interconnecting digital multimedia equipment such as cameras, set-top boxes and monitors with both video and sound on the same cable. Several sizes of cable connector exist to allow for portable devices like cameras, with different speeds and capabilities, but they are non-locking and not well suited to robust use on set.

HDR High Dynamic Range refers to an imaging technique that uses multiple exposures of the same image to maintain the detail in the shadows and highlights to increase the normal dynamic range by combining several images into one. Initially a photographic technique, HDR is now being used as a solution to increase dynamic range for video.

HMI Hydrargyrum Medium-arc Iodide lamps are daylight balanced, usually multi-kilowatt, and use an arc instead of a bulb to produce a high quality light. These lights are expensive and need a ballast to provide an ignition and to regulate the arc but are ideal for daylight filming and used in higher budget productions.

Kbps / Mbps / Gbps Kilo bits, Mega and Giga bits per second represent the speed of data transfer over cables such as Ethernet network cable or computer to device interconnection cables such as Firewire, Thunderbolt or USB. 1Kbps is 1000 bits per second where a bit is a '1' or '0'. 1Mbps is 1000 Kbps and 1 Gbps is 1000Mbps.

KHz Kilo Hertz

LANC Local Application Control Bus or LANC port is found on many Sony and Panasonic cameras to allow external peripherals to control the camera focus and zoom, especially when used on a tripod.

LED Light Emitting Diodes are small semiconductor-based light sources normally found in consumer electronics devices, but more recently used in bulk to produce low temperature light fixtures. These point sources need diffusing to make them usable for film and TV, and must be specially selected to avoid colour spikes caused by low-quality LEDs. Some expensive LED fixtures from ARRI and Gekko provide built-in colour temperature measurement and control to provide good quality light output, but beware of cheap LED panels providing no way to colour-match multiple panels.

MPEG Motion Picture Experts Group is a body that develops standards for audio and video compression like MPEG-2, the video compression standard used for DVD, and MP3 (short for MPEG-3) used for audio compression typical on a music player like an iPod. MPEG-4 compression is typically used for web video files and is also one of the Blu-ray video compression standards.

ND Neutral Density refers to a filter that does not change the colour temperature of light passing through it. ND filters come in various sizes to fit into a matte box such as 4" x 4" (100mm x 100mm) or larger and also as screw-on type filters. ND filters are used to control the amount of light.

POV Point of View

RAID Redundant Array of Inexpensive Disks

RAW originally came from the digital photography world, where uncompressed images can be captured as well as images pre-compressed using the JPEG algorithm. RAW really refers to the fact that the image data has not yet been manipulated or compressed and comes from the imaging sensor in a 'raw' way. RAW video is now produced in digital cinema video cameras like the RED, ARRI Alexa, Ikonoskop and Blackmagic Design cameras, which can produce uncompressed video files that need to be colour-graded before they are usable. **Rushes** is the term used for the straight-from-camera footage in its original raw state. This is also referred to as *dailies* or *daily rushes* especially in movie production where originally film would be printed and synchronized with sound to be projected for the director to watch after each day's shoot – always last-minute and rushed, hence the name.

SATA / eSATA Serial Advanced Technology Attachment or Serial ATA / External SATA is a method for attaching devices to a computer, especially hard disk drives.

SCSI Small Computer System Interface is another computer interface specification used for hard disk drives but also for tape back-up and storage tape devices like LTO (Linear Tape Open) and DLT (Digital Linear Tape), both magnetic tape data storage devices used for backing up large quantities of video data.

SD Video Standard Definition Video or **SDTV** (Standard Definition Television)

SDI Serial Digital Interface is commonly found on broadcast equipment such as cameras, monitors, VTRs, video mixers, distribution panels and convertors. This interface carries digital video and can include embedded audio channels too. SDI is used in a dual-link configuration for 3D filmmaking and uncompressed 4:4:4 video signals.

SEO Search Engine Optimization is a term used to describe steps taken to increase web traffic by increasing its page ranking or its listing on a search engine like

Google. SEO generally involves making sure that the code is all valid HTML and contains image and title tags, META keywords and descriptions and most importantly that is does contain information relevant to the search terms you're trying to optimize it for.

SSD Solid State Drives are made from memory chips with no moving parts. Large SSDs are taking over from HDDs for some applications since they are faster and more reliable with no mechanical wear, although some versions will deteriorate over time in terms of read/write speed.

UHDV Ultra High Definition Video or UHDTV (Ultra High Definition Television) was developed by engineers at the Japan Broadcasting Corporation (NHK Science and Technology Research Labs) and refers to video at 4K (3840 x 2160 pixels) or 8K (7680 x 4320 pixels) frame sizes with 120 frames per second rates. This emerging standard is designed as a future broadcast TV format and was demonstrated on large screens at the London Olympics in 2012.

VFR Variable Frame Rate refers to the ability of a camera system to allow you to change the frame rate of a scene, usually while still shooting. Most video cameras will shoot at European and US frame rates of between 24 fps and 60 fps, but VFR cameras will also allow incremental frame rates of between 1fps and 24 fps.

Vox Pops from the latin *vox populi* (voice of the people) is a term used in TV journalism for short interview sections, tightly edited, but is also used in corporate or documentary filmmaking as a general term for 'talking heads' or interview segments in an edit.

XLR A type of cable connector used for audio cables, using three pins for a balanced signal with a braided shield to reduce interference from external noise. XLR cables have a latch to lock them in place, making them suitable for professional audio. Four-pin XLR cables are used for power transmission, especially for battery belts and on some video cameras.

Index

Acknowledgements

Cover images: camera picture courtesy of Nikon; snowboarding image copyright imagebroker.net/SuperStock.

p2 © Nathan Griffith/Corbis; p6 © Nathan Wright/Shutterstock.com; p8 © elwynn/Shutterstock.com; p11 © Justine Evans/Alamy; p12tr © motionpicturecameras; p12bl © Ivo Marloh; p13tr & bl © Canon; p13cr © Shane Hurlbut; p14 © VladKol/Shutterstock.com; p16 © SlavaK/Shutterstock.com; p17t © SeanPavonePhoto/Shutterstock.com; p17b © Luminis/Shutterstock.com; p17c © RTimages/Shutterstock.com; p18bl © RED; p18tr © JVC; p19tl © Nikon; p19br © Sony; p20l all 5 © Germanskydiver/Shutterstock.com; p20cr & br © GoPro; p21t © Sony; p22bl © PHOTOunterwegs & Xidong Luo/Shutterstock.com, p22br © bogdan ionescu/Shutterstock.com; p23tr © Ivo Marloh; p23br © tlorna/Shutterstock.com; p24 © Nikon; p25t © stavklem/Shutterstock.com; p25b © Igor Karon/Shutterstock.com; p26bl © Brian Valente/Canon; p26br © Falk Kienas/Shutterstock.com; p27tl © Joby; p27tr © Ruslan Rizvanov/Shutterstock.com; p28bl © Adam Eastland Rome/Alamy; p28br © Konova; p29tr&l © Urbanfox.tv; p29br ©Tiffen; p30t © Taylor Jackson/Shutterstock.com; p30b © Røde; p31t © JVC; p31b © firedark/Shutterstock; p32 © Beachtek; p33t © Zoom; p33c © Cinedeck; p33b © Atomos; p34bl © Litepanels; p34tr © Axrtec; p35b © Rihardzz/Shutterstock.com; p36tl © Apple; p36bl © Dell; p37tl © Apple; p37tc © Blackmagicdesign; p37tr © Adobe; p39 © Paul_K/Shutterstock.com; p40 © John Churchman/Getty Images; p44 © Zoo Team/Shutterstock.com; p43t © Stanislav Fridkin/Shutterstock; p43ct Prixel Creative/Shutterstock.com; p43cb © Reynardt/Shutterstock.com; p43b © Felix Mizioznikov/Shutterstock.com; p44 © Manfrotto; p45tl & tr © Zacuto; p45bl © Olympus; p45br © Manfrotto; p46 © Manfrotto; p47tl © Photojojo; p47bl © Viktor Gladkov/Shutterstock.com; p47cr © Anthony Burokas/IEBA Tech Thoughts; p48 © ChameleonsEye/Shutterstock.com; p49tl © Yellowj/Shutterstock.com; p49r © Alta Oosthuizen/Shutterstock.com; p50 © My Portfolio/Shutterstock.com; p51t © Elnur/Shutterstock.com; p51b © Ivo Marloh; p52bl © peepo18/Shutterstock.com; p52br © S.Pytel/Shutterstock.com; p53t © Pete Saloutos/Shutterstock.com; p53b © leungchopan/Shutterstock.com; p54 all © Digital Vision; p56t © Canon; p56b © Sergey Ryzhov/Shutterstock.com; p57 © niderlander/Shutterstock.com; p58 © Pichugin Dmitry/Shutterstock.com; p59t © Ruta Saulyte-Laurinaviciene/Shutterstock.com; p59b © taramara78/Shutterstock.com; p60 © Sekonic; p61t ©Sunbounce; p61 © Warren Goldswain/Shutterstock.com; p62 © Konstantin Shishkin/Shutterstock.com; p63t © Dreamframer/Shutterstock.com; p63b © Formatt Hitech; p64br © Dario Diament/Shutterstock.com; p65t © Nikola Spasenoski/Shutterstock.com; p65c © SBremer/Shutterstock.com; p65b © Igor Grochev/Shutterstock.com; p66l © AISPIX by Image Source/Shutterstock.com; p66r © Alexander Ischenko/Shutterstock.com; p67t © Tom Davison/Shutterstock.com; p67b © Andreas Gradin/Shutterstock.com; p68 © Arman Zhenikeyev/Shutterstock.com; p69t © Photobac/Shutterstock.com; p69c © Markus Gann/Shutterstock.com; p69b © sint/Shutterstock.com; p70 © Franz Pfluegl/Shutterstock.com; p71t © Seth Fisher; p71b © doctor_bass/Shutterstock.com; p72bl © Jason Maehl/Shutterstock.com; p72tr © domturner/Shutterstock.com; p72br © Fostex; p73tl © Faraways/Shutterstock.com; p73b © Apple; p74 © Røde; p75t © Røde; p75c © Sennheiser; p75b © Røde; p76 © Andy Teasdale/Alamy; p77tl © Knud Nielsen/Shutterstock.com; p77tr © nexuslabs photography/Shutterstock.com; p78 © taboga/Shutterstock.com; p80 © alphaspirit/Shutterstock.com; p81 © AF archive/Alamy; p82 © Krzysztof Odziomek/Shutterstock.com; p83 © Aurora Photos/Alamy; p84 (1) ILYA AKINSHIN/Shutterstock.com; p84 (2) © Mile Atanasov /Shutterstock.com; p84 (3) © Colour /Shutterstock.com; p84 (4) © caliber_3D/Shutterstock; p84 (5) © Litepanels; p86 © urosr/Shutterstock.com; p87t © Andrey Arkusha/Shutterstock.com; p87b © StockLite/Shutterstock.com; p88 © Pierdelune/Shutterstock.com; p89tl © Oleg Golovnev/Shutterstock.com; p89tr © Hasloo Group Production Studio/Shutterstock.com; p89b © bloomua/Shutterstock.com; p90l © stefanolunardi/Shutterstock.com; p90r © Gilles DeCruyenaere/Shutterstock.com; p91 © Karin Hildebrand Lau/Shutterstock.com; p92 © Olympus; p93t © Gene Michael; p94 © Aga & Miko (arsat)/Shutterstock.com; p95bl © ruzanna/Shutterstock.com; p95tr Gilmanshin/Shutterstock.com; p95br © Songquan Deng/Shutterstock.com; p96-97b © Seaman Yury/Shutterstock.com; p97t © maga/Shutterstock.com; p98 © Cheryl Ann Quigley/Shutterstock.com; p99 © Maxisport/Shutterstock.com; p100 © Dmitriy Aseev/Shutterstock.com; p101t © Ciaran Griffin/Thinkstock; p101b © Philip Bloom; p102 ©

195069/Shutterstock.com; p103tl © asiana/Shutterstock.com; p103tr © Cameracorps; p103br © bogdanhoda/Shutterstock.com; p104tr © Oren Arieli; p104b © Ray Tang; p105tl © Ray Tang; p105tr © Røde; p105b © iriksavrasik/Shutterstock.com; p106 © djem/Shutterstock.com; p107 © Salim October/Shutterstock.com; p108 © Andreas Mohaupt/Getty Images; p110l © Robert Kneschke/Shutterstock.com; p110r © Mike Golubev/Shutterstock.com; p111tl © Apple; p111br ©Lacie; p114 © Apple; p113tl © Sony; p113tr © Microsoft; p113b © Avid Technology; p114 © Apple; p115t © Apple; p115b © Ivo Marloh/Apple; p116 © Ivo Marloh; p117 © Ivo Marloh; p118 © Ryan Boyle; p120l © Photos 12/Alamy; p120r © AF archive/Alamy; p121l © AF archive/Alamy; p122 © watchara/Shutterstock.com; p123 © Pictorial Press Ltd/Alamy; p124 © Sascha Burkard/Shutterstock.com; p126 Carolina K. Smith, M.D./Shutterstock.com; p127t © BestPhotoStudio/Shutterstock.com; p127b © Adam Michal Ziaja/Shutterstock.com; p130 © Halina Yakushevich/Shutterstock.com; p131 © KennethMan/Shutterstock.com; p132 © Peter Kim/Shutterstock.com; p133 © KUCO/Shutterstock.com; p134 © Rui Vale de Sousa/Shutterstock.com; p135 © Oleg Golovnev/Shutterstock.com; p136l © Kuzma/Shutterstock.com; p136r © Allstar Picture Library/Alamy; p137t © Featureflash/Shutterstock.com; p137br © addimage/Shutterstock.com; p138 © Hemera/Thinkstock; p139t © Stockbyte/Thinkstock; p139b © Jupiterimages/Thinkstock; p140 © Radyukov Dima/Shutterstock.com; p141t © Dennis Sabo /Shutterstock.com; p141bl © Kletr/Shutterstock.com; p141bc © ChinellatoPhoto/Shutterstock.com; p141br © Okssi/Shutterstock.com; 142 © Steve Heap/Shutterstock.com; p143 © Josef Hanus/Shutterstock.com; p144 © Jacques PALUT/Shutterstock.com; p145cl © waldru/Shutterstock.com; p145cr © olly/Shutterstock.com; p145br © vladm/Shutterstock.com; p146 © Arti_Zav/Shutterstock.com; p148 © Irbiss/Shutterstock.com; p150l © Dario Diament/Shutterstock.com; p150r © Carsten Medom Madsen/Shutterstock.com; p151t © Tatiana Belova /Shutterstock.com; p151bl © Christoph Weihs/Shutterstock.com; p151br © Garsya/Shutterstock.com; p152 © © AF archive/Alamy; p153tr © James Steidl/Shutterstock.com; p153b © Vasily Smirnov/Shutterstock.com; p154 © riekephotos/Shutterstock.com; p155 © FlashStudio/Shutterstock.com; p156 © SketchUp; p157t © Marcy J. Levinson/Shutterstock.com; p157b © Demotix/Corbis; p158t&b © Corbis; p159t © Corbis; p160 © Corbis; p161 © AF archive/Alamy; p162 © JPagetRFphotos/Shutterstock.com; p163t © Xidong Luo/Shutterstock.com; p163b © James Thew/Shutterstock.com; p164 t&b © Neil Horner; p165 © Karin Hildebrand Lau/Shutterstock.com; p166t&b © John Brawley; p167tl © B Calkins/Shutterstock.com; p167tc © Blaz Kure/Shutterstock.com; p167tr © Zacuto; p168t © hansenn/Shutterstock.com; p168c © Sergey Lavrentev/Shutterstock.com; p168b © OlegD/Shutterstock.com; p169 © straga/Shutterstock.com; p170t © Sony; p170b © Hadrian/Shutterstock.com; p171t © Sony; p171b © GoPro; p172 © Corbis; p173t © Reflecmedia; p173c&b © Aaron Amat/Shutterstock.com; p174 © AF archive/Alamy; p175t © Blazej Lyjak/Shutterstock.com; p175b © Sandra Fleck; p176 © My Good Images/Shutterstock.com; p177 © InqScribe; p178 © Makushin Alexey/Shutterstock.com; p180 © Ivo Marloh/Apple; p182t © corepics/Shutterstock.com; p182b © Apple; p183t © Killroy Productions/Shutterstock.com; p183b © Contour; p184 © Ivo Marloh/Avid Technology; p185 © Shutterstock/Apple; p186t © Apple; p186b © PureBlend Software; p189 © Pictorial Press Ltd/Alamy; p190–191 l-r © SVLuma/Shutterstock.com & Kinetic Imagery/Shutterstock.com; p191tl © HelleM/Shutterstock.com; p191tr © Mechanik/Shutterstock.com; p192–193 l-r © Ivo Marloh/Apple; p193t © AF archive/Alamy; p194 © Mark Brindle/Apple; p195tr © Apple; p195c © Ivo Marloh/Adobe; p196 © Mark Brindle/Apple; p197t © Mark Brindle/Apple; p197c&b Mark Brindle/Izotope; p198 © Holophone; p199 © Karina Becker; p200 Ivan Cholakov/Shutterstock.com; p201t © Pichugin Dmitry/Shutterstock.com; p201b © Everett Collection/Shutterstock.com; p202t&c © Ivo Marloh; p202b © Mark Brindle; p203 © Mark Brindle; p204–205 all © Ivo Marloh/Apple; p206 © Ivan Cholakov/Shutterstock.com; p211bl © imagefactory/Shutterstock.com; p211br © Sergey Mironov/Shutterstock.com; p214 © Ivo Marloh/Peter Zurek/Shutterstock.com; p215 (1) © jbor/Shutterstock.com; p2152 (2) © cinemafestival/Shutterstock.com; p215 (3) © Ivo Marloh; p215 (4) © nito/Shutterstock.com.

The author

Mark Brindle is a master member of the UK Institute of Videography (IOV) and a member of Cine South West and Plymouth Media partnership (PMP) and has won several Media Innovation Awards for films and DVDs through the South West media innovation network. He has a BENG Hons engineering degree in Electronic Computer Systems from Salford University and was a Cisco Certified Internetwork Expert (CCIE) before turning full-time to filmmaking.

More recently Mark has been involved in feature drama production in roles such as 1st AC (Focus Puller), Visual Effects Supervisor and Colour Grading. He does a lot of DVD authoring for both small scale productions and larger scale DVD and CD-ROM projects, as well as corporate video productions, especially in technical subjects where his strong IT background helps in understanding the subject matter.

Mark has written countless film production articles and camera reviews and runs his own film production hire business in Devon, UK.

Quercus Editions Ltd
55 Baker Street
7th Floor, South Block
London
W1U 8EW

First published in 2013

Copyright © 2013 Quercus Editions Ltd

Text by Mark Brindle
Design, layout and editorial by The Urban Ant, London
[www.theurbanant.com]

A catalogue record of this book is available from the British Library

UK and associated territories: ISBN 978 1 78087 813 3

Printed and bound in China

10 9 8 7 6 5 4 3 2 1